House Cat

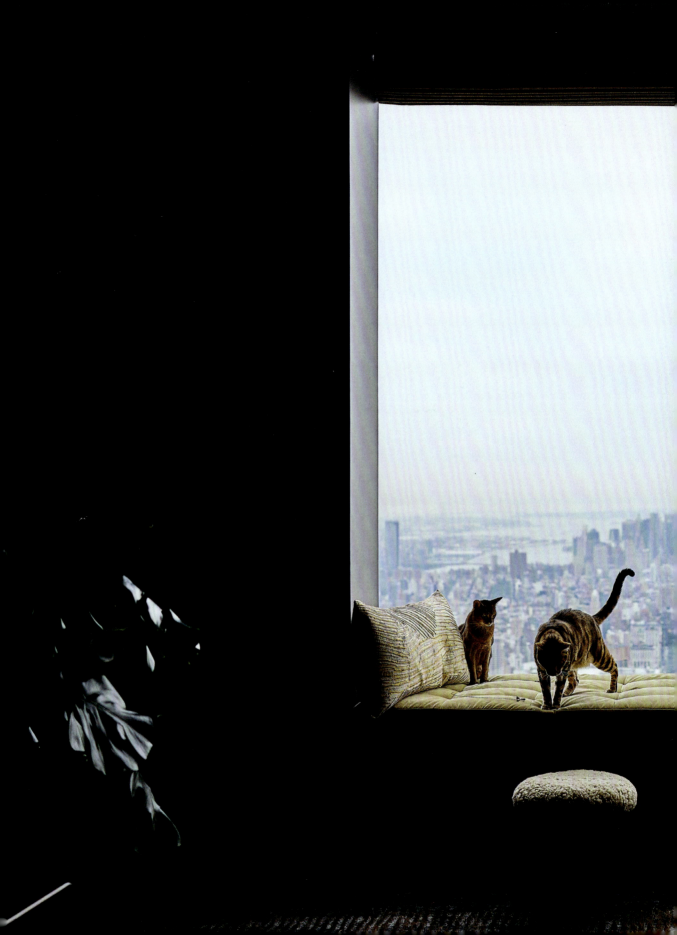

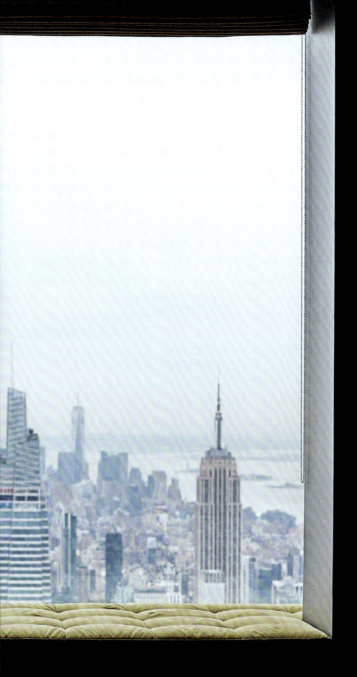

Paul Barbera
WITH RAFAEL WAACK

House Cat

INSPIRATIONAL INTERIORS
& THE ELEGANT FELINES
WHO CALL THEM HOME

Introduction 6

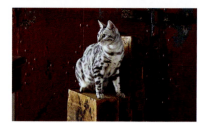

ALICE 9

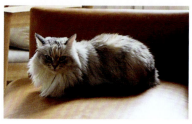

SHADOW 17

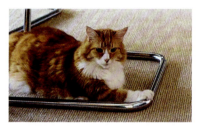

SHISO AND NIJI 25

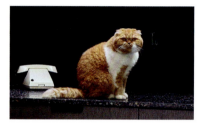

BIXBY AND JINX 31

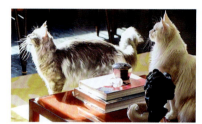

MONTY AND PUNK 41

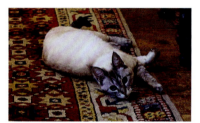

EVITA GATON 49

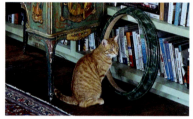

ROY BOY AND BABY BEAR 57

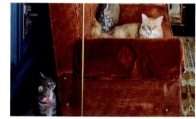

LUNA AND MOJO 67

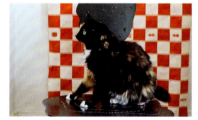

PIP 73

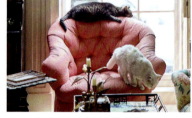

HUGO AND FRED 79

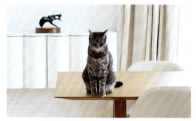

JUDY GARLAND 85

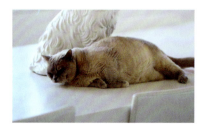

LADY PENELOPE 95

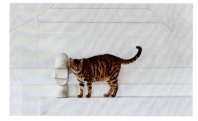

GARY AND GUNNAR 107

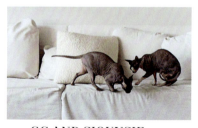

GG AND SIOUXSIE 115

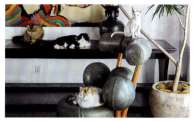

HELEN, MORRIS, SCOTTIE, BRIAN, BESSIE, RICKY, MIKEY, RALPHIE AND KARL 125

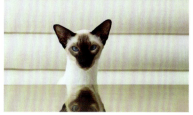

KELLY GIRL AND TOMMY BOY 139

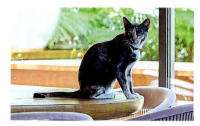

GIGI 147

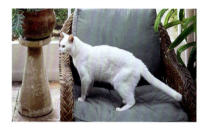

SNOWY 155

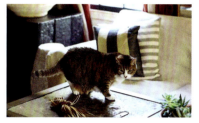

BETTY 165

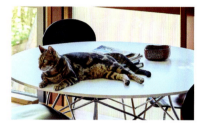

LINUS AND LUCY 171

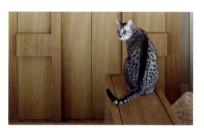

MATSU 177

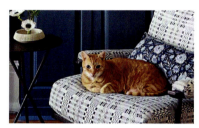

CAPTAIN REGINALD HENRY 187

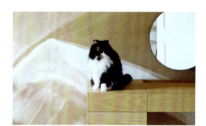

IRIE 195

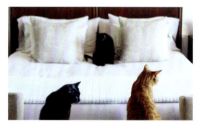

DEL FERBER, HOLLY GO LIGHTLY AND FRED BABY 205

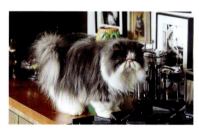

BLANKET, JIMI AND BLONDIE 215

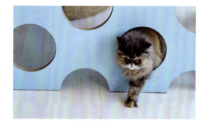

PINOT 223

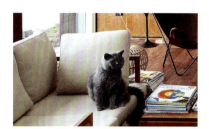

WHALE AND ELEPHANT 229

Acknowledgements 239

INTRODUCTION

This is not a book about cats. Nor is it a book on interiors. It is somewhere in-between: a look at how cats and interiors interact, and how cats become a fundamental part of the home. *House Cat* introduces us to fifty feline residents and offers a fascinating insight into their luxurious lives.

Where They Purr was my first iteration of this theme. I shot it in Australia in between lockdowns, before returning to New York, which has been my home for over a decade. When I got back to the States, it felt natural to celebrate US cats. After all, why should they miss out?

I learned a lot shooting the first book. The elusive and seriously aloof nature of cats can make them difficult subjects. I was keen to shoot more cute details this time around, which required getting close up. Luckily I am very, very patient. I just took my time and let them come to me, which enabled me to capture more of the intricacies of their personalities.

I particularly enjoyed Lady Penelope (page 95) nonchalantly strolling past the Russian satellite Sputnik sitting in the middle of her living room, and then there's Alice (page 9), who was the most active feline model I've ever had to chase after. And how could I go past Kelly Behun's kittens, Gary and Gunnar (page 107), looking out from their penthouse above Billionaires' Row.

We meet legendary Grace Coddington's felines, Blanket, Jimi and Blondie (page 213), in their cosmopolitan apartment in New York's Chelsea, and Snowy (page 155), an outdoor farmhouse cat in Connecticut, whose owner is the renowned interior designer, Bunny Williams. It has to be said that, as charming as they were, none of these cats had any interest in the lives of their design-aware owners.

In terms of its two key subjects – cats and interiors – this book is both broad and specific. Although it covers a very slim slice of America through the abodes of our star cats, it moves freely among designs from every style, era and corner of the country.

What the owners of these homes have in common is a deep love and affection for cats. What the cats have in common is that, while they accept their human housemates, they won't modify their behaviour for them. Somehow, despite living in such unique and inspiring homes, it seems the cats can do no wrong and are quickly forgiven for a few scratches here and there. To quote Lewis Carroll: 'Your house will always be blessed with love, laughter and friendship if you have a cat.' I agree wholeheartedly, though I'd probably add grace and style!

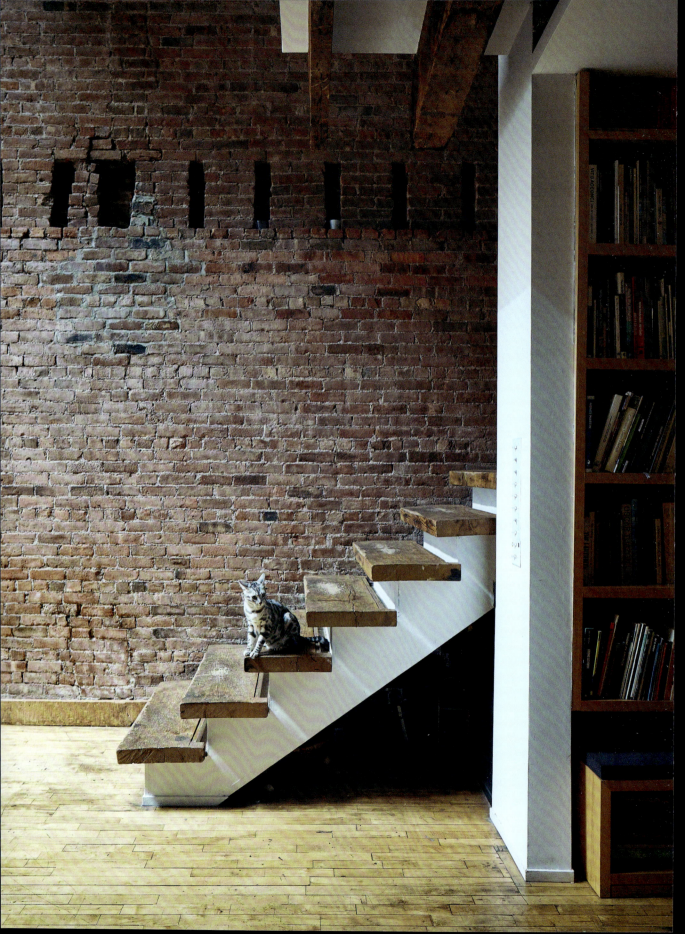

ALICE

ARCHITECTS: LINDA POLLAK AND SANDRO MARPILLERO
LOCATION: TRIBECA, NEW YORK

Alice came into a finished home, yet it sometimes seems like the design had her in mind all along. For the nearly two-year-old silver Bengal, the three-storey apartment's exposed structure is like a boundless jungle gym – she can usually be found balancing on cantilevers six metres above the living room, tiptoeing on the grill floor of open balconies or carefully pausing for a perch on one of the home's many spaces that are accessible only to her.

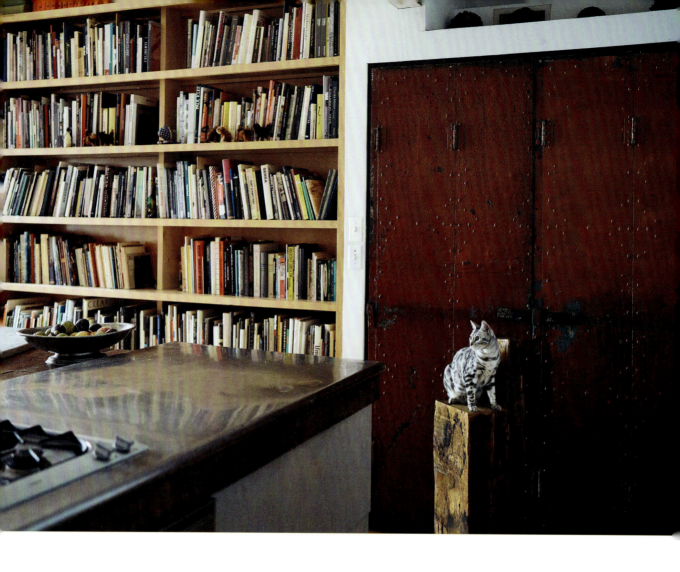

Combining the basement, ground floor and mezzanine of an 1860s industrial structure in downtown Manhattan, Alice's loft posed a great challenge to her architect owners: how to bring light into this long, half-buried space. The unexpected solution was to remove a large portion of the original rear yard extension and first floor, then fit an eight-metre-tall glass wall instead.

Architects: Linda Pollak and Sandro Marpillero

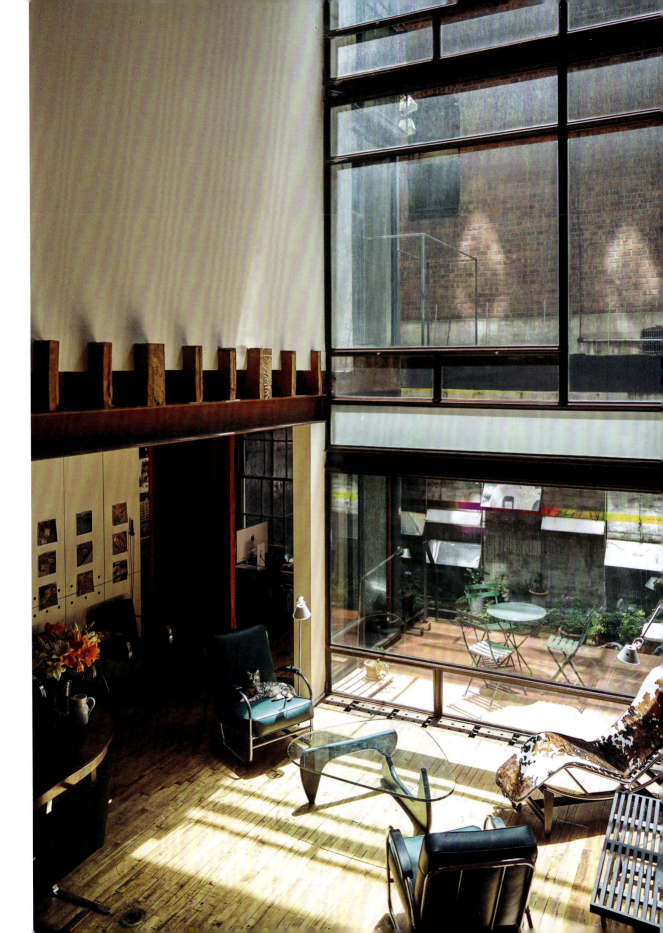

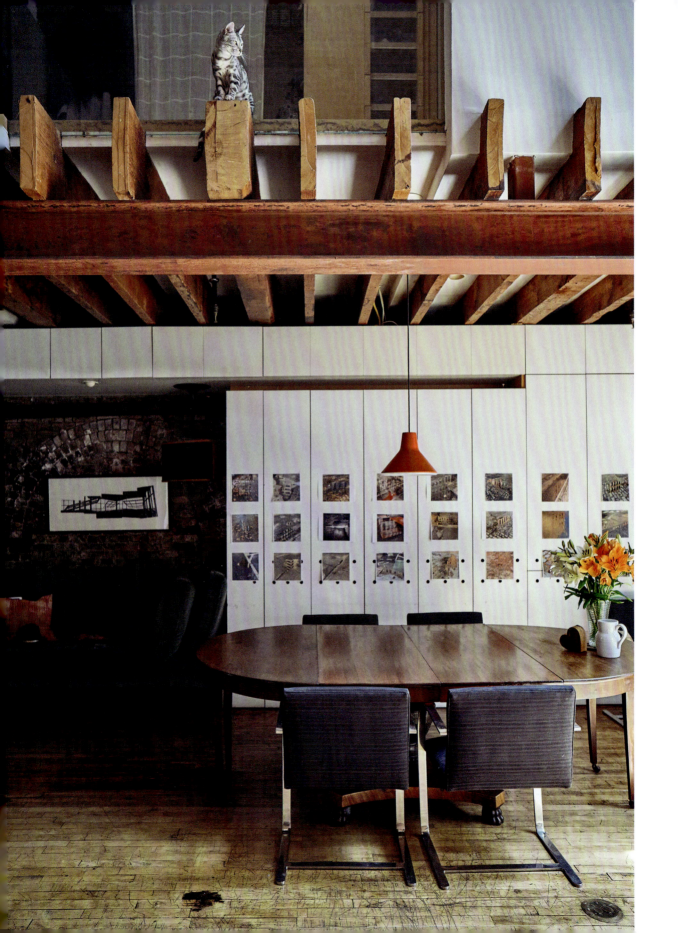

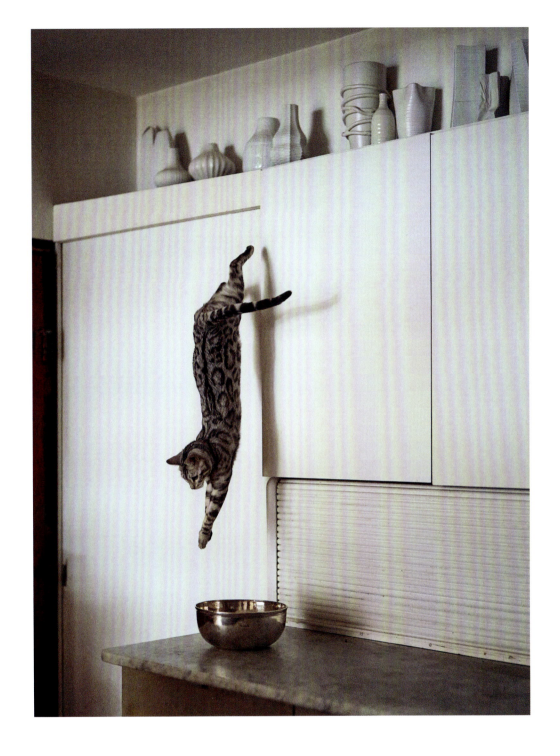

Cantilevered stairs and balconies stream light into the dramatic living room. The original brick walls, heart pine beams and wrought iron joist hangers wrap around the new installation in an almost archaeological showcase of building technology development. However, it takes a feline like Alice to fully explore the nooks and crannies of this architectural tour de force.

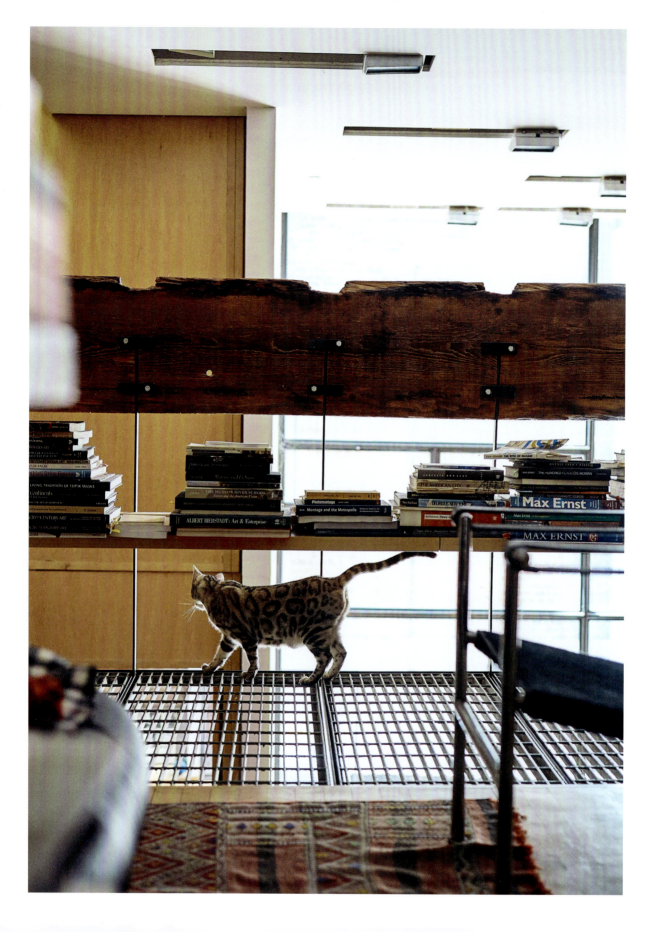

Q&A

DIVA OR DEVOTED FRIEND?
Devoted but independent.

INTROVERT OR EXTROVERT?
A bit of both.

LAP CAT OR NOT?
Not. She wants affection but is not always able to accept it.

OLD SOUL OR KITTEN AT HEART?
Both.

EXPLORER OR HOMEBODY?
More explorer, though much has to do with the house.

LAZY OR ACTIVE?
Loves to burn energy – she is lazy after that's done.

DOGS – FRIEND OR FOE?
Foe, so far.

SHADOW

ARCHITECT: WILLIAM McLOUGHLIN | INTERIOR DESIGNERS: CAROLYN DAVIS AND MATTHEW PAGE
LOCATION: TRIBECA, NEW YORK

True to her name, Shadow spends most of her time chasing after her beloved humans. Belly scratches aren't enough to satisfy the seven-year-old Siberian; she is quick to demand a cuddle, and likes to chew charging cables, presumably to win even more attention away from anything electronic. Her owners have repaid the love with heated windowsills for her city watching, and a range of plywood shelves that let her climb up and down the wall. The home's palette is also a deliberate match to her colouring.

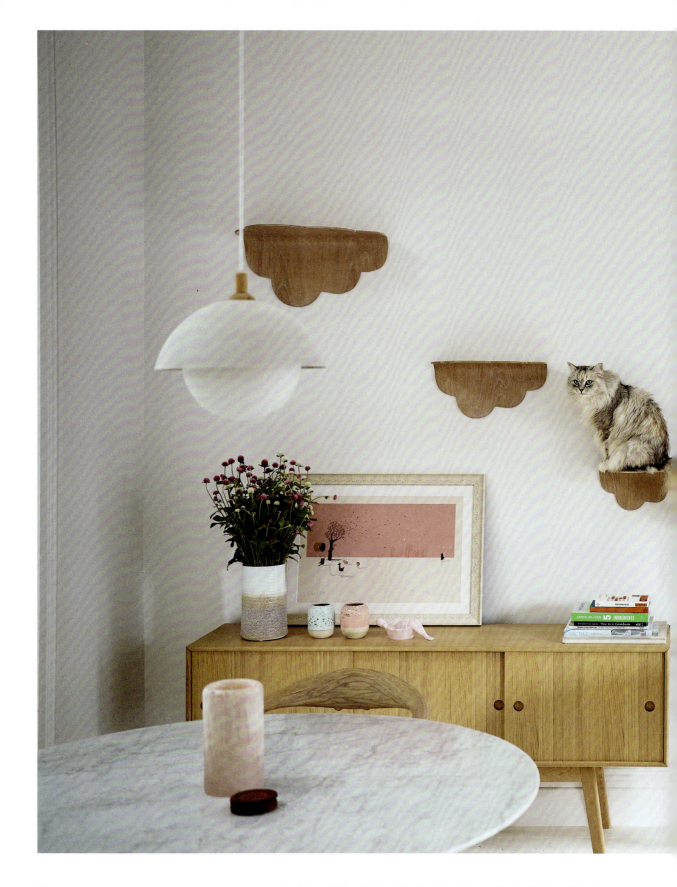

Architect: William McLoughlin | Interior designers: Carolyn Davis and Matthew Page

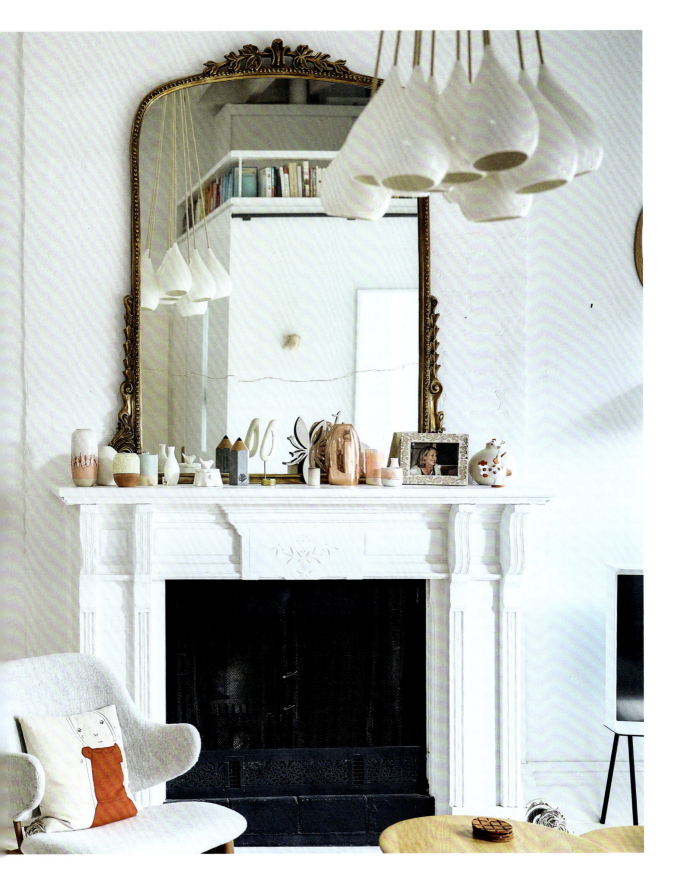

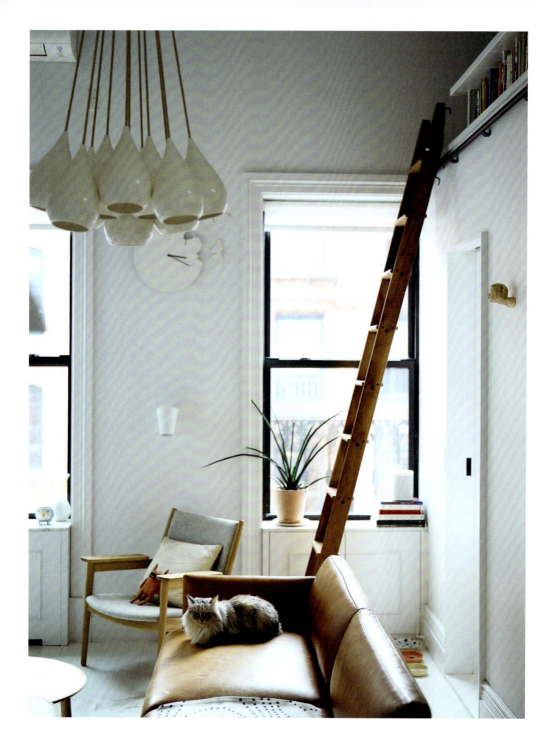

Despite its limited size, Shadow's loft feels spacious. Thoughtful architecture and design elements maximise every square metre, while a touch of Scandinavian minimalism helps prevent any sense of clutter. Untreated natural materials such as raw oak, leather, wool and marble add pops of colour to an otherwise restrained, light palette that keeps the space airy and soothing.

Architect: William McLoughlin | Interior designers: Carolyn Davis and Matthew Page

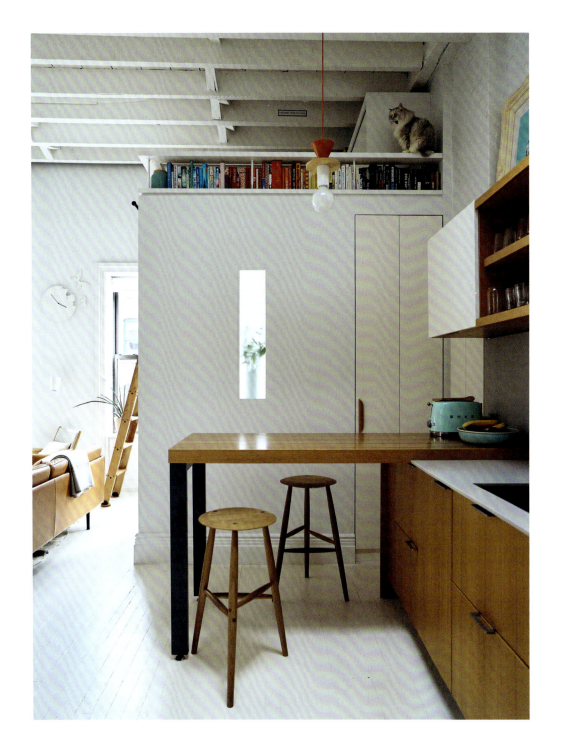

Every month or so Shadow picks a completely new place to hang out – favourites include on top of the highest shelf or inside a cupboard. But nothing compares to nestling between her owners at bedtime or delicately lapping from the bowl of fresh water she receives daily right on top of the breakfast table.

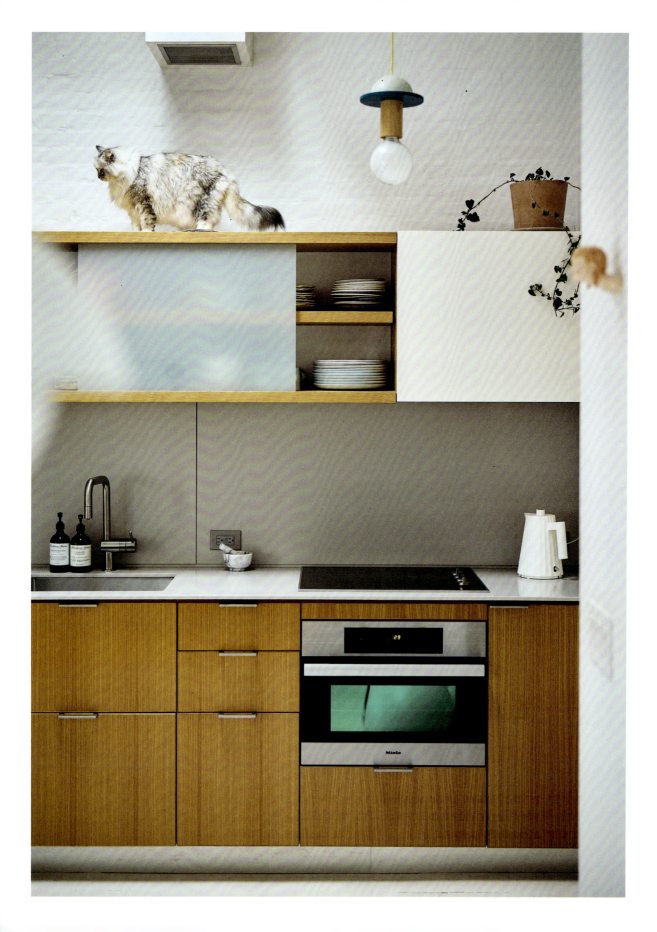

Q&A

DIVA OR DEVOTED FRIEND?
Diva-oted friend.

INTROVERT OR EXTROVERT?
Quirky but introverted. She likes to dance like no one is watching.

LAP CAT OR NOT?
Lap cat, chest cat, arm cat – and fully expects one not to move.

OLD SOUL OR KITTEN AT HEART?
Siberians like to stay kittens for a long time and Shadow is pushing even beyond that.

EXPLORER OR HOMEBODY?
Homebody: scurries up to her owners' shoulder at the slightest gust of wind.

LAZY OR ACTIVE?
Hours of nothing with bursts of way-too-much.

DOGS – FRIEND OR FOE?
Met one dog; there was significant tension.

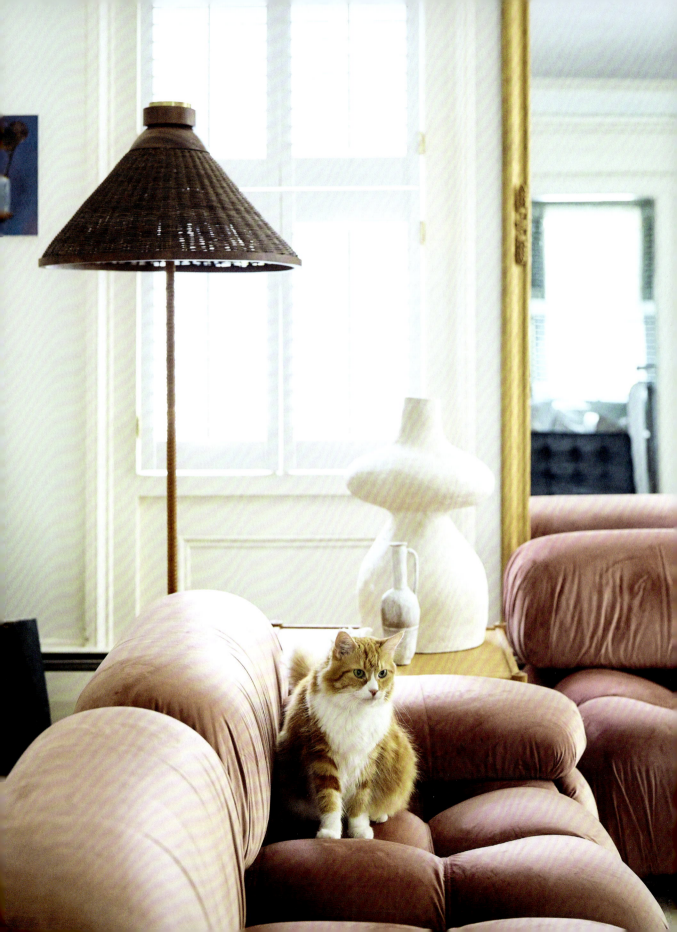

SHISO AND NIJI

LOCATION: KINGSTON, NEW YORK

Shiso and Niji are both rescue tabby cats getting on in years, but their similarities end there. Shiso is a gentle, devoted companion who enjoys the simple things in life – food, a good sunbathe or a long nap on a carefully chosen ottoman. Meanwhile, Niji, the older of the two, is a feline jack-in-the-box, popping out of suitcases and grocery bags or sneaking up on guests who she greets with a welcoming purr or a glare and a hiss, depending on her ever-changing mood.

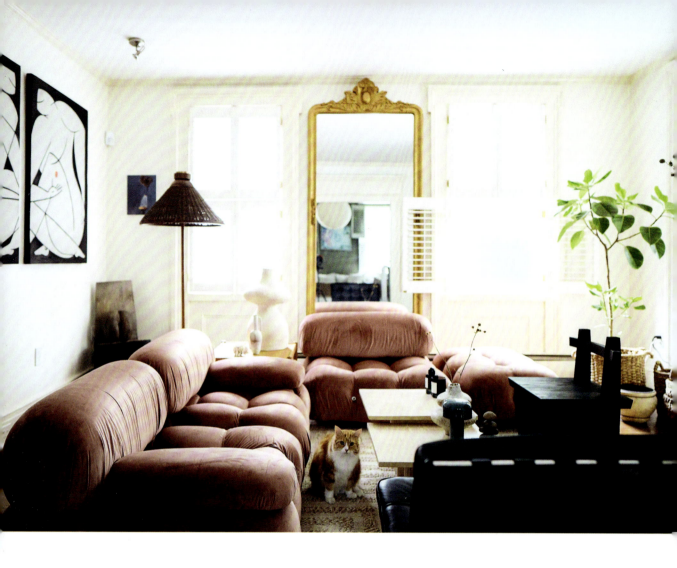

The cats live in a mid-19th-century Greek Revival home edited over the years with expansions, updates and an eclectic art collection. The weight and decadence of the original style is reasserted through the modern elements and by a striking use of colour.

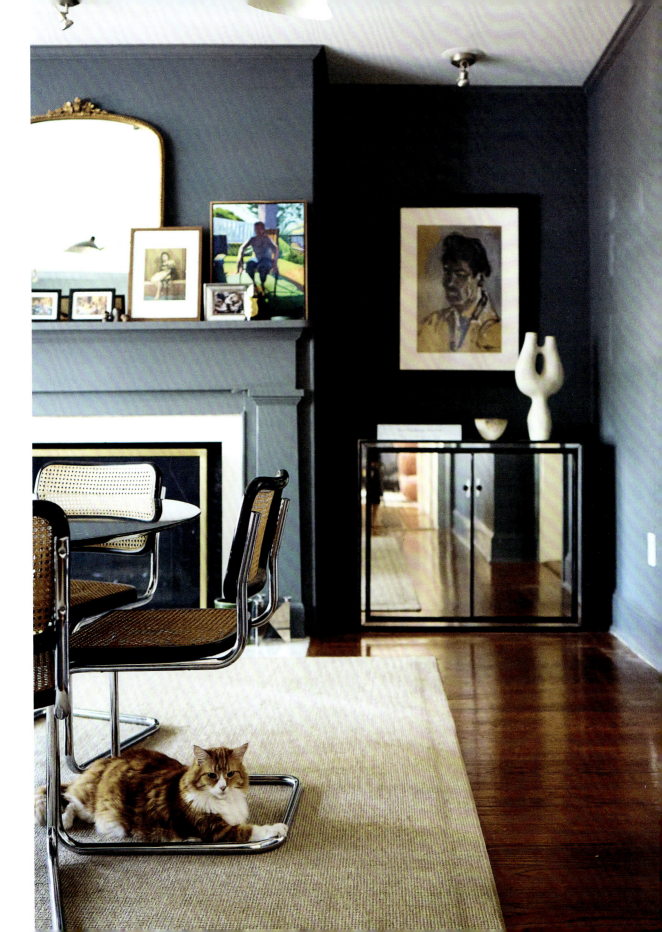

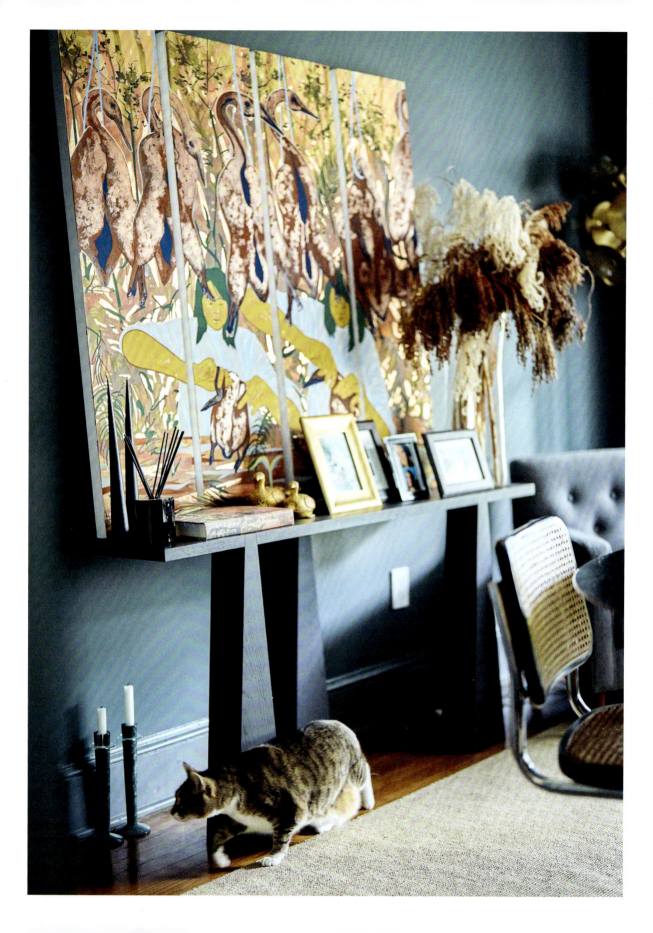

Q&A

DIVA OR DEVOTED FRIEND?
Niji is a diva with a softer, playful side.
Shiso is a (skittish) devoted friend.

INTROVERT OR EXTROVERT?
Niji is an extrovert and can be a bit of a bully.
Shiso is the introvert.

LAP CAT OR NOT?
Lappers exclusively with their owners,
particularly in the winter.

OLD SOUL OR KITTEN AT HEART?
Both are both. Niji has the energy of a younger cat and the crankiness of an old lady, while Shiso's eternal drowsiness is offset by a very kitten-like innocence and sweetness.

EXPLORER OR HOMEBODY?
Shiso is a homebody. Niji wants nothing more than
whatever is behind a closed door.

LAZY OR ACTIVE?
The cats are laziness and action personified –
which should by now be clear.

DOGS – FRIEND OR FOE?
Foes but can coexist.

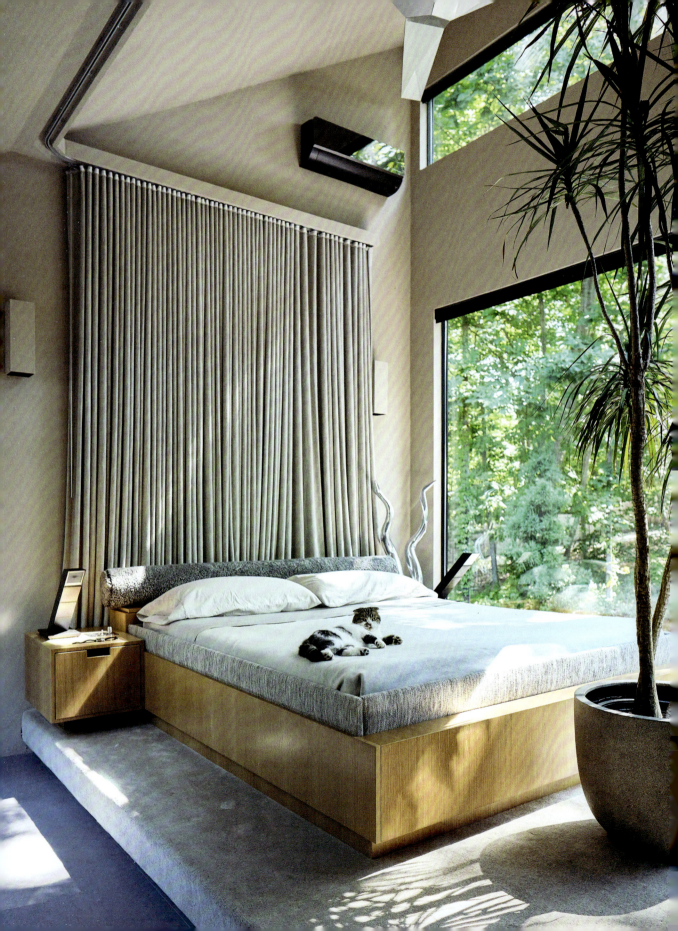

BIXBY AND JINX

INTERIOR DESIGNER: TIMOTHY GODBOLD
LOCATION: SOUTHAMPTON, NEW YORK

Bixby rules supreme over both his home and his quieter and much tinier cat-mate Jinx. The siblings were each adopted from busier households and enjoy the quieter pace of a beach home. While Jinx, a three-year-old British shorthair ginger, can usually be found wherever the sun is strongest, Bixby – a Scottish fold around the same age – has taken to stalking frogs and terrorising the local bird population.

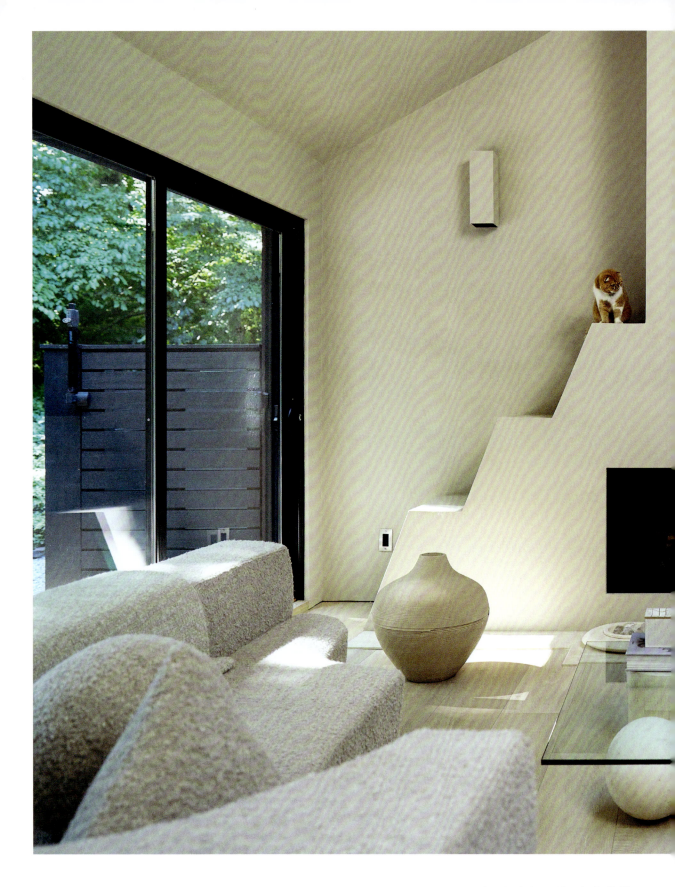

Interior designer: Timothy Godbold

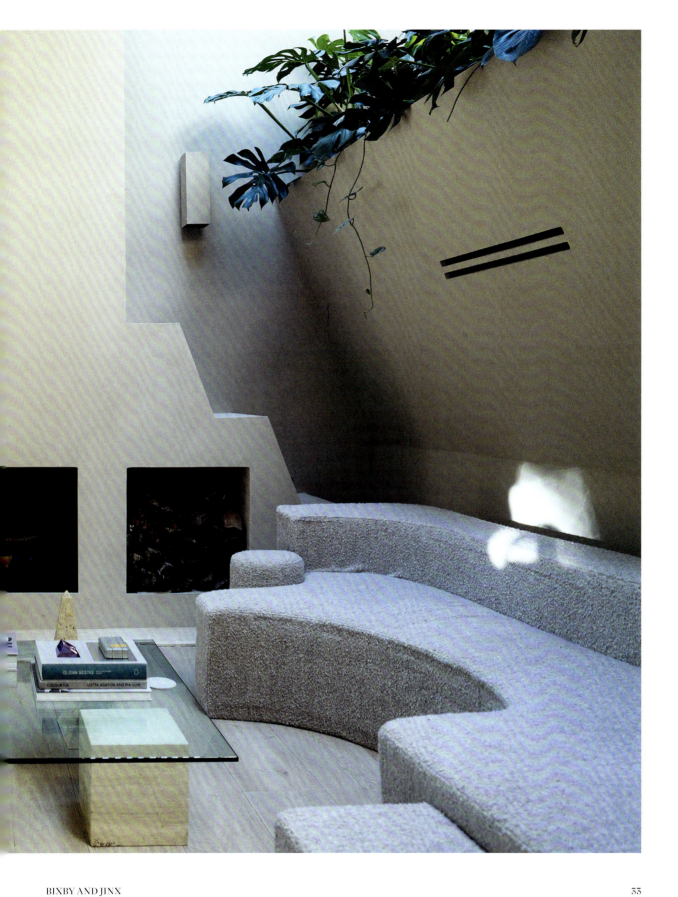

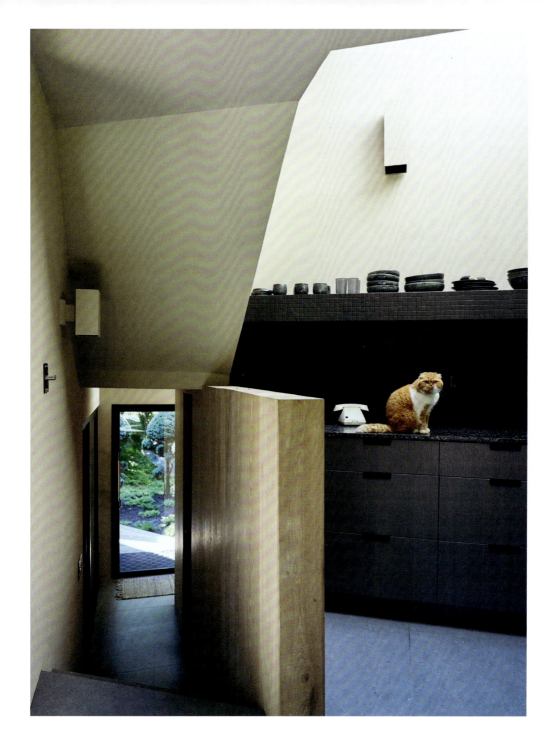

To the cats' great enjoyment, their home abounds with lounging areas and spectacular views of nature. The futuristic design feels straight from a Bond movie, complete with skylights and floor-to-ceiling windows that run from the living room up to the main suite. A muted palette of beiges, greys and light wood juxtaposes a fully black exterior that heightens the house's impact.

Interior designer: Timothy Godbold

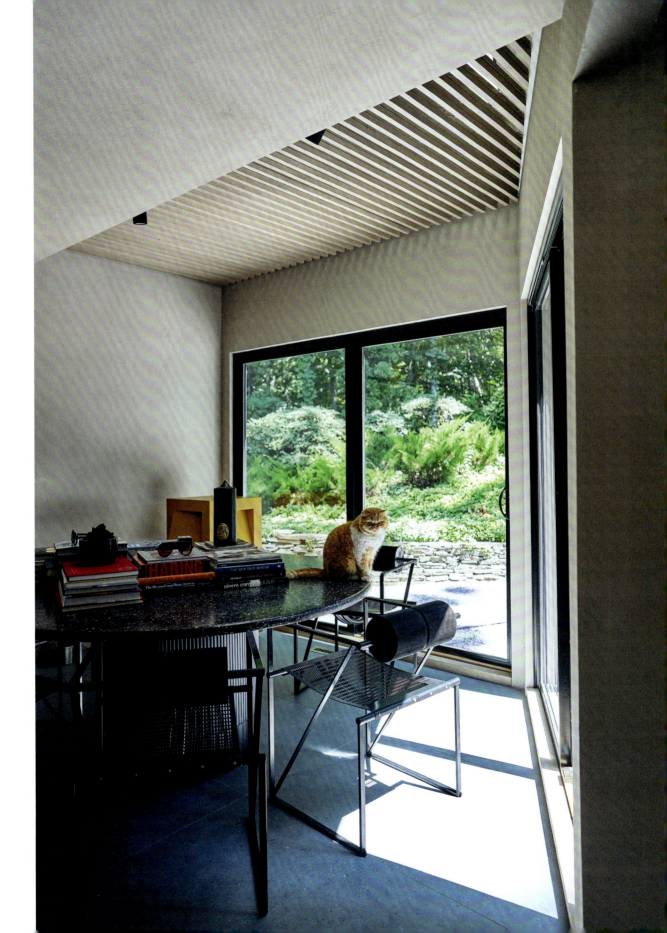

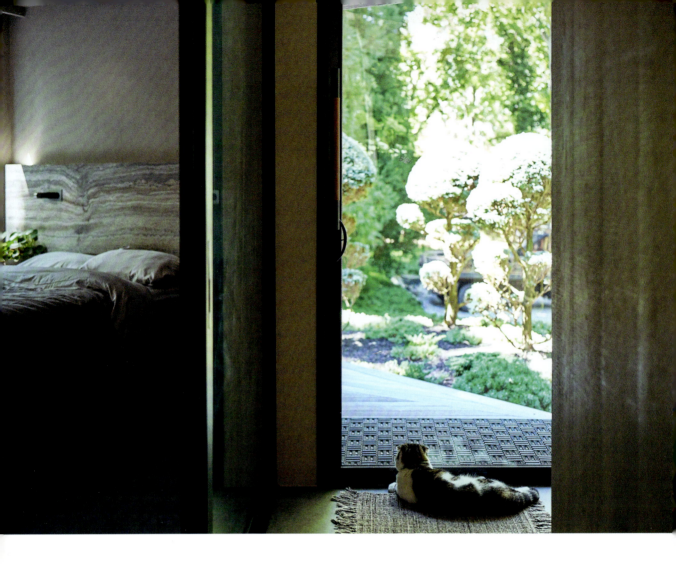

Interior designer: Timothy Godbold

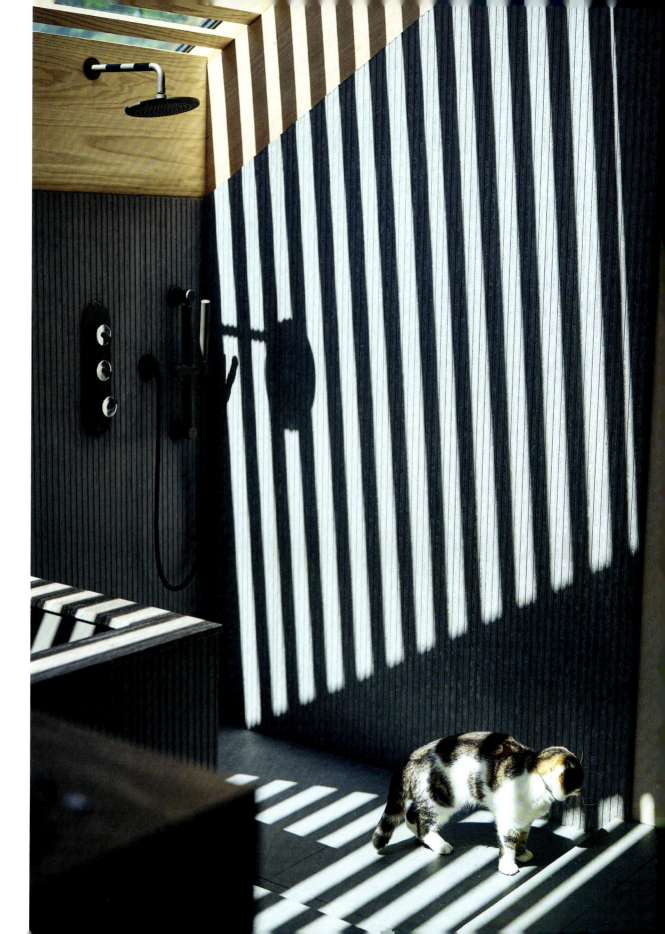

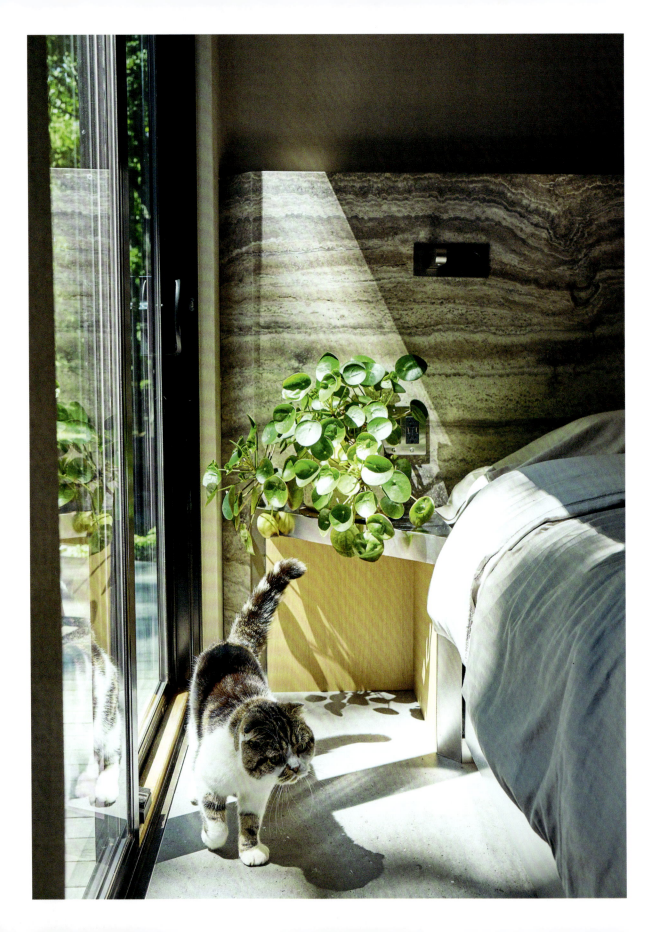

Q&A

DIVA OR DEVOTED FRIEND?
Jinx is a diva, Bixby a devoted friend.

INTROVERT OR EXTROVERT?
Both are extroverts.

LAP CAT OR NOT?
Yes, with some competition.

OLD SOUL OR KITTEN AT HEART?
Bixby, despite the frog hunts, is an old soul.
Jinx is a kitten at heart.

EXPLORER OR HOMEBODY?
Explorers, though with different interests.

LAZY OR ACTIVE?
The cats are active in the summer, lazy in the winter.

DOGS – FRIEND OR FOE?
Never had the pleasure of meeting one.

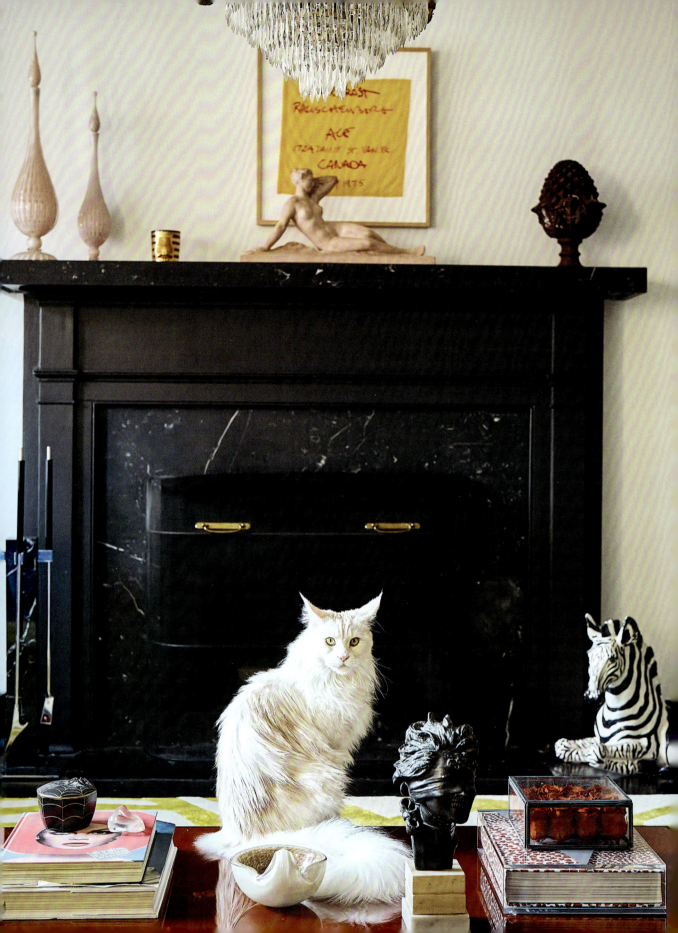

MONTY AND PUNK

INTERIOR DESIGNER: NICOLE FULLER
LOCATION: CHELSEA, NEW YORK

Monty and Punk work in tandem to obliterate even the suggestion of dullness from their owner's life. When they are not flying around the house wrestling, the one-year-old Maine Coon brothers take turns in an array of shenanigans, including unzipping makeup bags in search of hair ties to destroy or carrying around, and even sleeping, with silk hangers as if they were a bone – and the cats dogs! They have learned yoga poses from their owner's classes but apparently slept through their own lessons on not destroying the Jean Royère furniture. However, the most impressive of their tricks is an ability to, without warning, become peaceful and loving as if seconds before they hadn't been typhoons.

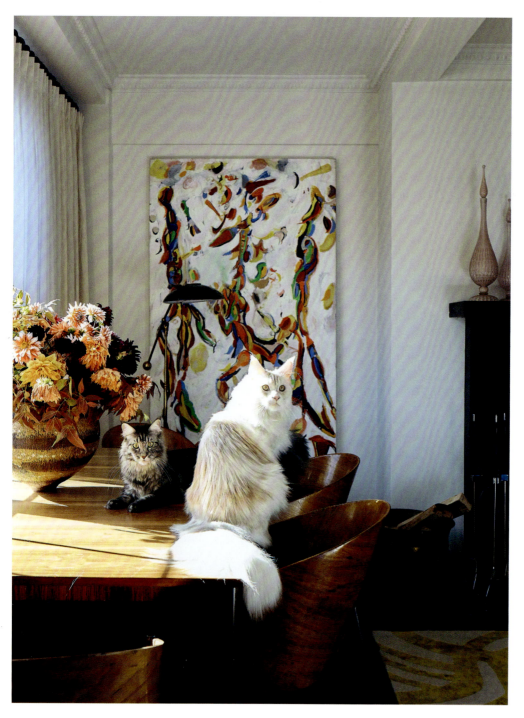

The cats live in a 1920s baroque building, complete with gargoyles and a large English garden that safeguards their apartment from the furore of New York City. Besides original tiles in the bathrooms and a functioning wood fireplace, the home leans towards a clean and classical modern aesthetic, with carefully placed bursts of the eclectic and unique personality of the cats' designer owner. Unusual sculptural pieces, ample paintings – by the likes of John Koga and Eddie Martinez – and authorial furnishing from collaborations with Ann Sacks, The Rug Company and Savoir Beds add vibrant colour to the black-and-white walls and floors.

Interior designer: Nicole Fuller

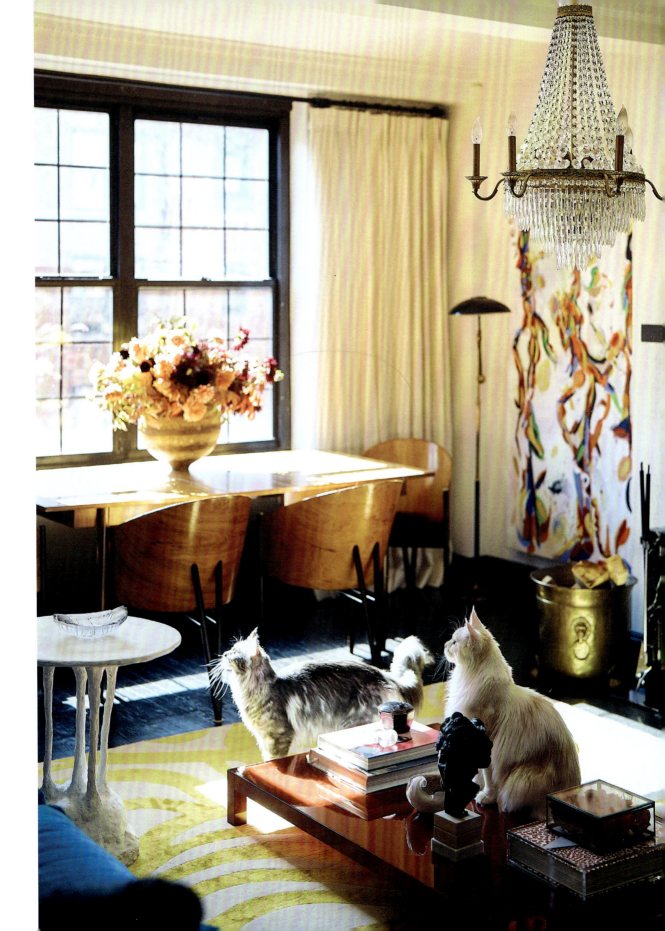

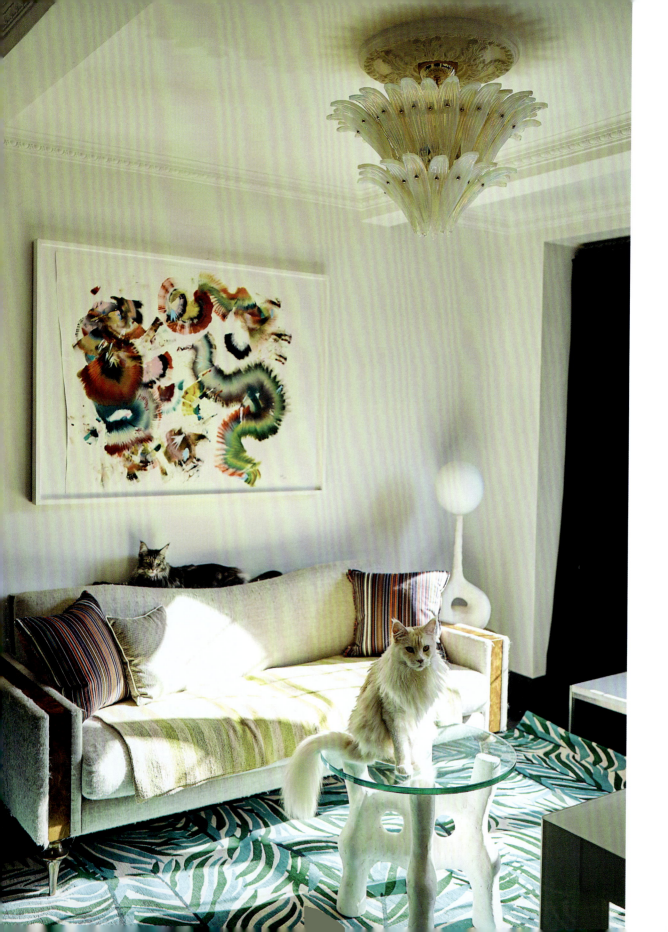

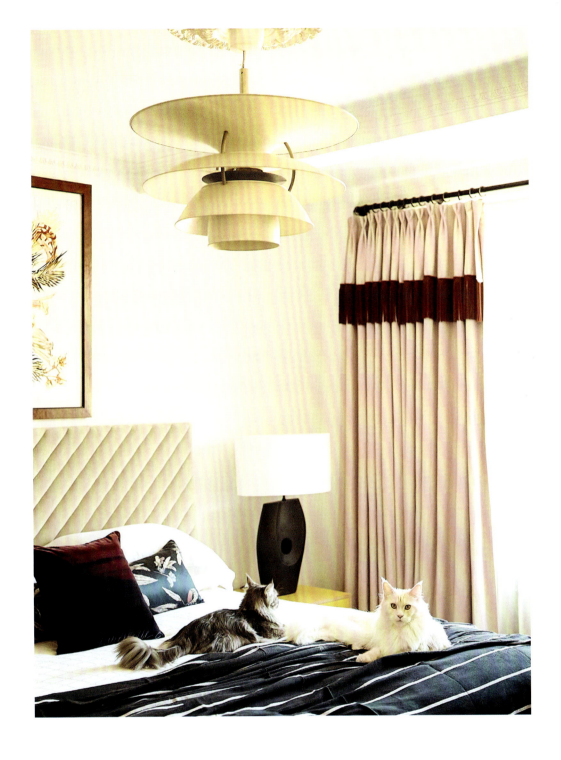

Deliberate mismatching evades trends and tropes in an always surprising, room-at-large harmony that goes beyond simple groupings. Nothing better than two unpredictable cats to tie it all together.

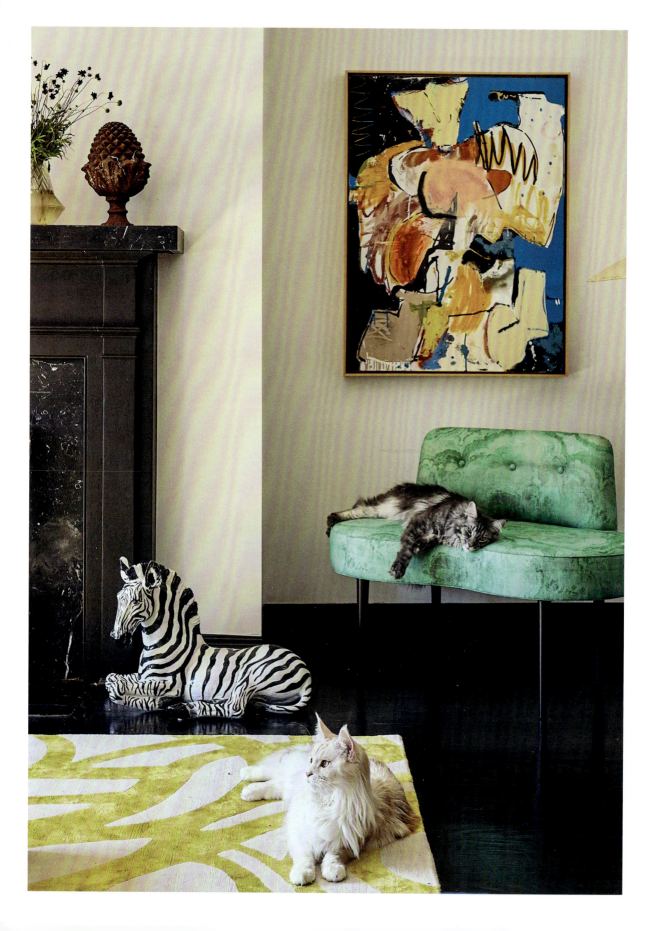

Q&A

DIVA OR DEVOTED FRIEND?
Devoted friends, with a supermodel's swag.

INTROVERT OR EXTROVERT?
Decidedly extroverts, though their social needs begin and end with their owner.

LAP CAT OR NOT?
Yes, and they ignore the very spacious custom mattress to sleep right on top of the human.

OLD SOUL OR KITTEN AT HEART?
Kittens, literally, but no sign of it going away any time soon.

EXPLORER OR HOMEBODY?
Explorers in the kingdom of their own home.

LAZY OR ACTIVE?
Extremely lazy and extremely active, as they please.

DOGS – FRIEND OR FOE?
Never met one.

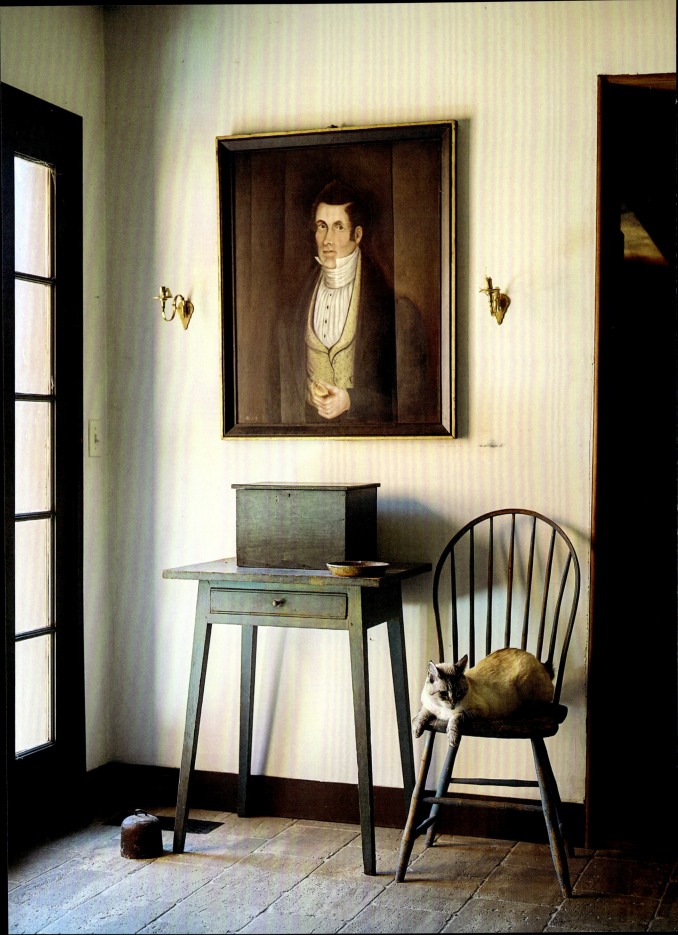

EVITA GATON

CURATION: GEORGE SCHOELLKOPF
LOCATION: WASHINGTON, LITCHFIELD COUNTY, CONNECTICUT

Even in her golden age, Evita Gaton has yet to relinquish her hunting habits. The twelve-year-old lynx point Siamese is an independent and sometimes demanding presence in her 18th-century home, where her timeless feline habits befit the time-appropriate furniture she curls up on for her naps. She enjoys her days and is generally happy to repay the affection she receives – albeit on her own terms.

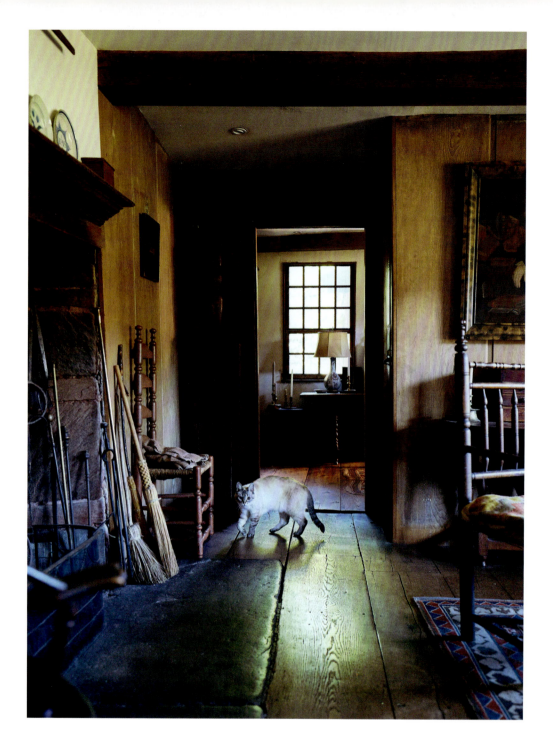

Evita's home is a Connecticut saltbox furnished with an important collection of 18th- and 19th-century American folk art and furniture. Original flooring, exposed beams and deep-set windows, alongside an imposing fireplace and enough candelabras to be fully illuminated without the aid of electricity, the house is a museum-worthy testament to rustic life in pre-Independence America.

Curation: George Schoellkopf

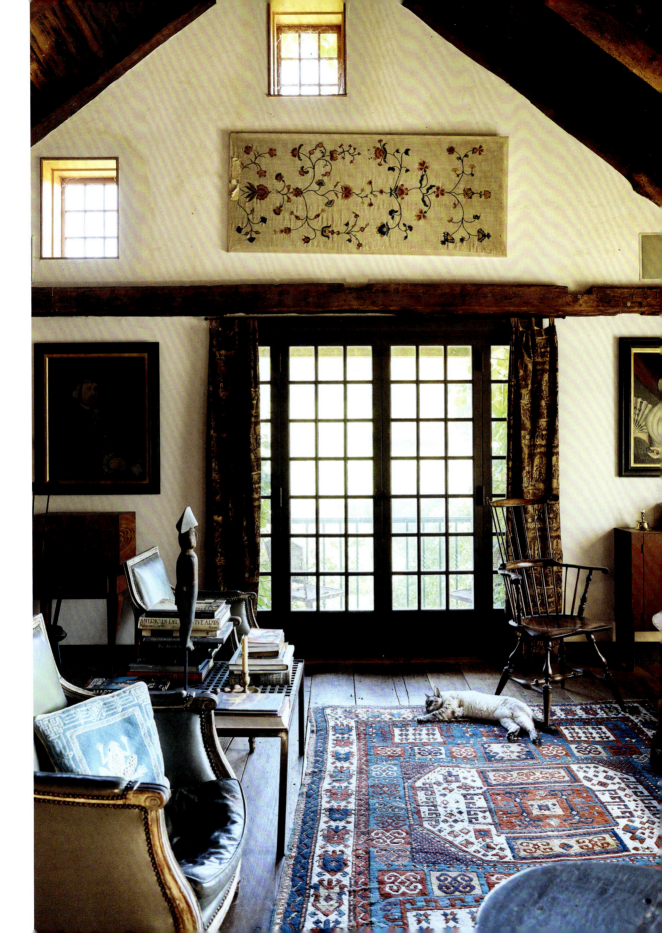

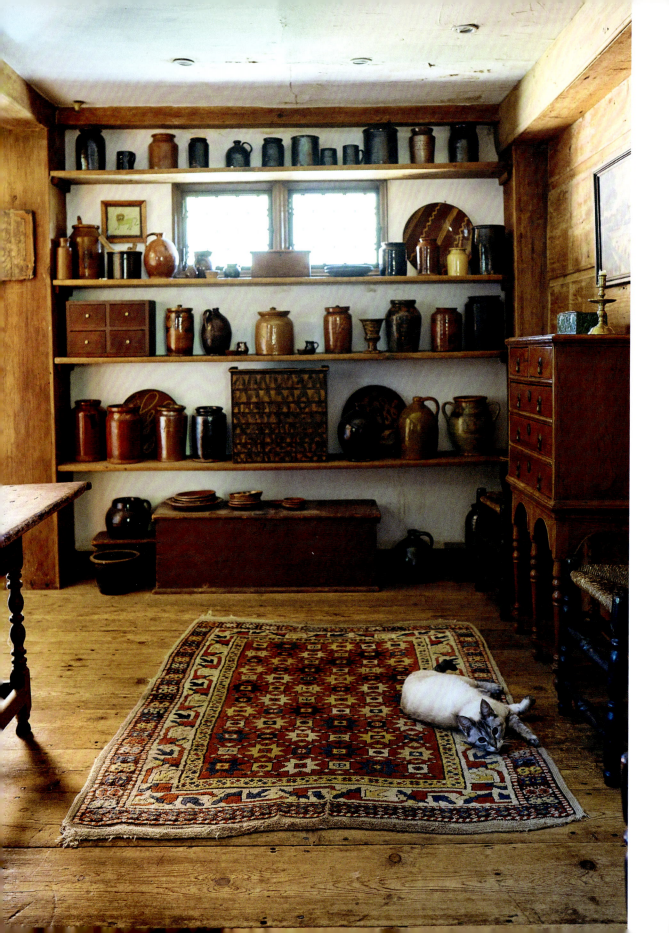

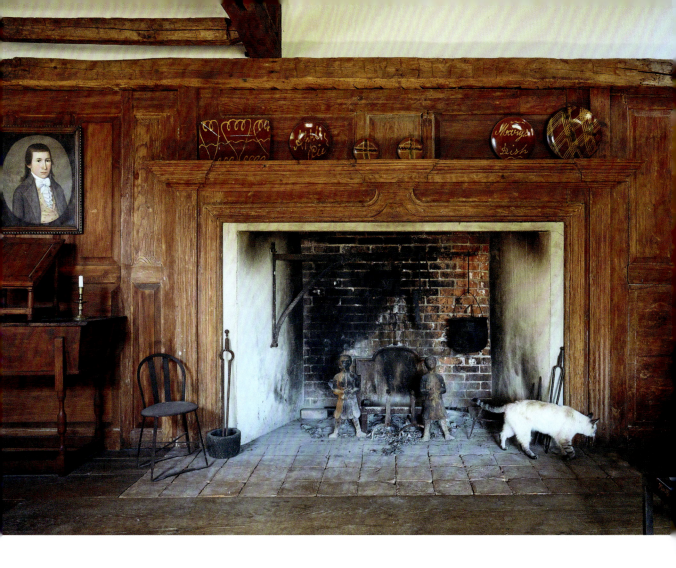

EVITA GATON

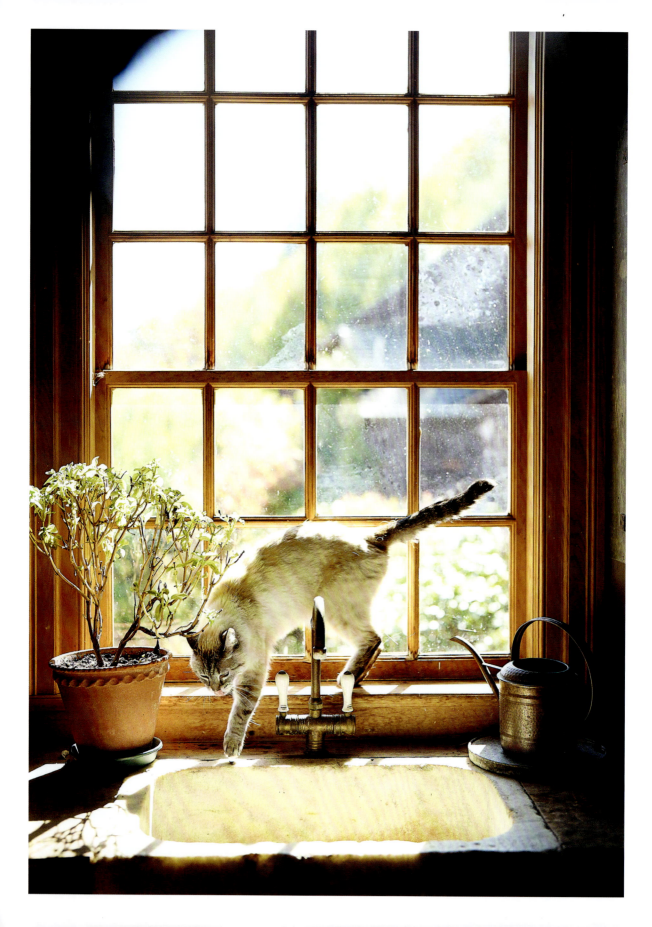

Q&A

DIVA OR DEVOTED FRIEND?
Both, depending on her mood.

INTROVERT OR EXTROVERT?
Extrovert, for the most part.

LAP CAT OR NOT?
A lap cat when she so chooses.

OLD SOUL OR KITTEN AT HEART?
A bit of both.

EXPLORER OR HOMEBODY?
Explorer and an excellent hunter.

LAZY OR ACTIVE?
Depends on the time of day.

DOGS – FRIEND OR FOE?
Friends. She loves her housemate dog.

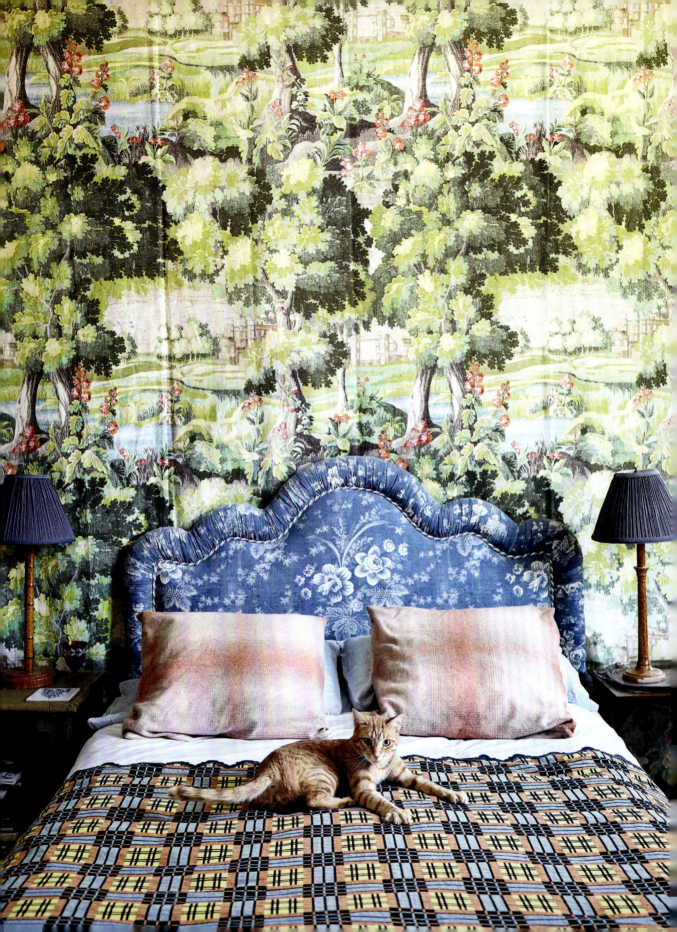

ROY BOY AND BABY BEAR

INTERIOR DESIGNER: MIEKE TEN HAVE
LOCATION: MILLERTON, NEW YORK

Roy Boy and Baby Bear joined the family for the purpose of catching mice in the garage, but once inside they never left. Two years later, these once-feral siblings have settled fully into domesticity. While Baby Bear can often be found napping in the baby's bassinet, Roy Boy prefers the *bergère* or the shielded nook of a windowsill. But the cats earn their keep, catching a mouse here and there, which they swallow and vomit back out in a gruesome display of affection.

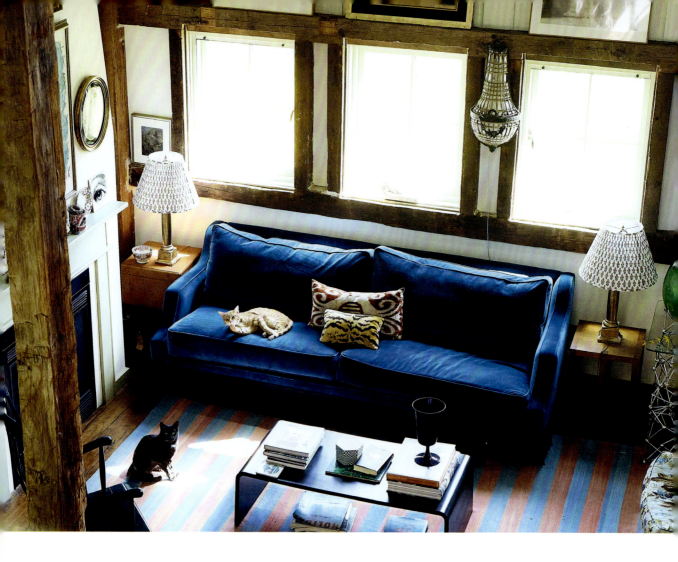

The cats' home is a converted 18th-century barn built by Dutch settlers in Upstate New York. Their owner/designer took on the challenge of transforming the space into a liveable home for her young family. The old owners' eccentricities, which include massive Roman numerals carved into the house's ancient beams and a cast-iron, claw-foot bathtub sitting in the living room, are matched by surefooted additions, such as a Manuel Canovas hyper-romantic linen panel on the bedroom wall.

Interior designer: Mieke ten Have

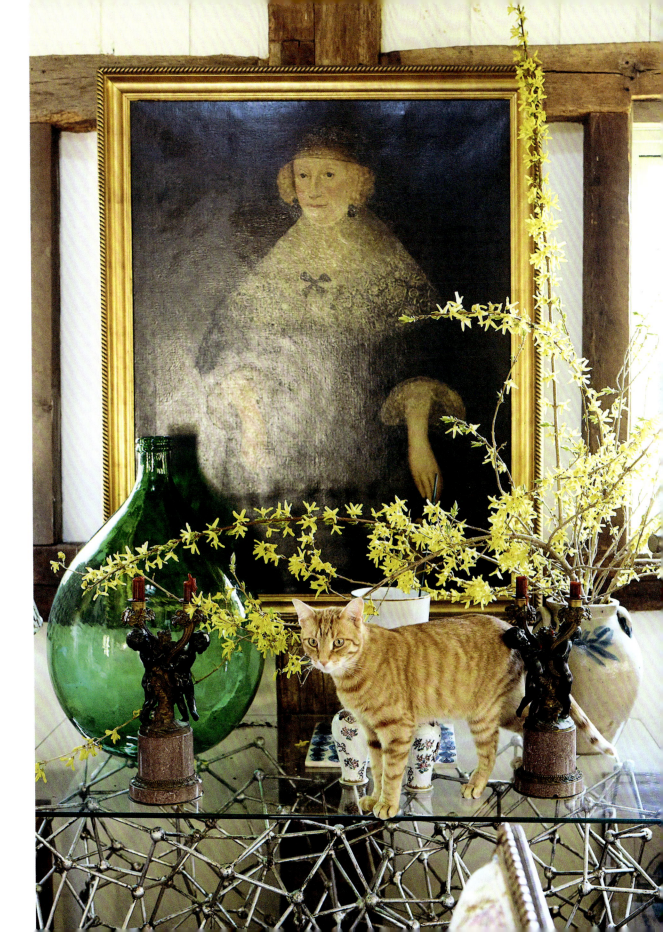

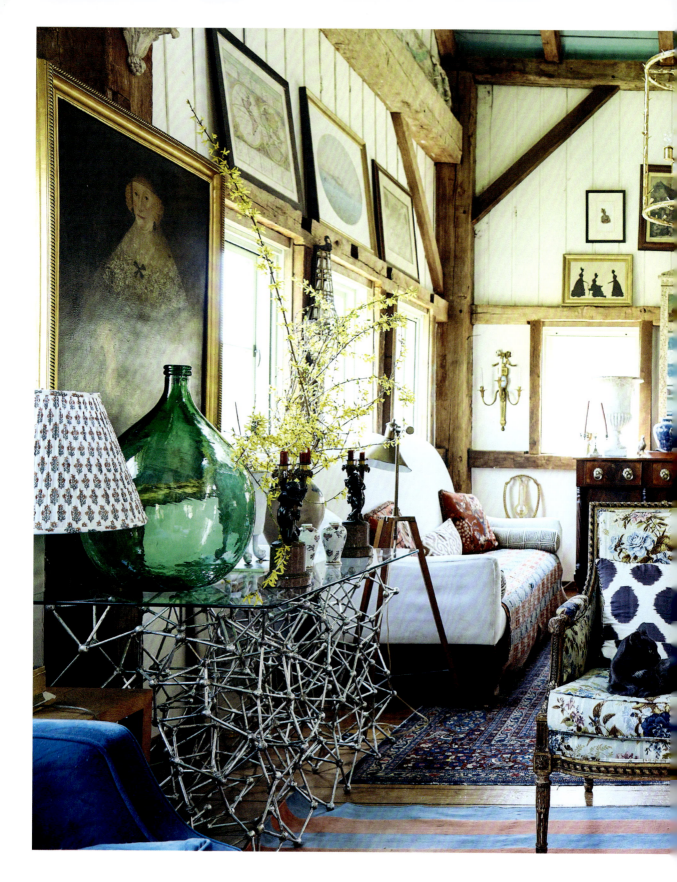

Interior designer: Mieke ten Have

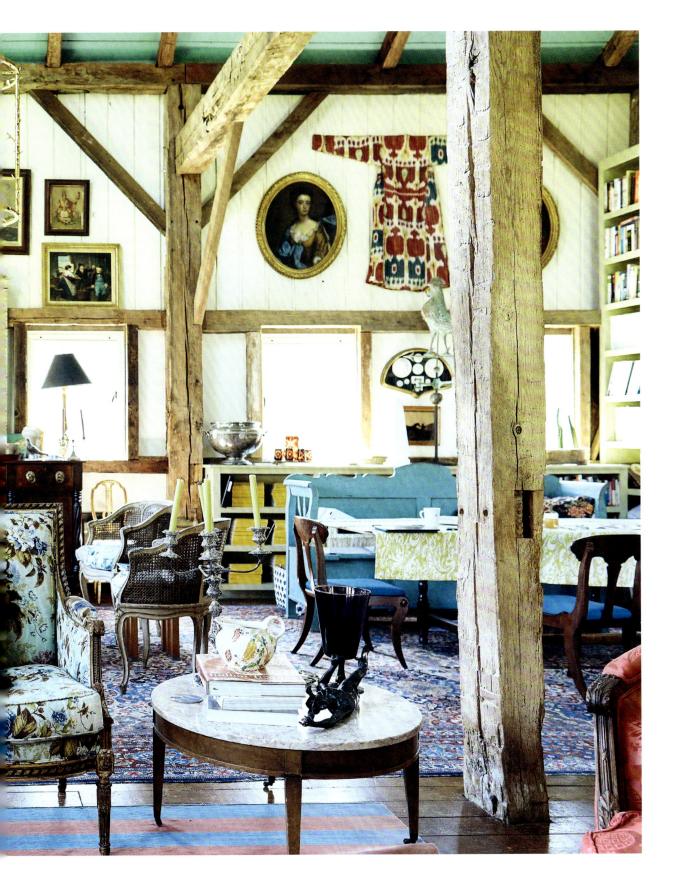

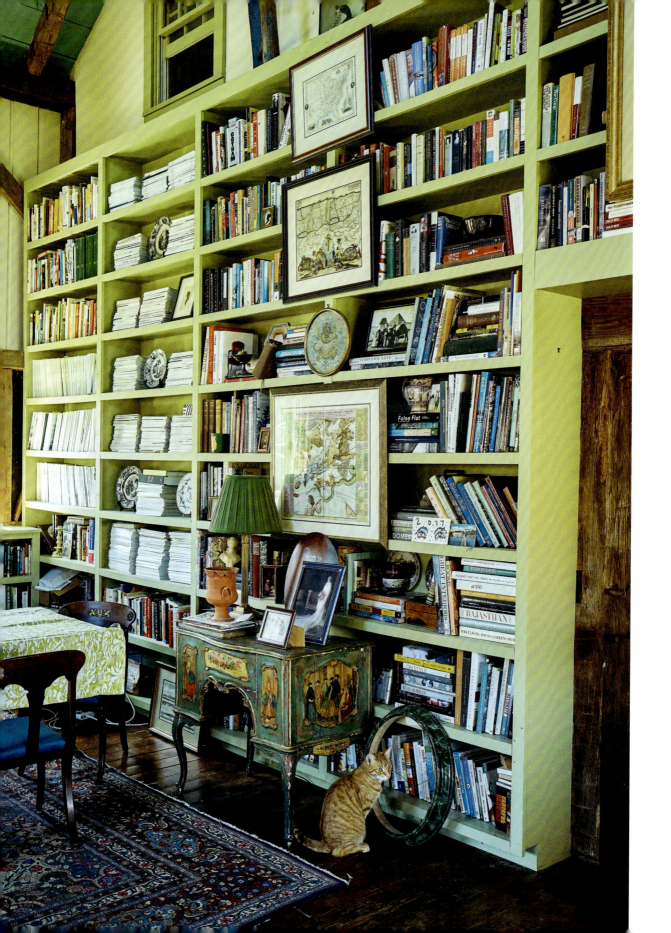

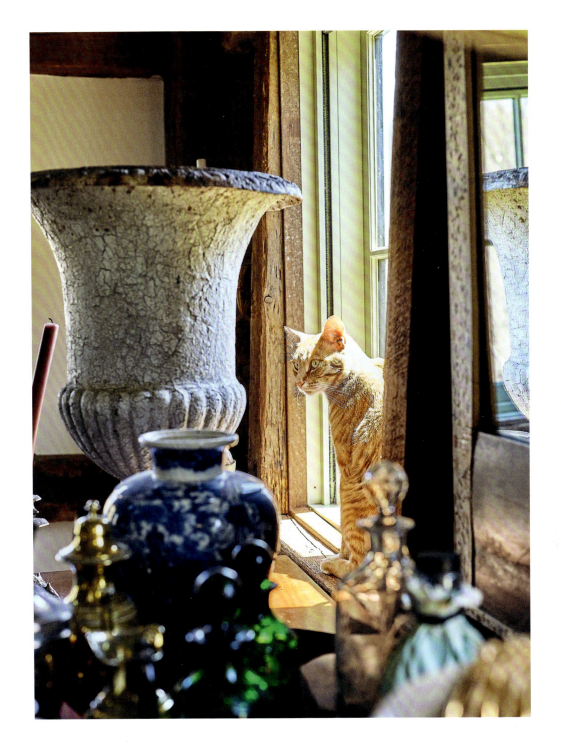

The home's design pieces span several centuries, boasting Wedgwood china, Pierre Frey upholstery, Le Manach fabric and Farrow & Ball wallpapering. Roy Boy and Baby Bear had to learn a few manners around the furniture, but their untamed sides go well with the home's unique layering of rustic and palatial.

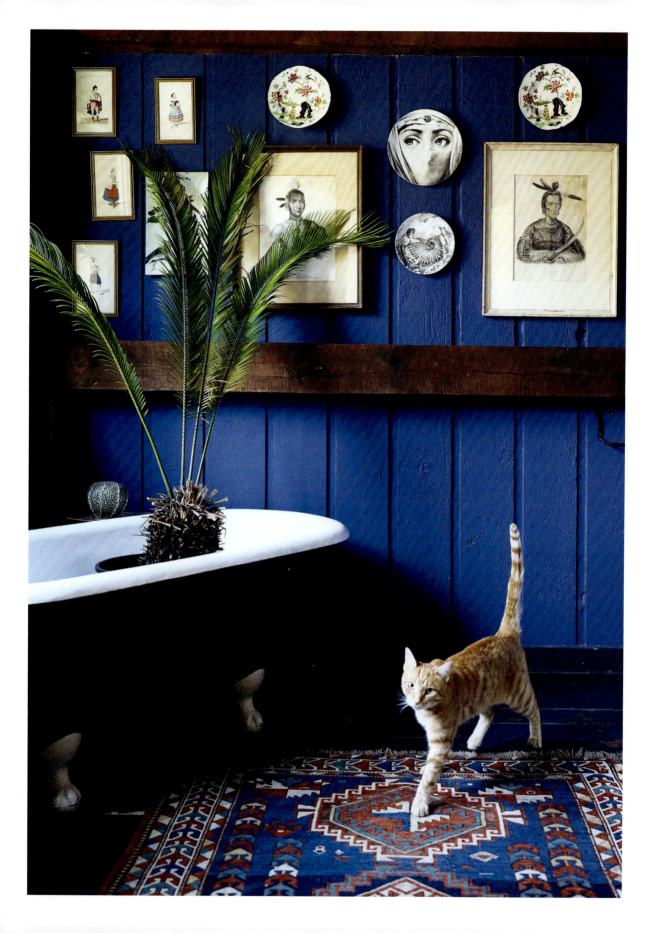

Q&A

DIVA OR DEVOTED FRIEND?
Baby Bear is a diva, Roy Boy a devoted friend. But both only have eyes for their owner, which does not always ensure obedience.

INTROVERT OR EXTROVERT?
Baby Bear is an introvert, Roy Boy an extrovert.

LAP CAT OR NOT?
Roy Boy is an occasional lap cat, Baby Bear an inveterate one who doubles as a neck warmer when he perches on his owner's shoulder.

OLD SOUL OR KITTEN AT HEART?
Two old souls.

EXPLORER OR HOMEBODY?
Roy Boy is the explorer, Baby Bear the homebody.

LAZY OR ACTIVE?
They have two modes: acrobatic ninjas or asleep.

DOGS – FRIEND OR FOE?
Friends, always trying to get their canine siblings' attention.

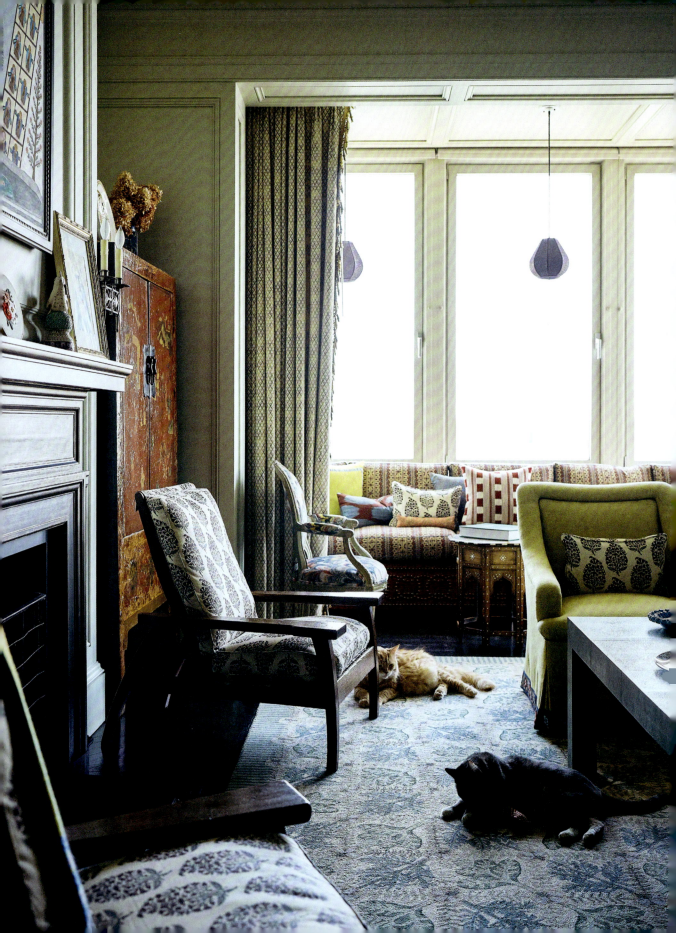

LUNA AND MOJO

ARCHITECT: PETER PENNOYER | INTERIOR DESIGNER: KATIE RIDDER
LOCATION: UPPER EAST SIDE, NEW YORK

Mojo was born on a horse-racing track, while his sister, Luna, was discovered inside a drainpipe during a raging downpour. Despite their humble beginnings, the cats had no trouble making a home of their Upper East Side apartment. Luna, a young Bengal mix, has appropriated the spare bedroom for her own personal castle, while Mojo, an older Siberian mix, favours the hearth. The cats love nothing more than a house full of guests and will follow their owners around for attention, as well as the occasional treat.

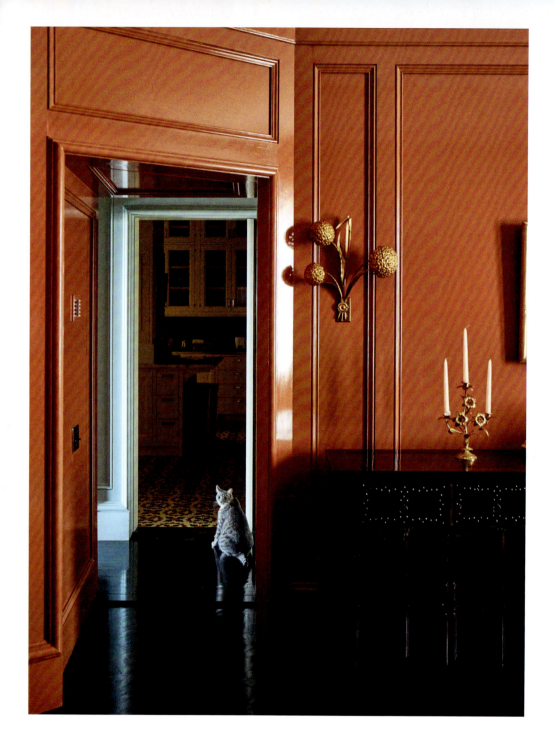

The cats' apartment, overlooking New York's East River, mixes extravagant colours and eclectic decor as a counterpoint to the clean, classical architecture of the pre-war building. Richly layered and pristinely kept, the design includes scratch-proof upholstery and carpeting to accommodate the home's feline residents. Most valued by both Luna and Mojo are the river views, which, combined with two sets of staircases, give the apartment the feel of a house.

Architect: Peter Pennoyer | Interior designer: Katie Ridder

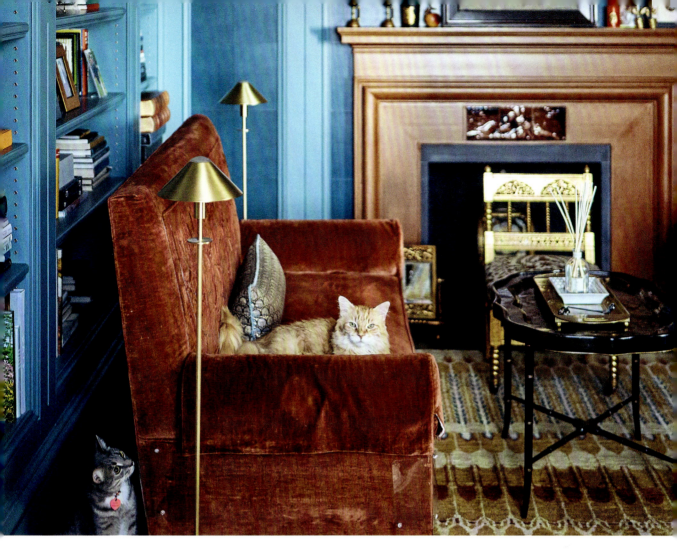

LUNA AND MOJO

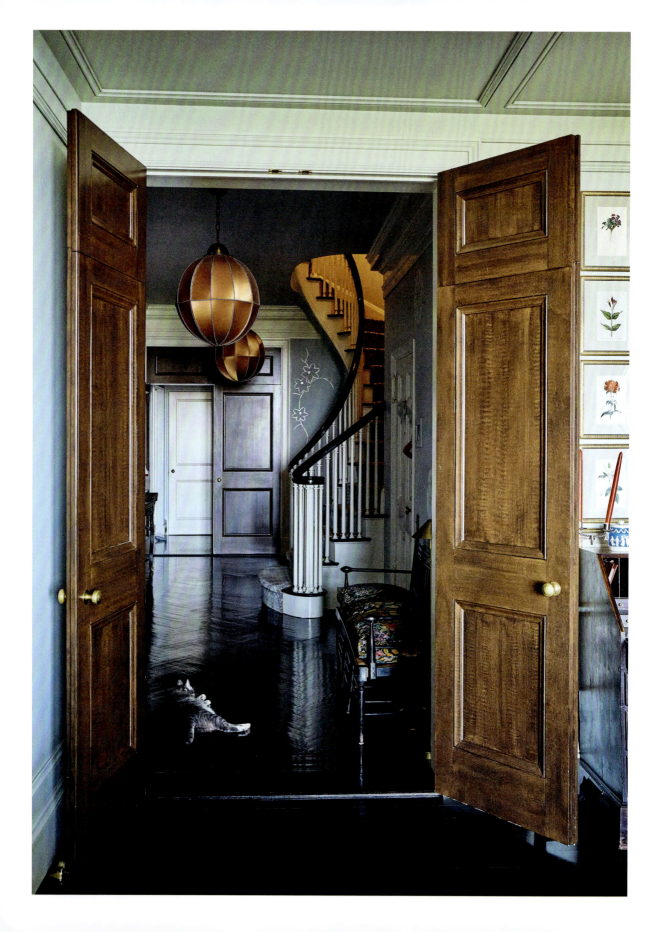

Q&A

DIVA OR DEVOTED FRIEND?
Despite having all her needs met, Luna's drainpipe beginnings assure her she is no diva. Mojo is a devoted best friend.

INTROVERT OR EXTROVERT?
Each has a little of both. Luna might watch her guests from afar, but never too far.

LAP CAT OR NOT?
Mojo loves a lap until he gets too hot. The younger Luna finds it more challenging to sit still.

OLD SOUL OR KITTEN AT HEART?
Luna is a mix, Mojo undoubtedly an old soul.

EXPLORER OR HOMEBODY?
Mojo is a homebody, while Luna is an explorer at heart, despite living in an apartment.

LAZY OR ACTIVE?
More than lazy, Mojo is always sleepy. There are no limits to Luna's energy.

DOGS – FRIEND OR FOE?
Luna takes an interest in the dogs she sees on her walks in the park, but neither cat knows many canines.

PIP

INTERIOR DESIGNER: ALYSE ARCHER-COITÉ
LOCATION: POUGHQUAG, NEW YORK

Pip was adopted as an 'anxious' adult, but the nine-year-old long-haired calico has long forgotten about this supposed anxiety. These days, she enjoys nothing more than chasing balls, bugs and lasers around her historic home; she is a dedicated hunter but also an avid lap cat – just as long as these activities are on her own terms.

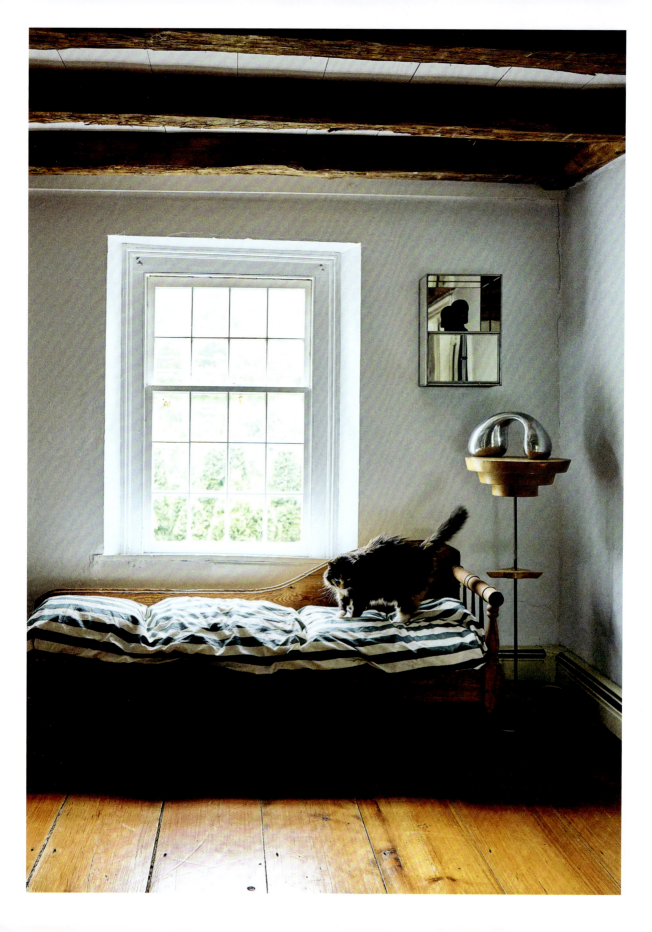

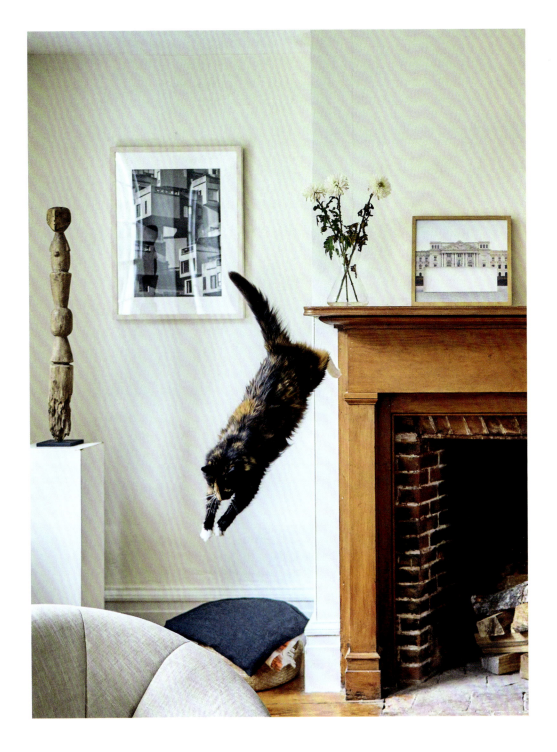

Pip lives in a 1770 Georgian estate that was a tavern by the time of the American Revolution. Symmetrical and keeping many of its austere original details, the home can nonetheless be both cosy and relaxed, thanks to a playful design that in turns highlights and offsets the architecture. Mid-century and modernist elements, and a large contemporary photography collection, coexist with period-appropriate antiques, while outside, neither the home nor the remote terrain surrounding it have changed much over three centuries.

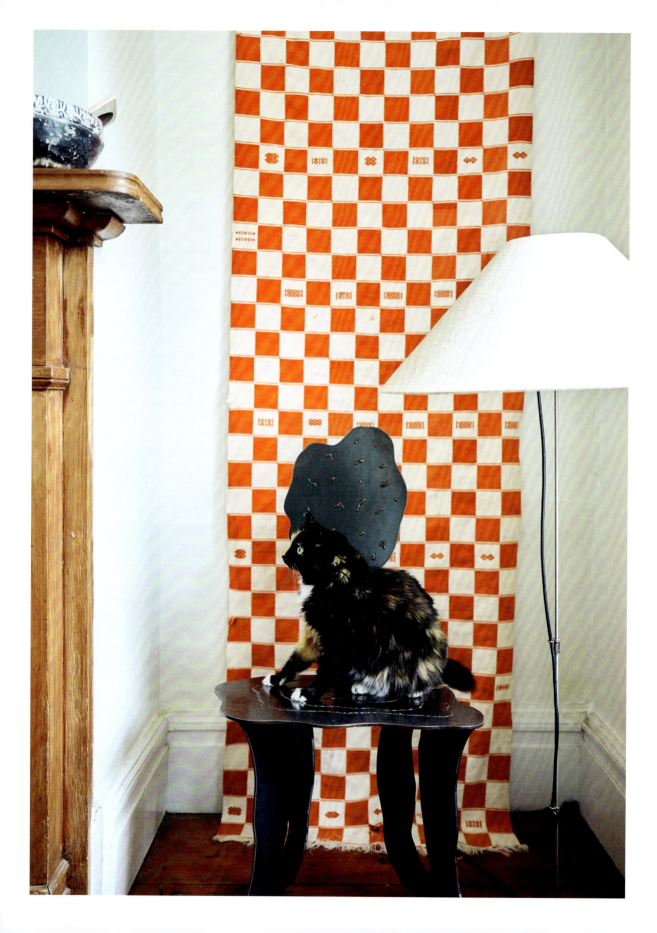

Q&A

DIVA OR DEVOTED FRIEND?
Friendly diva.

INTROVERT OR EXTROVERT?
Extrovert.

LAP CAT OR NOT?
A lap addict.

OLD SOUL OR KITTEN AT HEART?
Kitten (or puppy?) at heart – loves a ball chase.

EXPLORER OR HOMEBODY?
Explorer and a serious hunter.

LAZY OR ACTIVE?
Very active.

DOGS – FRIEND OR FOE?
Hasn't had the pleasure of an introduction.

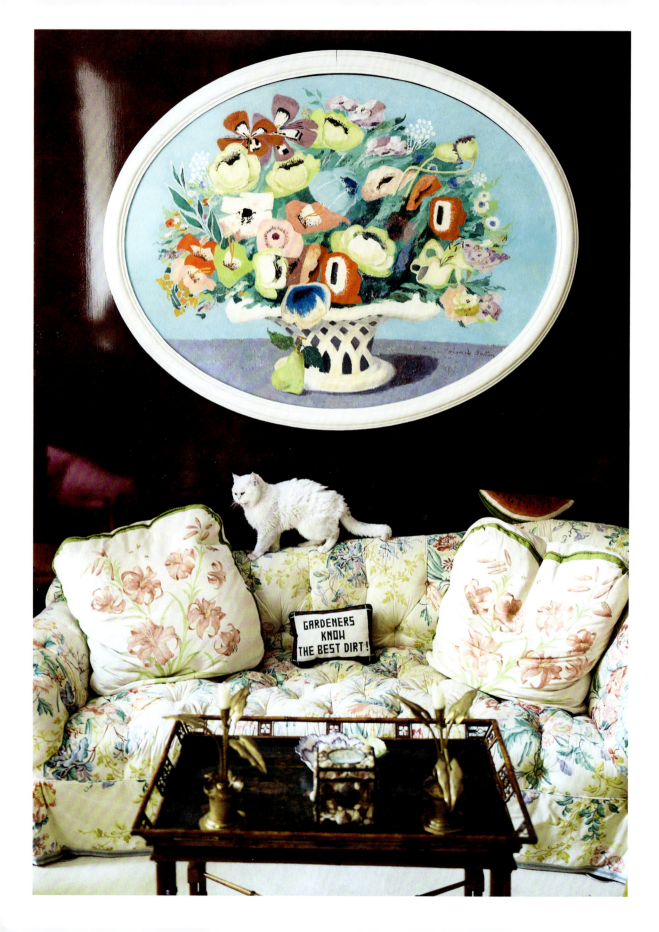

HUGO AND FRED

INTERIOR DESIGNER: EMILY EERDMANS
LOCATION: GREENWICH VILLAGE, NEW YORK

After Fred's feline companions passed away, Hugo was brought into the family with big shoes to fill. But at four years old and timid, the British shorthair has little in common with his fourteen-year-old alpha companion, who seems to be growing more intrepid with each added year. Still, the cats come together to watch over the streets of New York, and every night there are hints of a secret double life starting around 3 am.

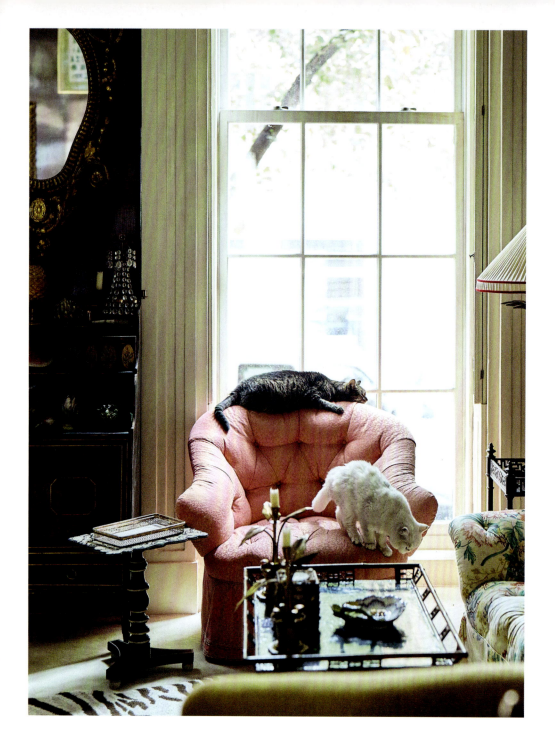

The cats' home is a landmarked Greek Revival townhouse in New York's historic Greenwich Village. Besides the living quarters, it includes a series of art galleries accessible through a separate entrance. Each of its many rooms is painted a different colour and inspired by different interior designers and design movements from the 19th century to the present.

Interior designer: Emily Eerdmans

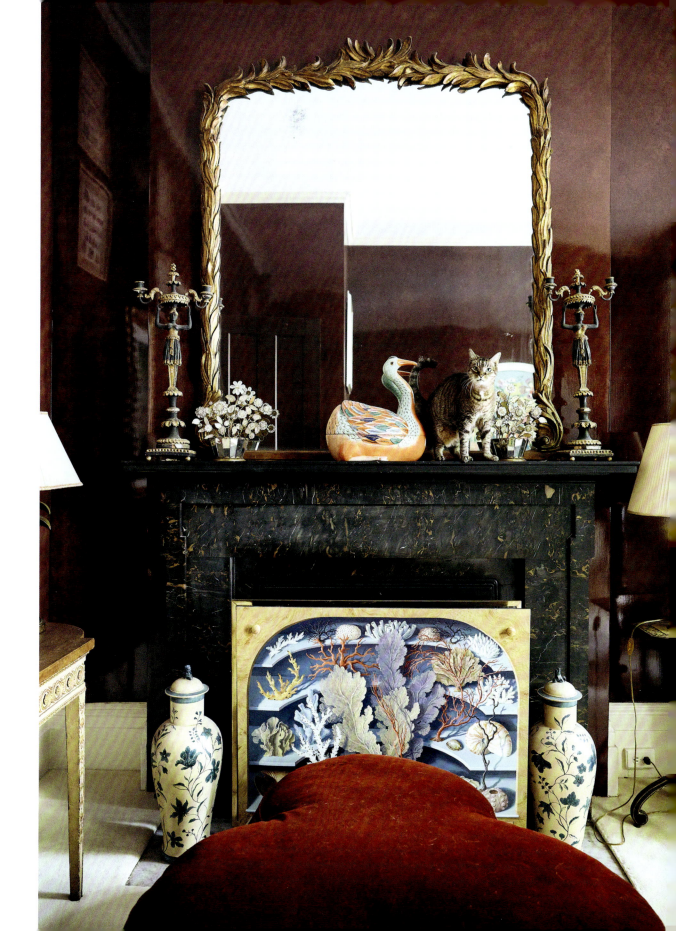

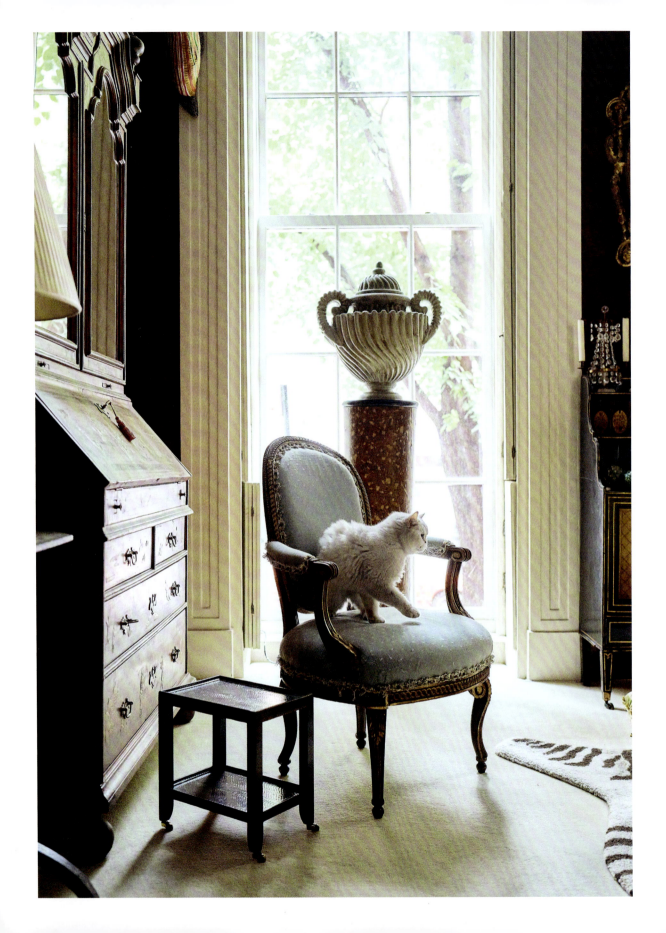

Q&A

DIVA OR DEVOTED FRIEND?
Devoted friends.

INTROVERT OR EXTROVERT?
Hugo is an introvert, with a penchant for greeting visitors with a very ugly look. Fred is an extrovert, for the most part.

LAP CAT OR NOT?
Only Fred is a lap cat.

OLD SOUL OR KITTEN AT HEART?
Kittens at heart.

EXPLORER OR HOMEBODY?
Fred is becoming more and more of an explorer, even in his old age. Hugo is a renegade homebody.

LAZY OR ACTIVE?
Both are lazy – only Fred has the excuse of his age.

DOGS – FRIEND OR FOE?
The house's new dog is tolerated, so far.

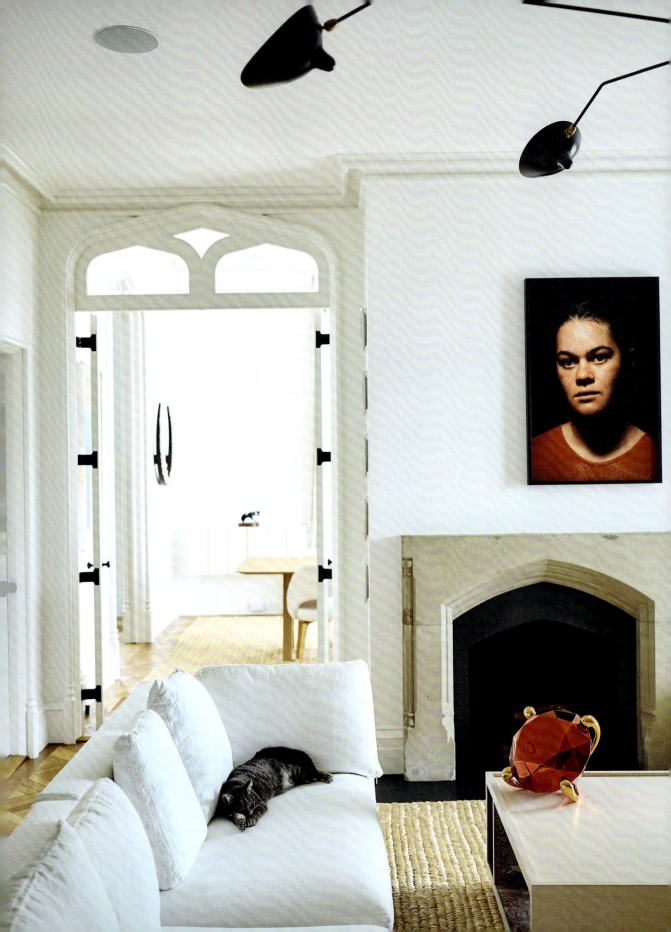

JUDY GARLAND

INTERIOR DESIGNER: GHISLAINE VIÑAS
LOCATION: TIVOLI, NEW YORK

Judy Garland was named for her charisma. She was adopted as a barn cat to keep the rodent population in check but almost immediately began auditioning for the part of inside cat. Warm welcomes and charming performances helped her edge her way into the kitchen and, on special occasions, she is allowed into the other rooms. But Judy remains committed to her day job hunting mice and rodents, which she volleys onto the terrace for her owners to appreciate.

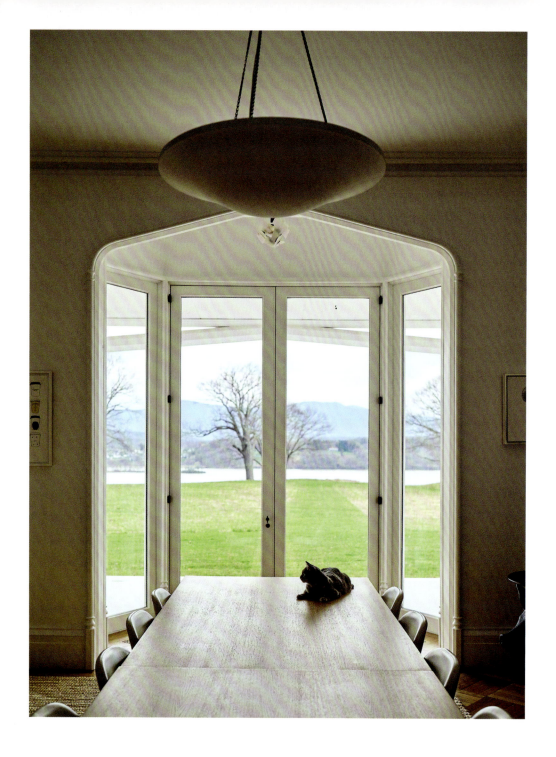

Breathtaking views of the Hudson Valley and the Catskill Escarpment give Judy plenty to admire. These pastoral scenes have inspired American painting since the Hudson River School art movement, which was forming around the same time as Judy's home was built.

Interior designer: Ghislaine Viñas

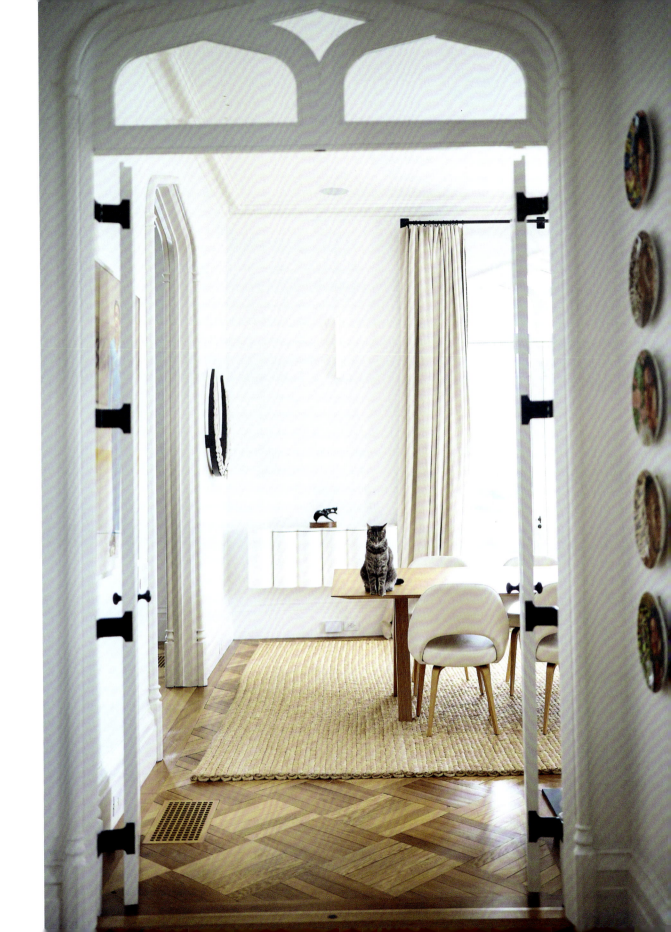

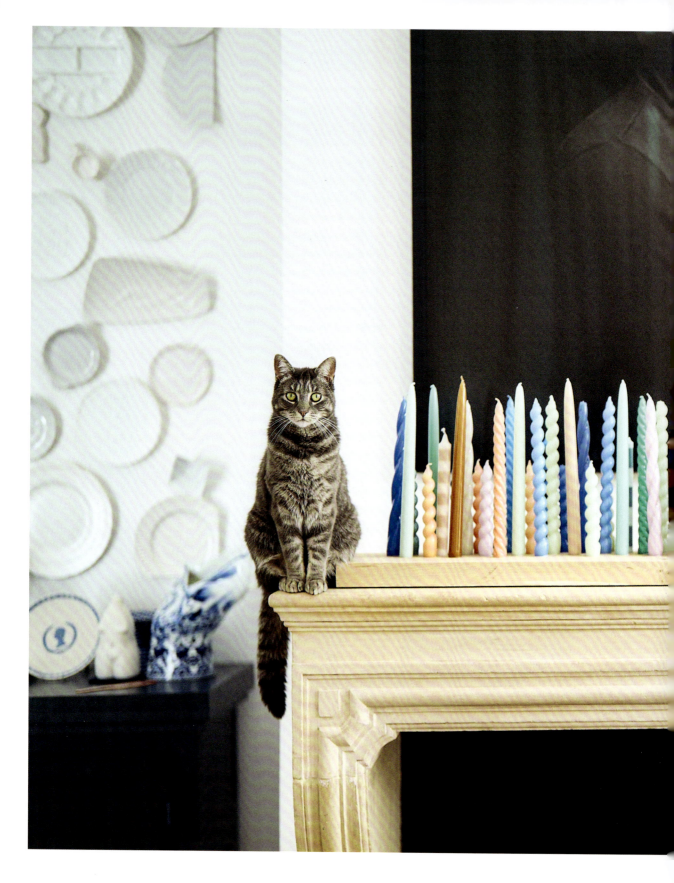

Interior designer: Ghislaine Viñas

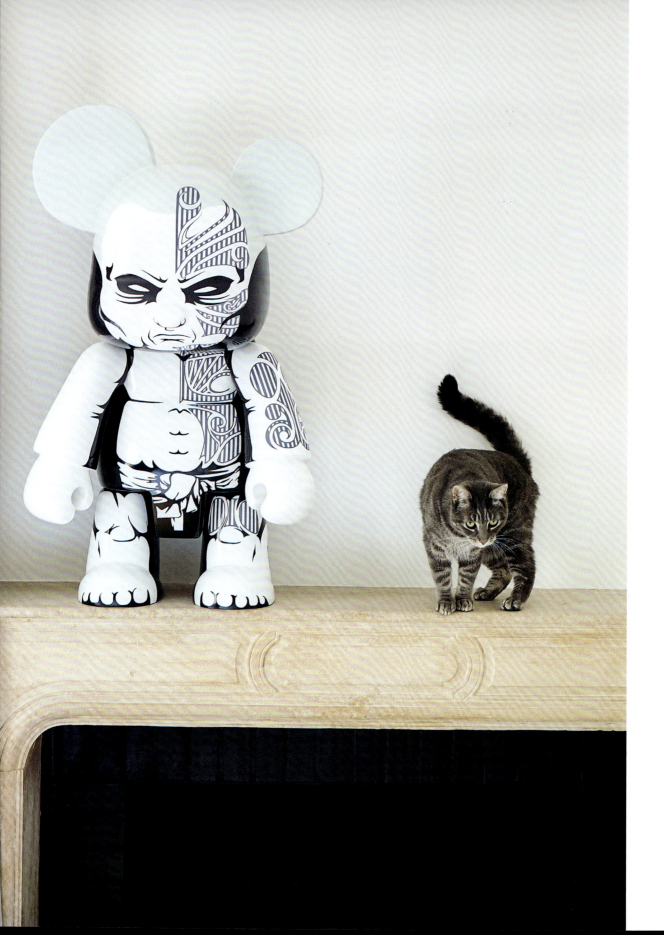

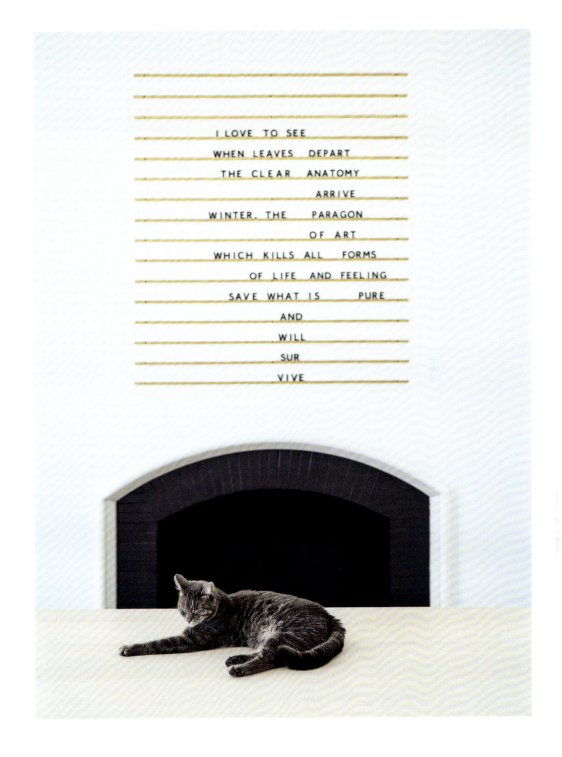

Judy's home was built in the 1840s by one of New York's most powerful dynasties, the Livingston family. The Gothic Revival architecture is counterbalanced by an intricate layering of more modern pieces that make the home's interior both cosy and stimulating.

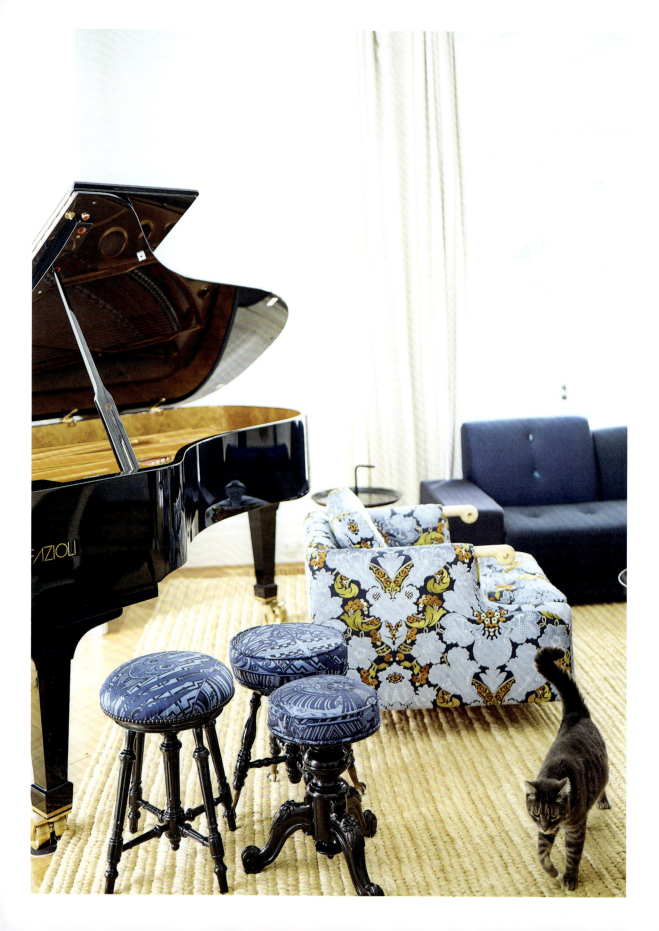

Q&A

DIVA OR DEVOTED FRIEND?
Devoted friend.

INTROVERT OR EXTROVERT?
A born performer!

LAP CAT OR NOT?
Lap, when she's allowed.

OLD SOUL OR KITTEN AT HEART?
Kitten at heart.

EXPLORER OR HOMEBODY?
Explorer.

LAZY OR ACTIVE?
Active, loves showing off her lightning-fast hunting moves.

DOGS – FRIEND OR FOE?
Friend: Judy likes everyone and everything.

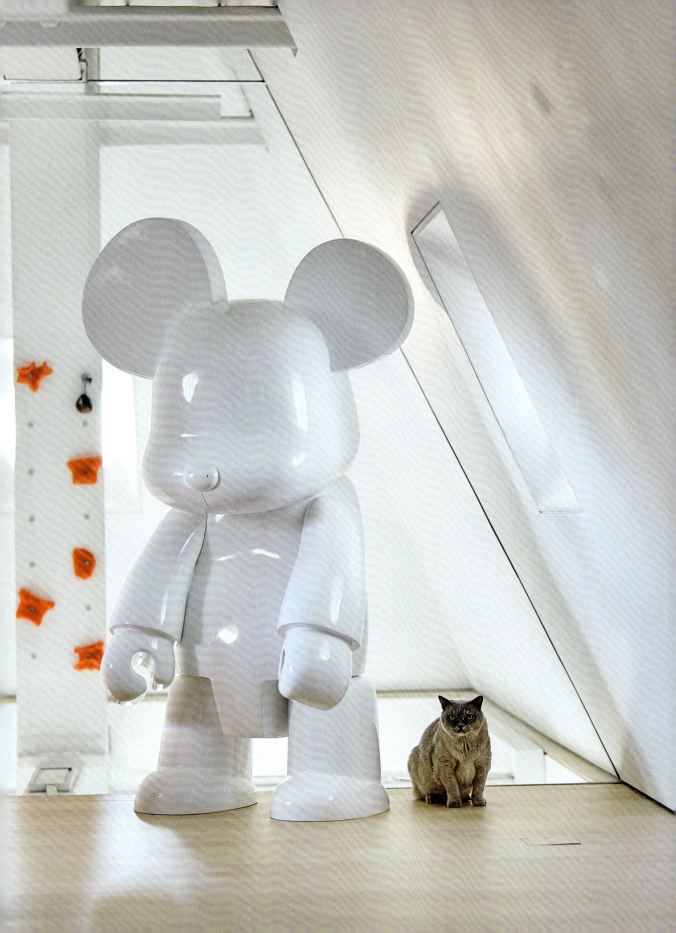

LADY PENELOPE

ARCHITECT: DAVID HOTSON | INTERIOR DESIGNER: GHISLAINE VIÑAS
LOCATION: FINANCIAL DISTRICT, NEW YORK

Lady Penelope runs a tight ship in the New York penthouse she shares with her two owners. The sixteen-year-old European Burmese rises at 7 am for her 'catpuccino' – a demitasse of foamed lactose-free milk – then ushers her owners into the shower so she can retire to her favourite space: a windowless room with a heated floor and a dozen cat beds to choose from. At 10 pm, she is ready for her midnight snack and a cuddle before bedtime seals another day under her strict orders.

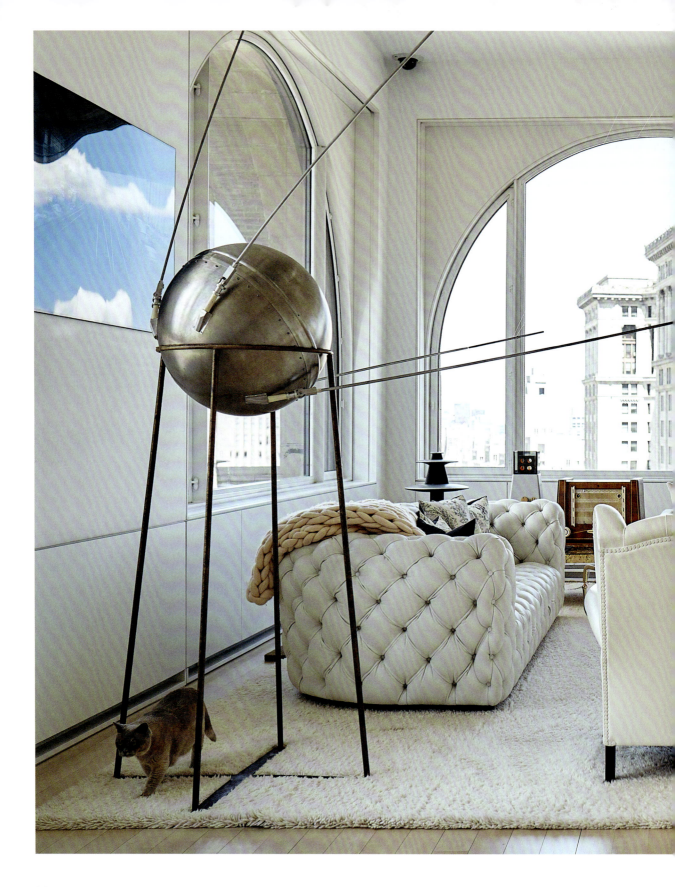

Architect: David Hotson | Interior designer: Ghislaine Viñas

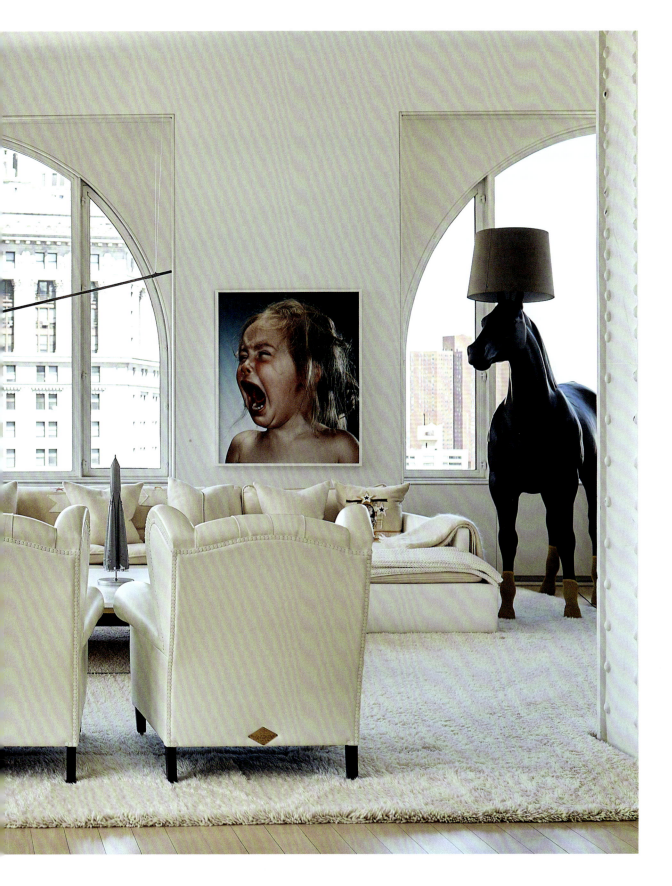

Architect: David Hotson | Interior designer: Ghislaine Viñas

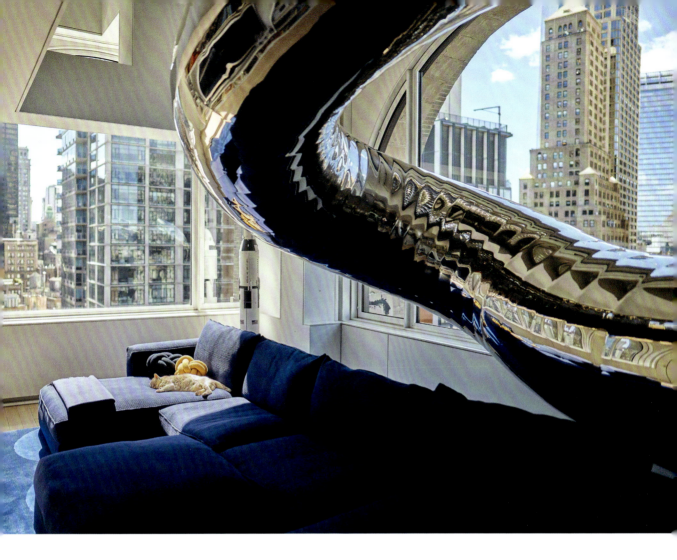

By the close of the 19th century, this penthouse was the tallest in the world. Today the rococo exterior, complete with terracotta angels and copper lions, hides a four-storey apartment that could not be more modern or more playful. Its features include a twenty-four metre, adult-sized stainless-steel slide and a cat-sized network of ladders and tunnels connecting bedroom, bathroom and living room. Incandescent colour, windows on the floor, structural glass bridges, a fifteen-metre-high rock-climbing column and an assortment of animal statues finish off this habitable adventure playground in the heart of Manhattan.

Penelope has recently developed arthritis and has become reliant on her obedient human elevators. She is so vocal about her needs that her mobility around the apartment has hardly diminished.

Architect: David Hotson | Interior designer: Ghislaine Viñas

Architect: David Hotson | Interior designer: Ghislaine Viñas

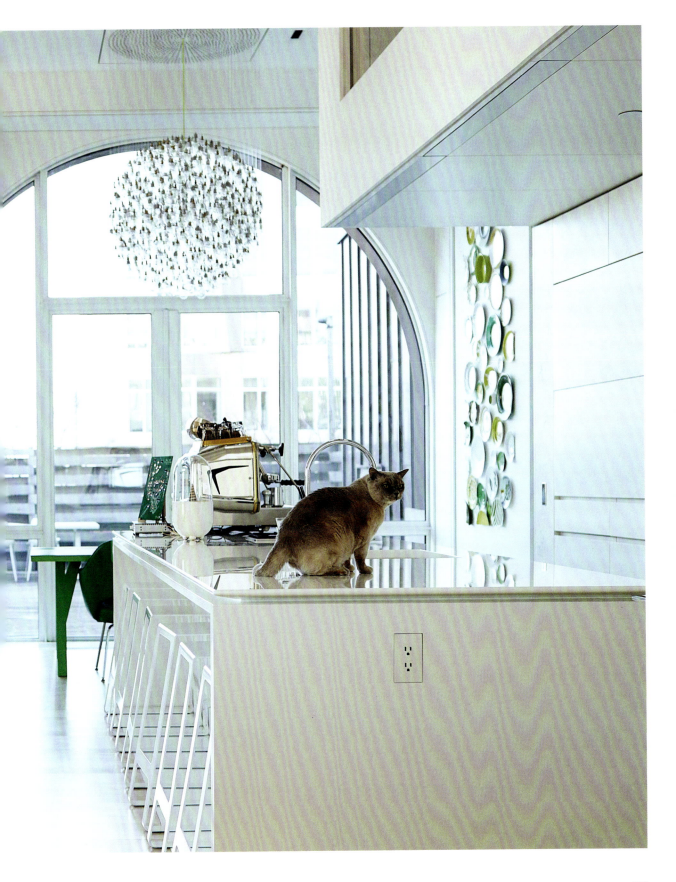

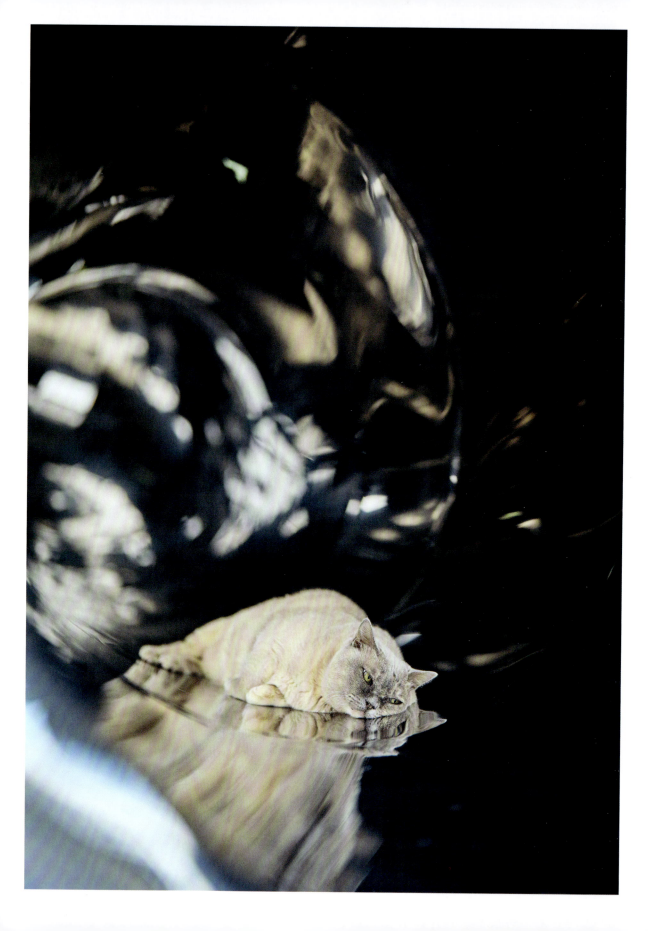

Q&A

DIVA OR DEVOTED FRIEND?
Chief Operating Officer, with a softer side.

INTROVERT OR EXTROVERT?
Introvert.

LAP CAT OR NOT?
Not.

OLD SOUL OR KITTEN AT HEART?
Kitten at heart.

EXPLORER OR HOMEBODY?
Explorer as a kitten but a homebody now.

LAZY OR ACTIVE?
Lazy.

DOGS – FRIEND OR FOE?
Foe.

GARY AND GUNNAR

INTERIOR DESIGNER: KELLY BEHUN
LOCATION: BILLIONAIRES' ROW, NEW YORK

Gary and Gunnar have found the perfect balance between affectionate and aloof. The Abyssinian, Gary, and the Toyger, Gunnar, can usually be found wherever their owner is – often on the computer keyboard to make sure all attention is theirs. But once they have received their share of pats, they are content to move over to the nearest window to watch over the hustle and bustle of Central Park from the refuge of their New York penthouse.

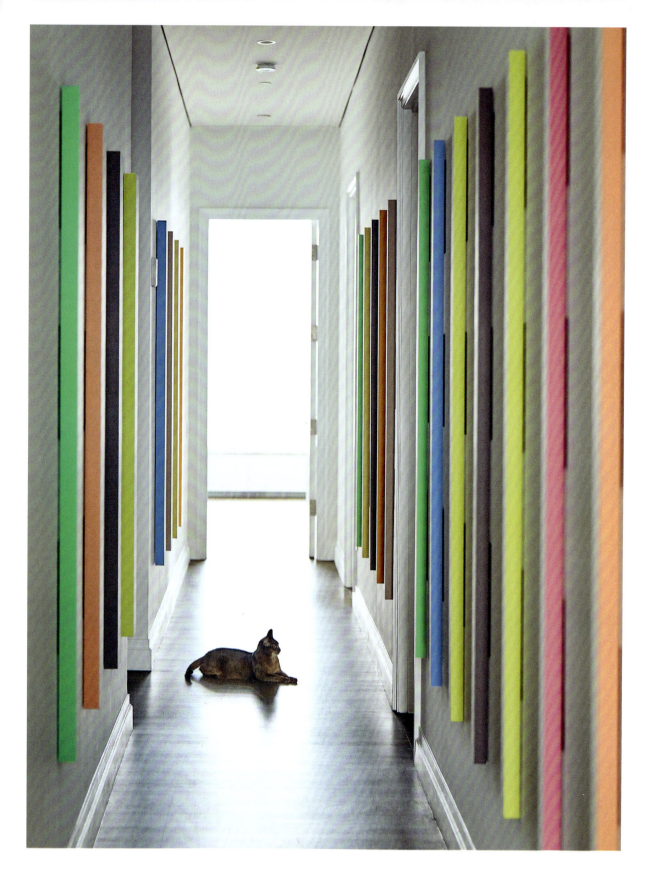

Interior designer: Kelly Behun

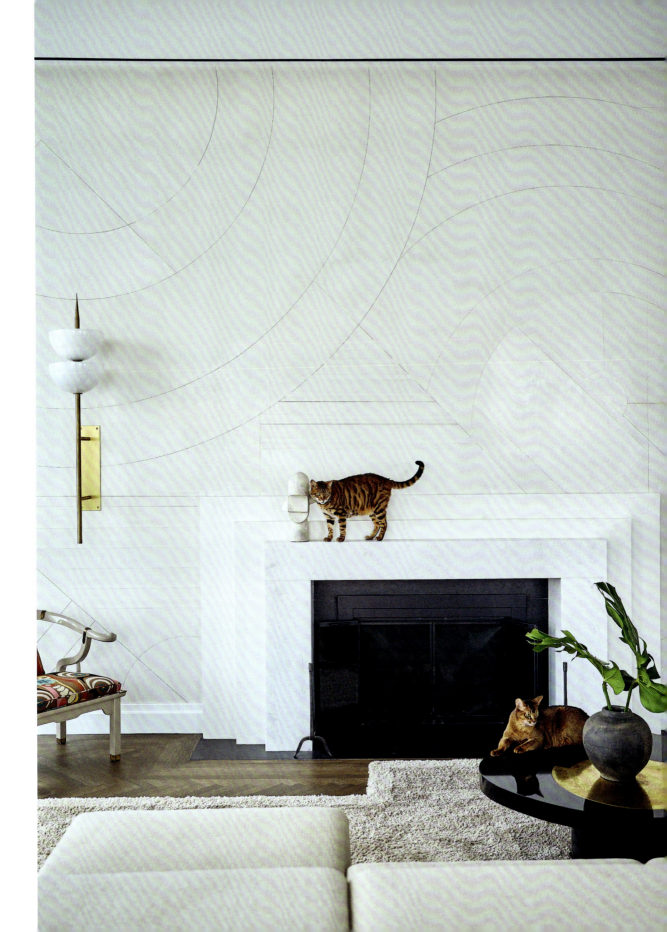

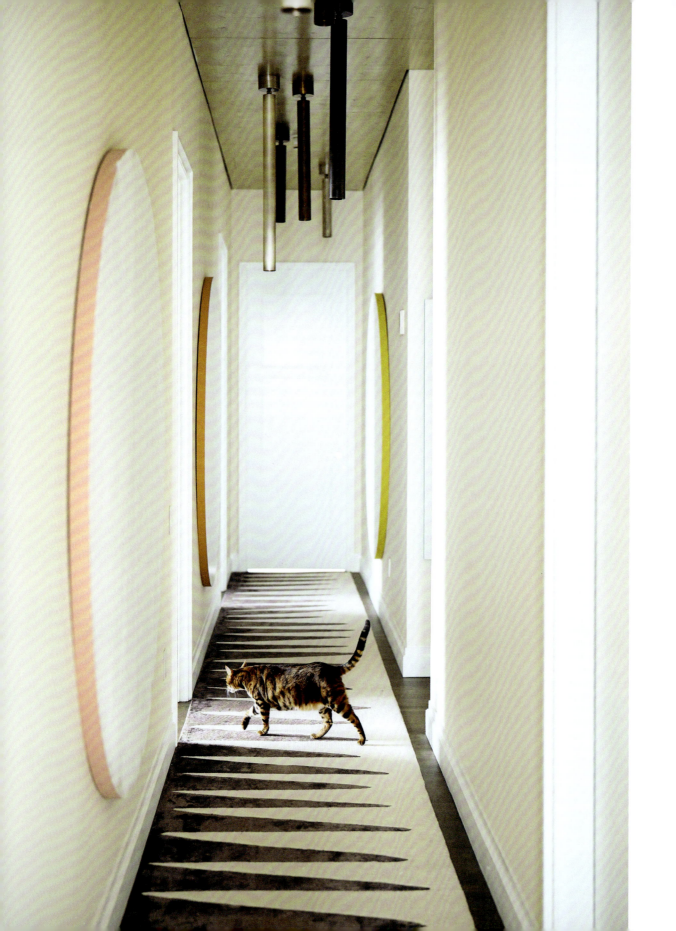

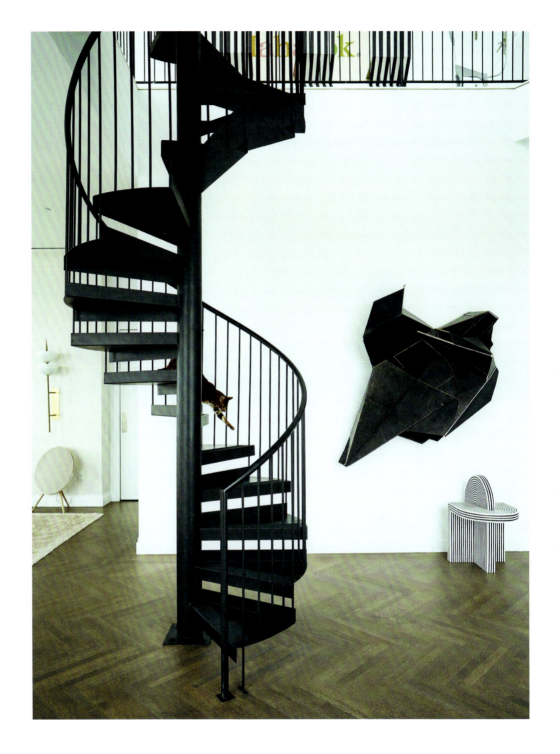

Gary and Gunnar's owner used minimalism and pastel colours to design a space that feels light in its above-the-clouds location and harmonious with the bird's-eye cityscapes behind the glass walls. But much like its cats, the home has bursts of energy at every turn through carefully placed splashes of colour. This interplay of sophisticated and spunky is echoed in the cats' personalities, and while Gunnar is occasionally discovered chewing on the strap of a designer handbag, Gary can often be spotted smuggling stolen food from the kitchen.

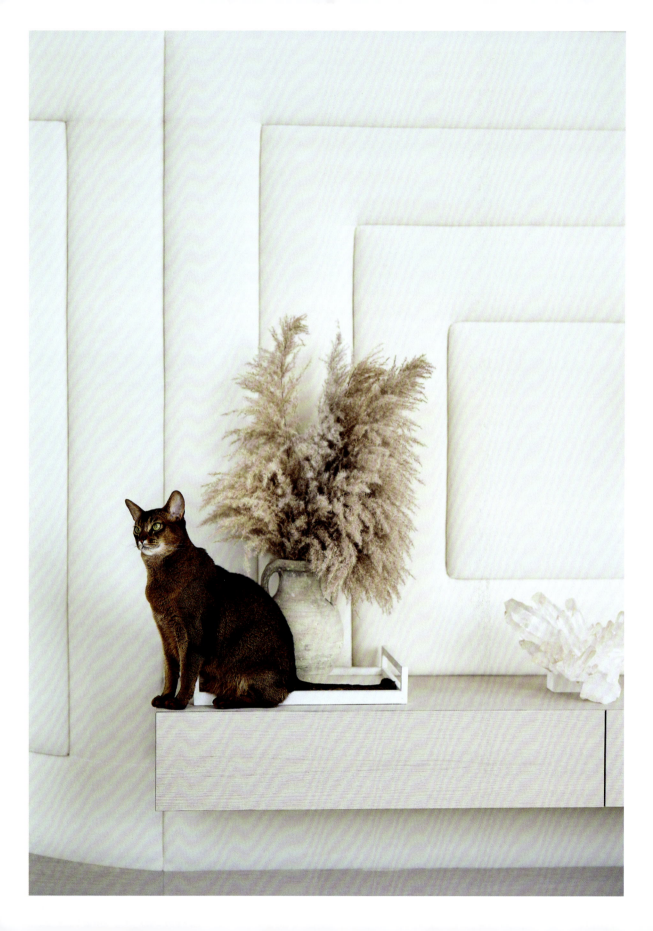

Q&A

DIVA OR DEVOTED FRIEND?
Both are both, and they switch freely between the two states.

INTROVERT OR EXTROVERT?
Gunnar is an introvert, Gary an extrovert.

LAP CAT OR NOT?
Lap cats.

OLD SOUL OR KITTEN AT HEART?
Gunnar is an old soul, Gary an eternal kitten.

EXPLORER OR HOMEBODY?
Homebodies.

LAZY OR ACTIVE?
Lazy during the day, turned up to eleven at night.

DOGS – FRIEND OR FOE?
Unclear, though they would probably condone any arrangement that highlights their superiority over the canine world.

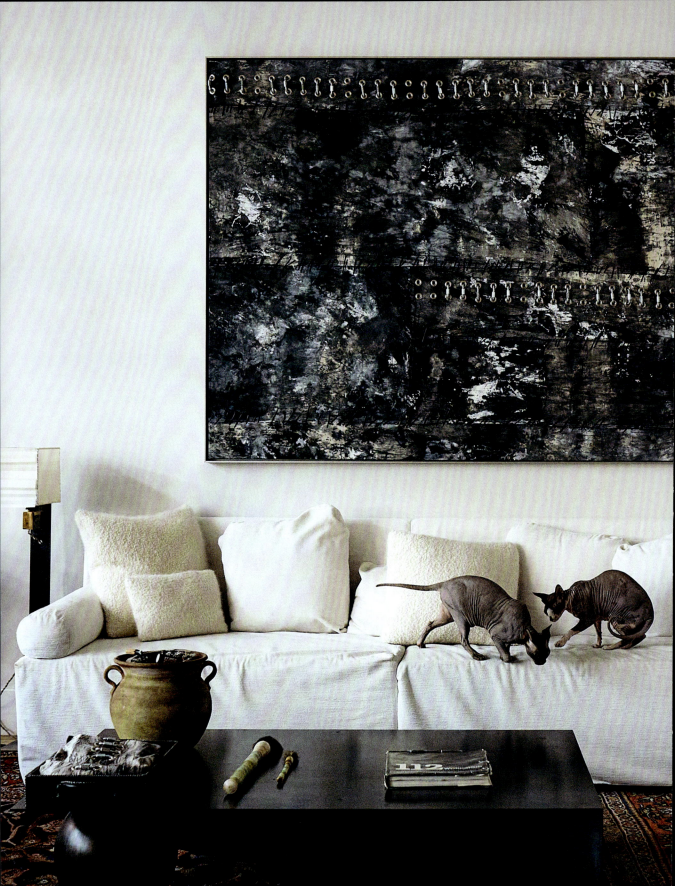

GG AND SIOUXSIE

INTERIOR DESIGNER: AUGUSTA HOFFMAN
LOCATION: SOHO, NEW YORK

GG and Siouxsie are named aptly after two punk rock legends. But under the leather jackets are two affectionate, needy companions who sprint to the elevator to greet their owners with bellies ready for rubs. Lacking the hair to keep them warm, the nine-year-old sphinx cats love nothing more than a lap to curl up on and, in the absence of humans, can be found basking in the sun or on the bathroom's heated floor. And yet, the punk is no mere aesthetic: GG and Siouxsie have wrecked enough furniture to have their owners completely rethink the home's design.

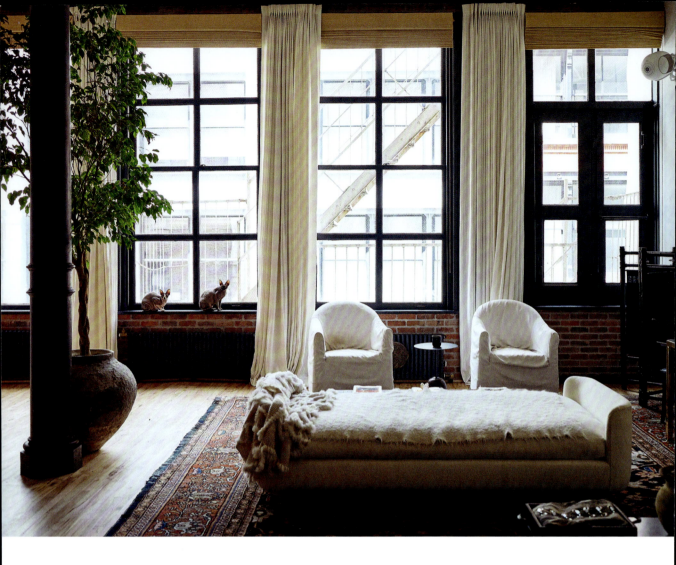

The cats' home is a quintessential New York loft: a historic industrial structure repurposed into a bohemian abode. The dramatic open floor plan with high ceilings and an imposing iron colonnade is divided into more intimate spaces through careful intervention that includes oversized Isamu Noguchi lanterns and colossal expressionist paintings, the work of the cats' owner, Rachel T. Hicks. The black and white minimal architecture lets these new layers shine while keeping the home's aesthetic authority.

Interior designer: Augusta Hoffman

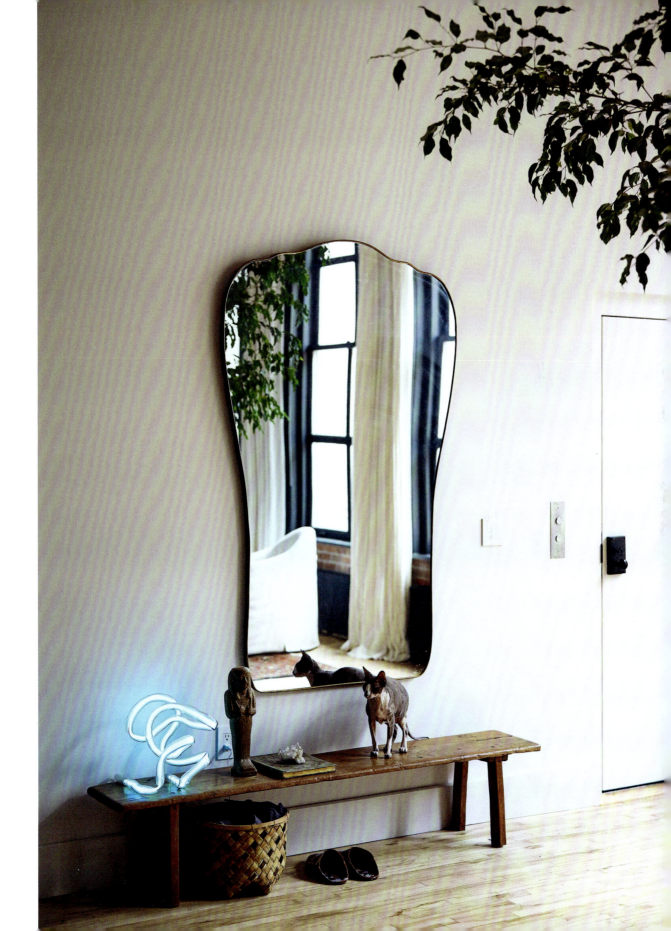

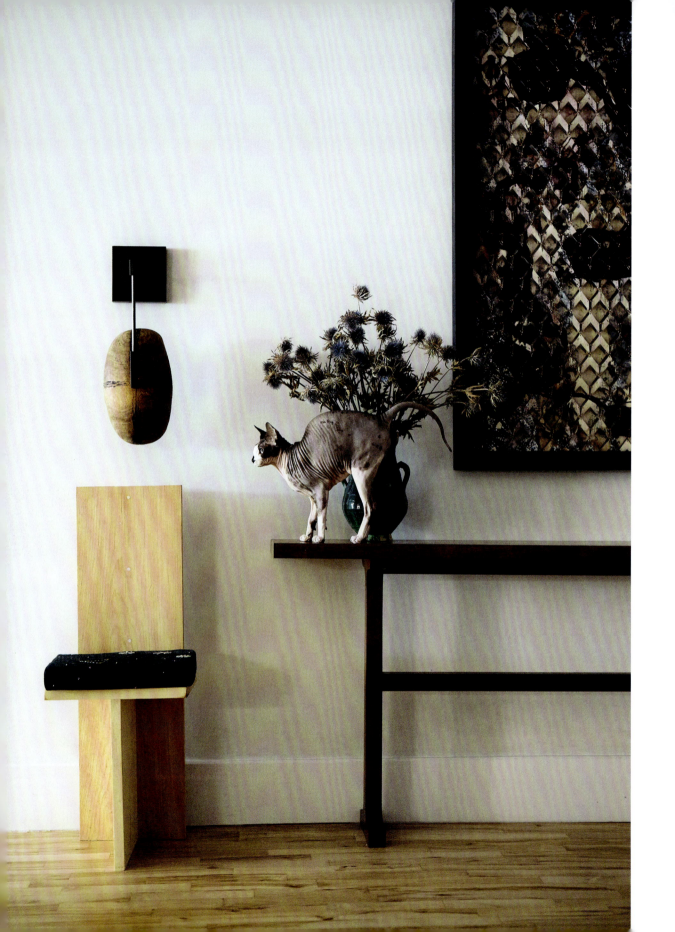

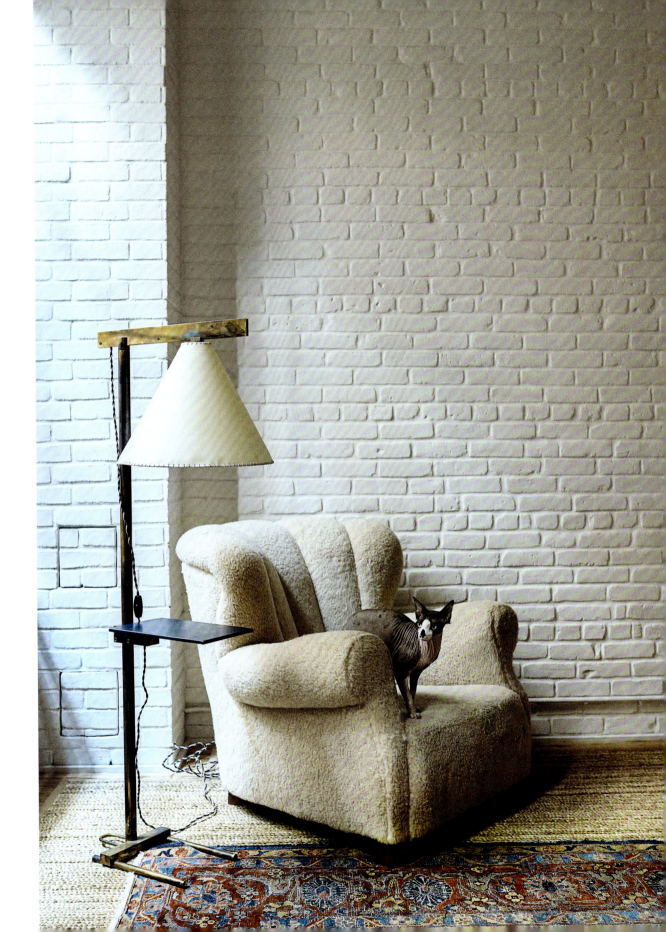

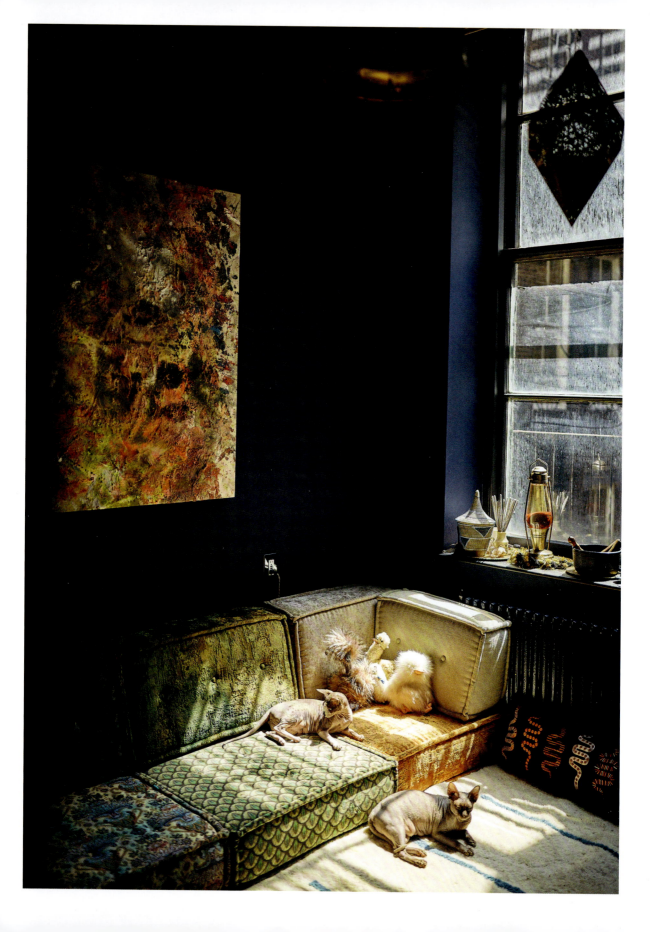

Q&A

DIVA OR DEVOTED FRIEND?
GG is a diva, Siouxsie a devoted friend, but the breed in general requires a lot of diva care.

INTROVERT OR EXTROVERT?
Siouxsie is an extrovert, GG an introvert.

LAP CAT OR NOT?
Devout lappers.

OLD SOUL OR KITTEN AT HEART?
GG is an old soul, and Siouxsie is somewhere in between.

EXPLORER OR HOMEBODY?
Homebodies.

LAZY OR ACTIVE?
Can be quite lazy but will always find the energy to destroy a bit of furniture.

DOGS – FRIEND OR FOE?
They love dogs but hate cats.

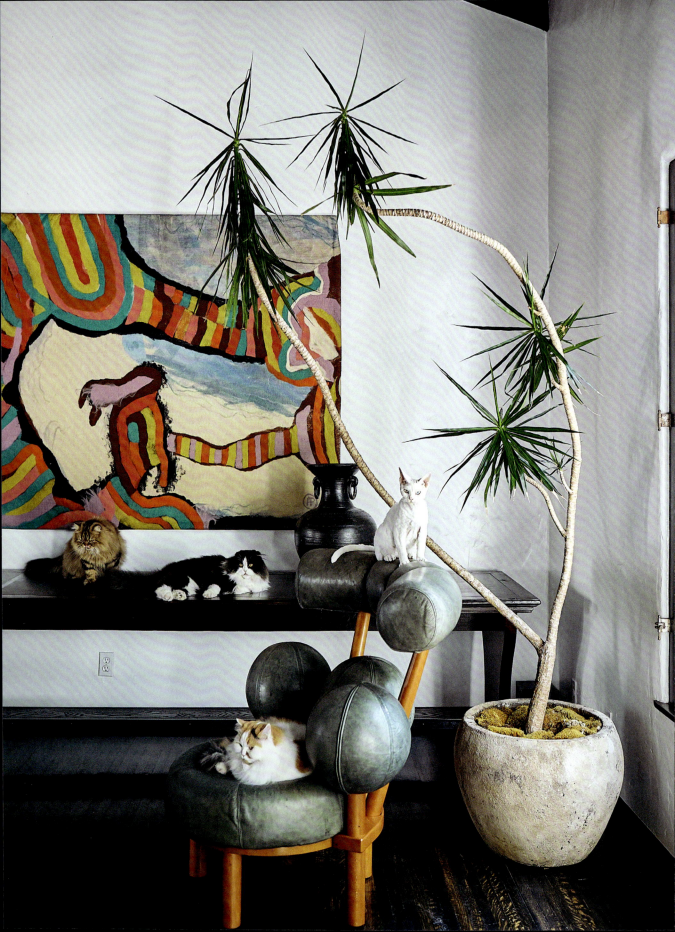

HELEN, MORRIS, SCOTTIE, BRIAN, BESSIE, RICKY, MIKEY, RALPHIE AND KARL

ARCHITECT: RALPH CARLIN FLEWELLING | INTERIOR DESIGNER: CAILIN SHANNON-WUNDER
LOCATION: BEVERLY HILLS, CALIFORNIA

Despite coming from all corners of the world, these nine felines couldn't form a more cohesive clowder. Morris, Mikey and Ralphie are Scottish fold long hairs, as are Helen and Ricky, although their ears did not fold. Bessie is a Scottish fold mixed with British shorthair; Brian and Scottie are full British shorthairs. Karl, the pack's baby, is a Devon Rex with an eternal head tilt that falls in line with his inquisitiveness. To adequately describe each cat's unique personality would be a Herculean task, but together they strike the perfect balance between tranquil and playful.

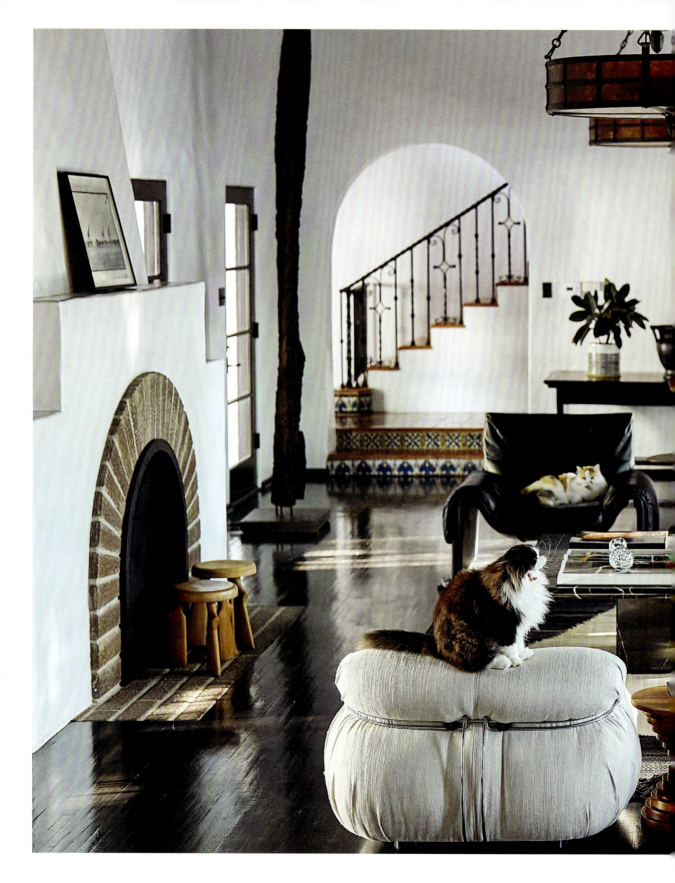

Architect: Ralph Carlin Flewelling | Interior designer: Cailin Shannon-Wunder

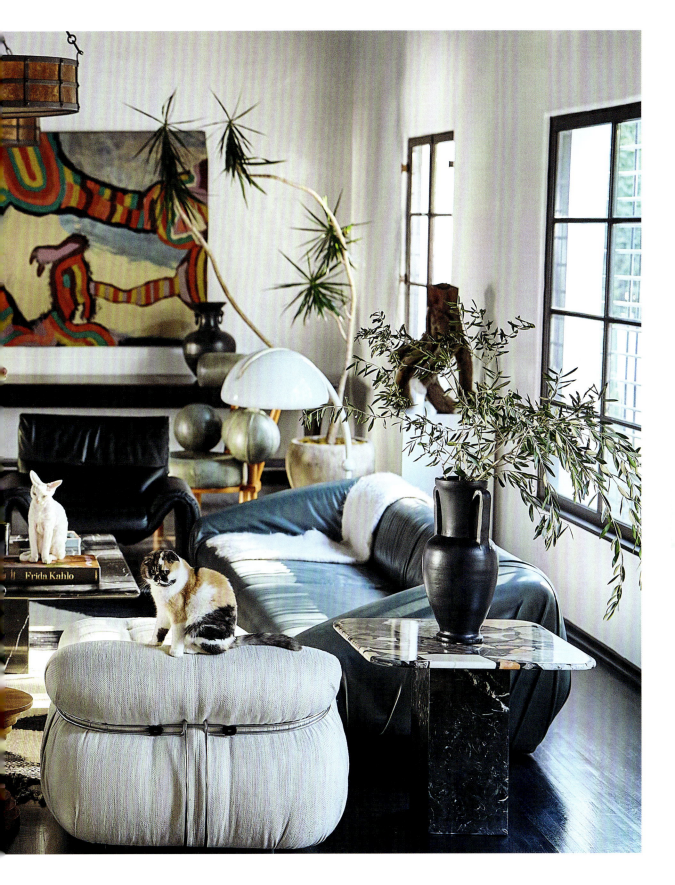

HELEN, MORRIS, SCOTTIE, BRIAN, BESSIE, RICKY, MIKEY, RALPHIE AND KARL

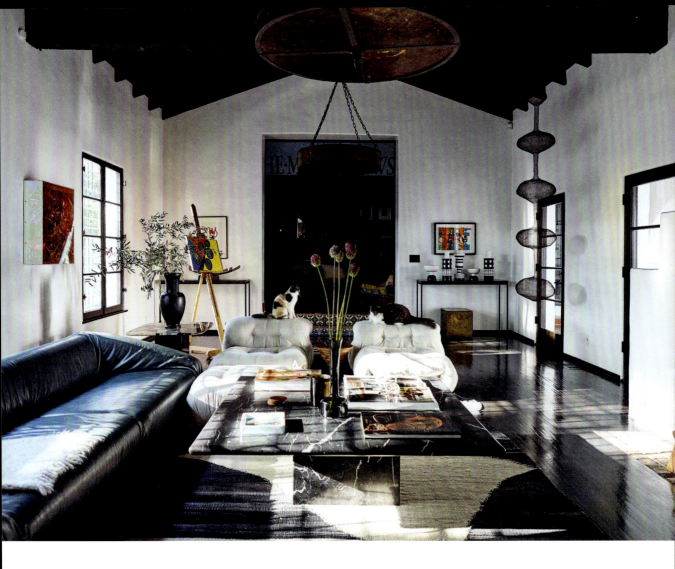

The cats' home dates back one hundred years to the beginnings of the glamorous Beverly Hills we know today. It draws inspiration from Mexican haciendas, with a large central courtyard that was renamed the 'catio'. Radiating around it are living quarters and communal spaces displaying an assortment of modern and postmodern art and design pieces carefully assembled over the years. This is an approachable and cosy home that lends itself just as well to large gatherings as to the more intimate life of its young family.

Architect: Ralph Carlin Flewelling | Interior designer: Cailin Shannon-Wunder

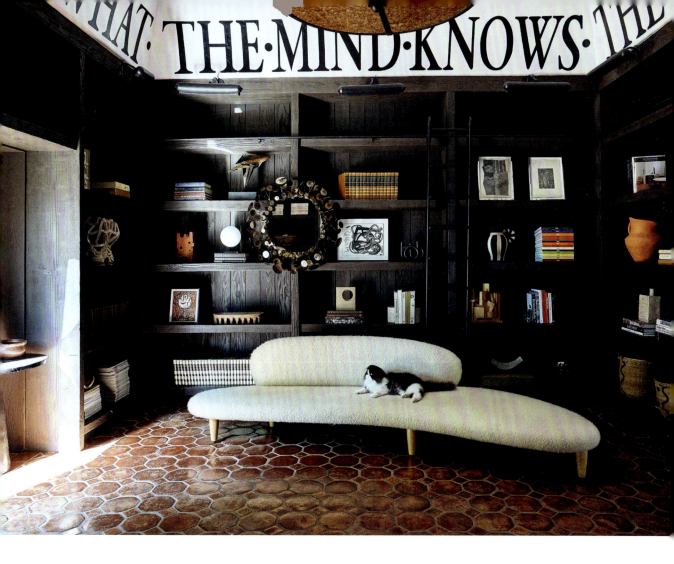

HELEN, MORRIS, SCOTTIE, BRIAN, BESSIE, RICKY, MIKEY, RALPHIE AND KARL

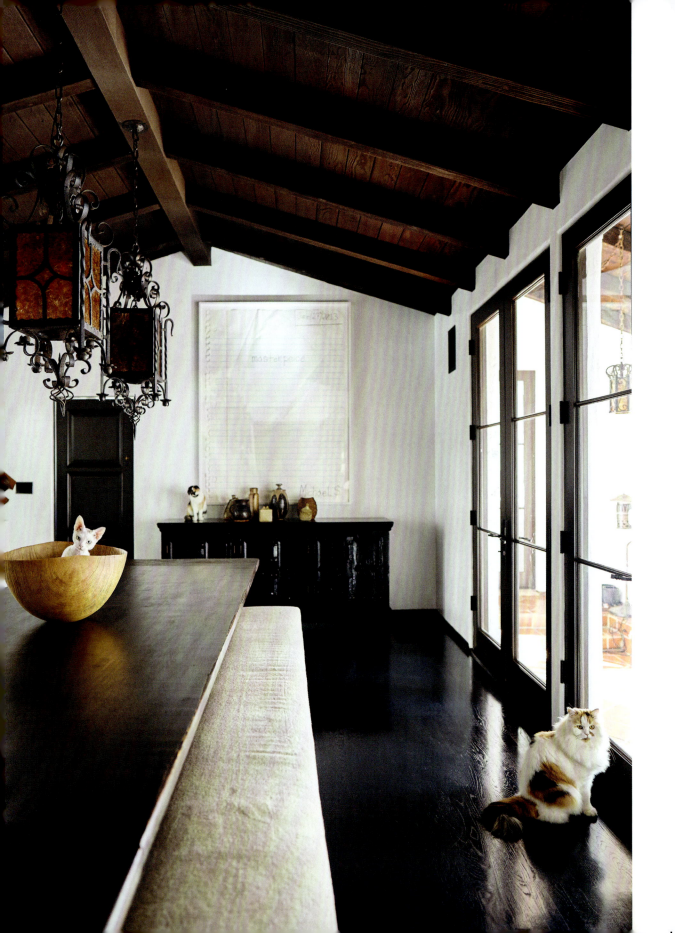

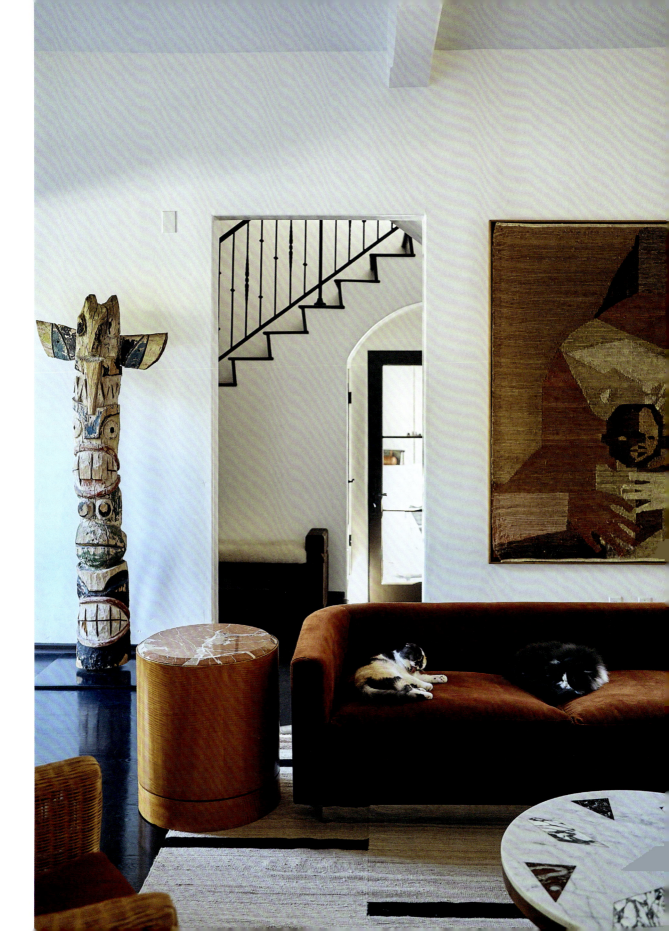

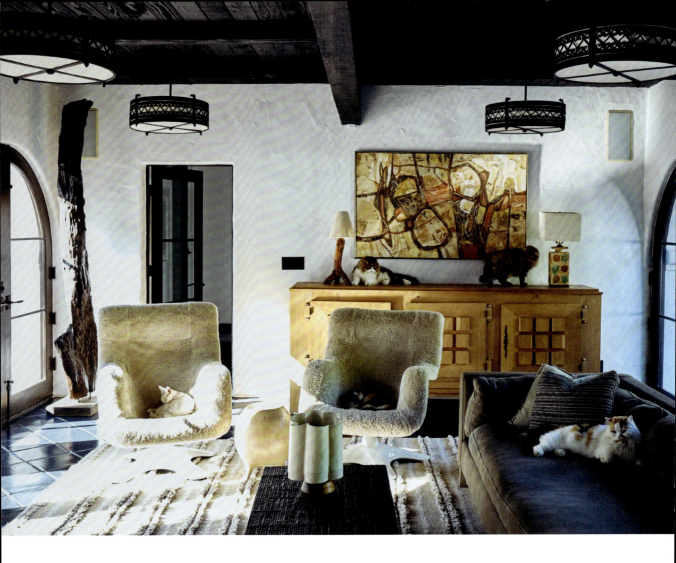

Architect: Ralph Carlin Flewelling | Interior designer: Cailin Shannon-Wunder

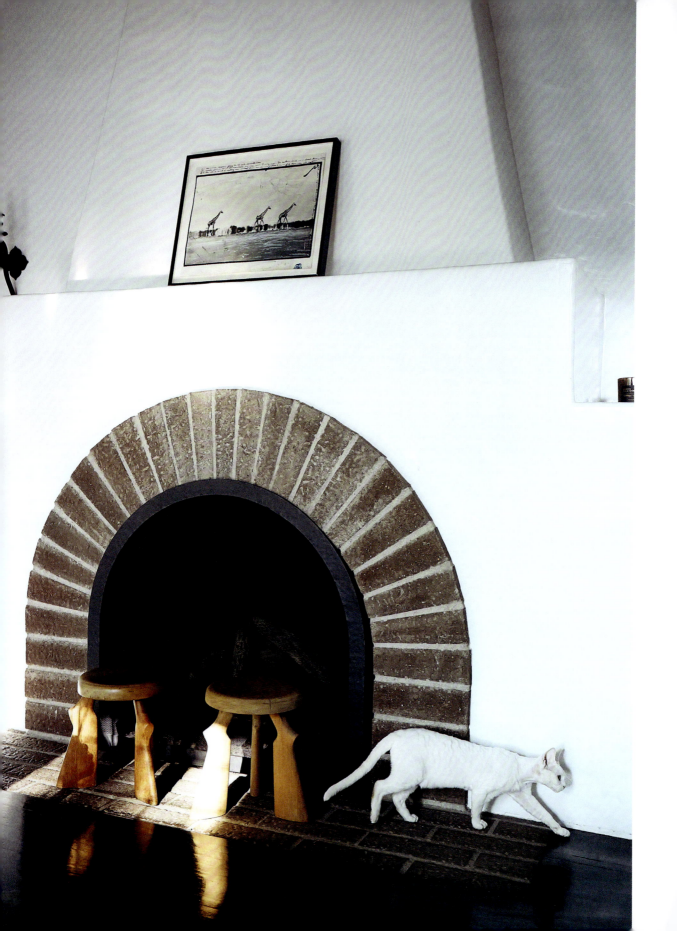

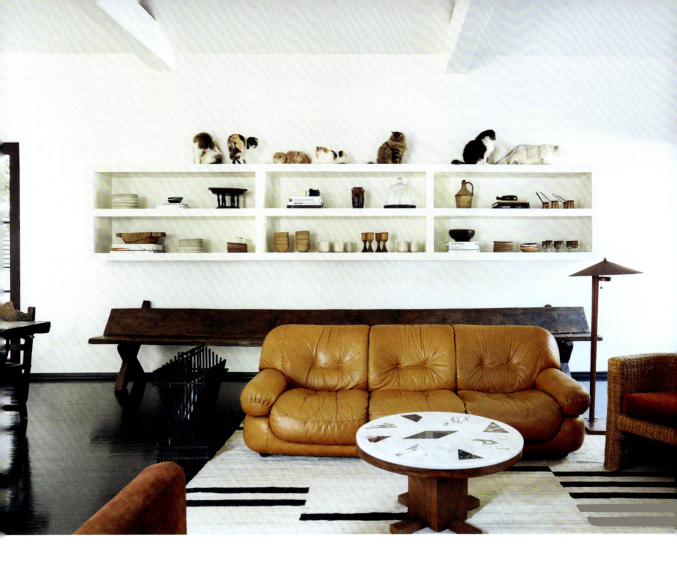

HELEN, MORRIS, SCOTTIE, BRIAN, BESSIE, RICKY, MIKEY, RALPHIE AND KARL

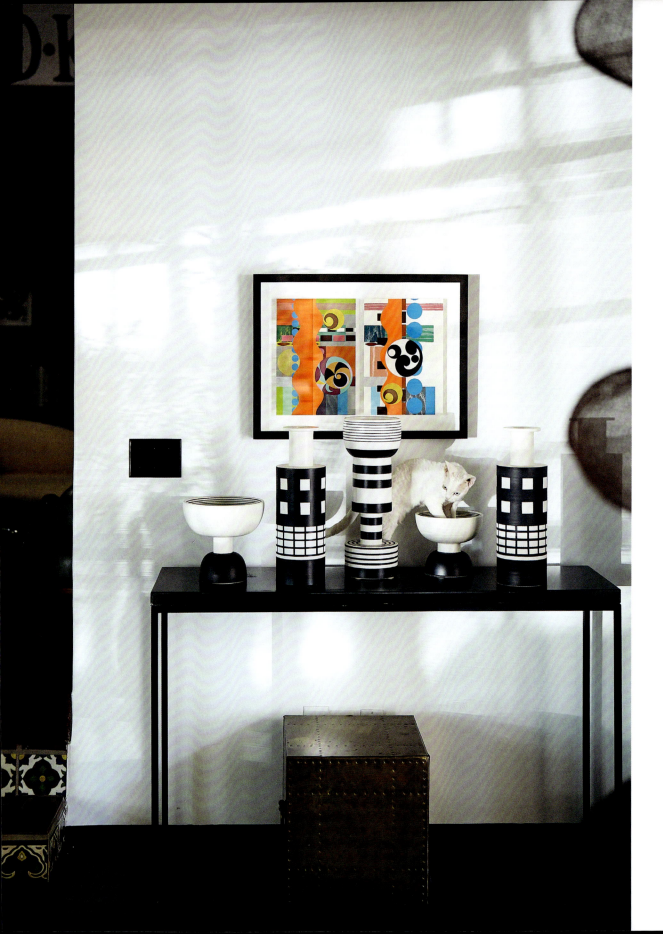

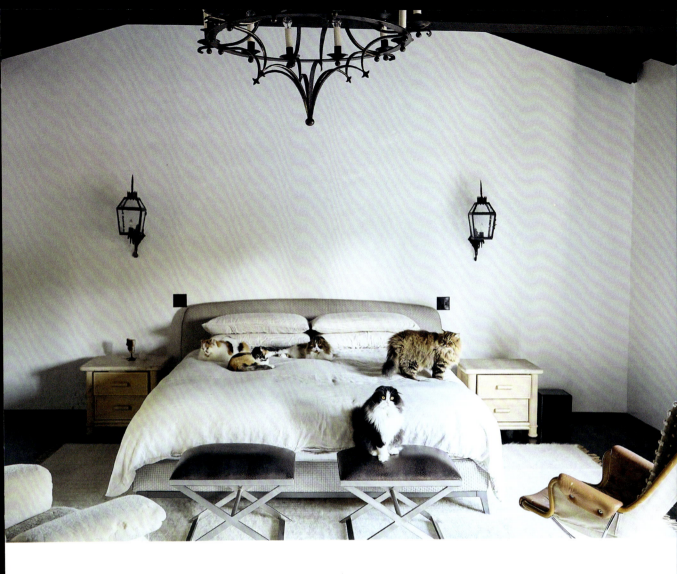

Despite the enclosed outdoors and large feline-only play area, the cats' favourite spaces are, of course, everywhere they are not allowed to be.

HELEN, MORRIS, SCOTTIE, BRIAN, BESSIE, RICKY, MIKEY, RALPHIE AND KARL

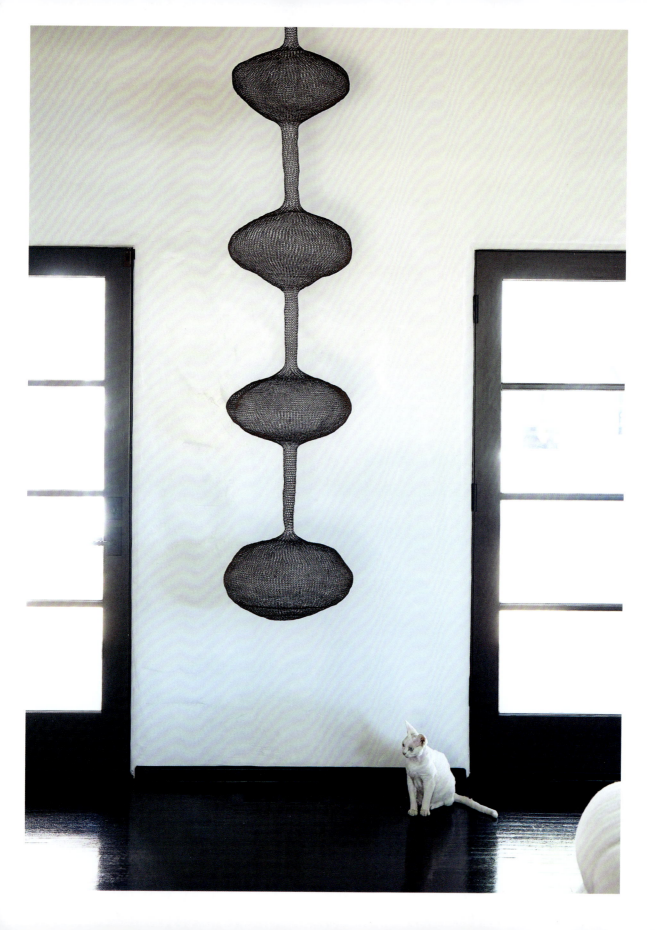

Q&A

DIVA OR DEVOTED FRIEND?
Helen and Bessie, the only girls, are major divas.
Karl, Morris and Ralphie are everyone's friends.
The rest are devoted to their owner only.

INTROVERT OR EXTROVERT?
With a pool of cats so large, there is room for both
and the full spectrum in between.

LAP CAT OR NOT?
Karl, the youngest, is an assiduous lap cat –
the only one.

OLD SOUL OR KITTEN AT HEART?
The cats are all old souls, no doubt informed
by the pack's joint personality.

EXPLORER OR HOMEBODY?
Helen and Morris, who are brother and sister,
are the only explorers. Helen in particular always
has somewhere to be, but they both pay visits
to all their neighbours.

LAZY OR ACTIVE?
The cats are mostly a lazy pack, and even
Helen has her days off.

DOGS – FRIEND OR FOE?
With so many intimidated guests telling the cats they
are not cat people, they could only return the favour.
Dogs are foes ... but tolerated.

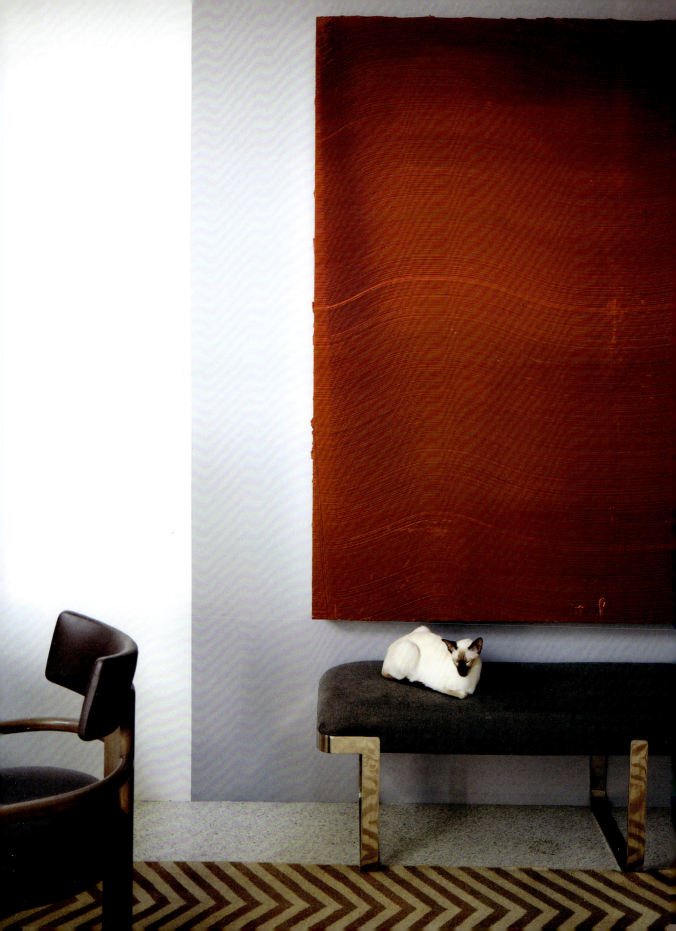

KELLY GIRL AND TOMMY BOY

INTERIOR DESIGNER: BROWN DAVIS
LOCATION: MIAMI BEACH, FLORIDA

Tommy Boy's arrival sent Kelly Girl into a full meltdown that might have endured were it not for his insistence on winning her over. Tommy, a one-year-old chocolate point Siamese, has just started to change colour and look more like his beloved older sister, from whom he is now inseparable – and vice-versa. The cats revolve around the house, oriented by their owner and the sun in equal measures. It is only at sundown that Kelly asserts her seniority, demanding to have her heating pad turned on. Tommy may curl up close by or embark on a solo adventure, but he knows not to trespass.

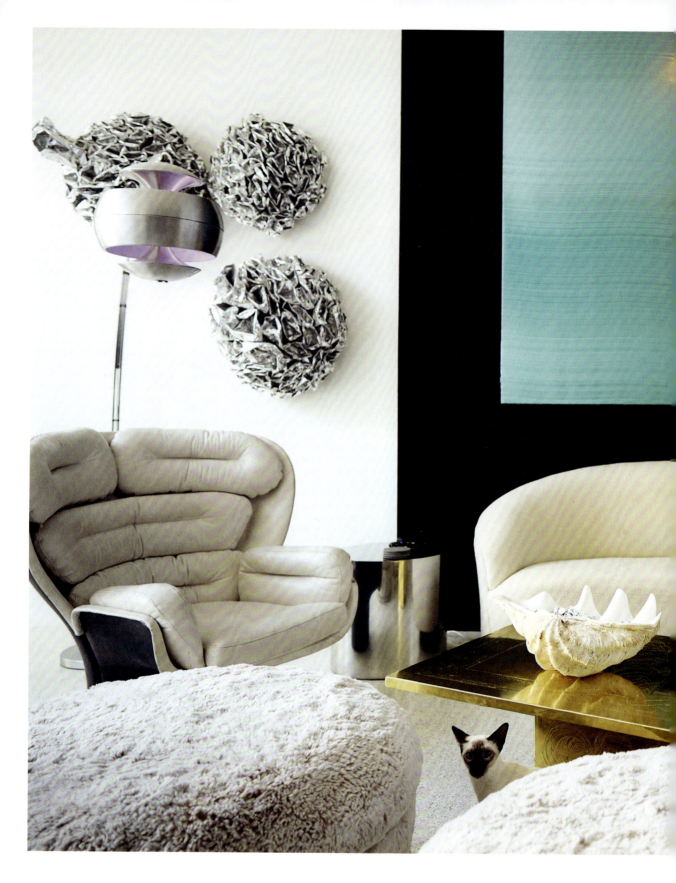

Interior designer: Brown Davis

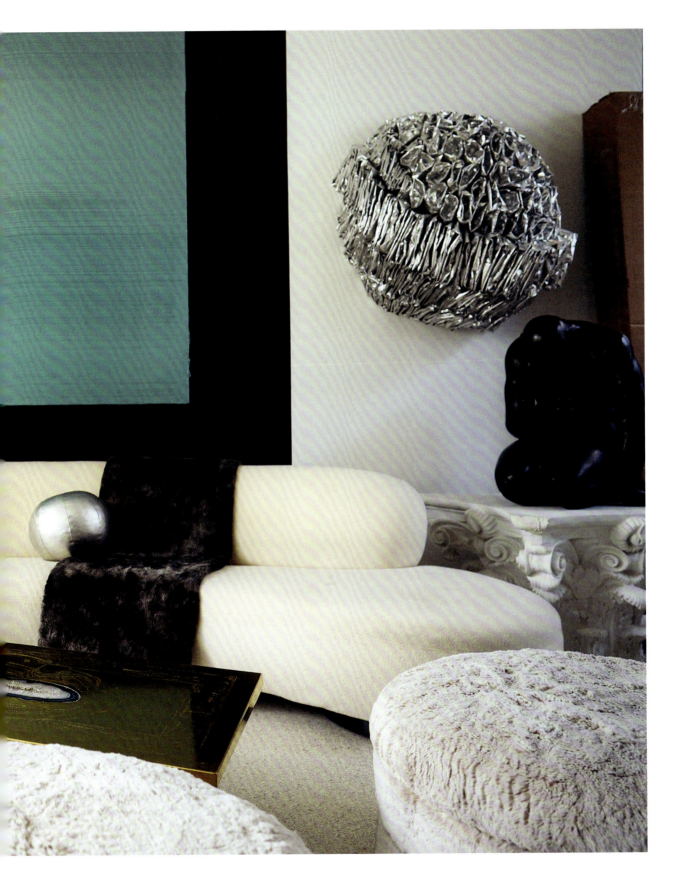

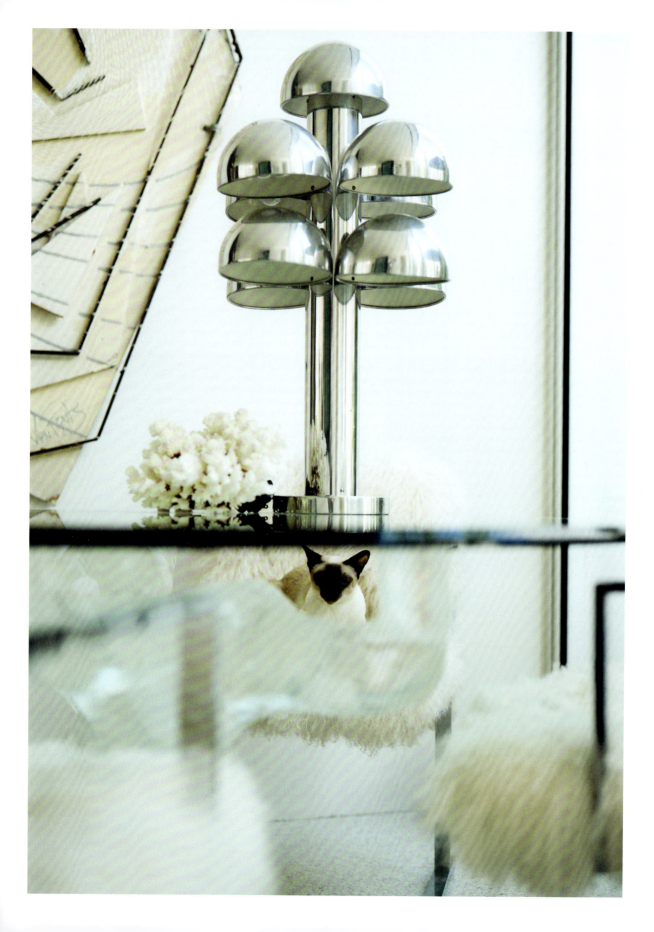

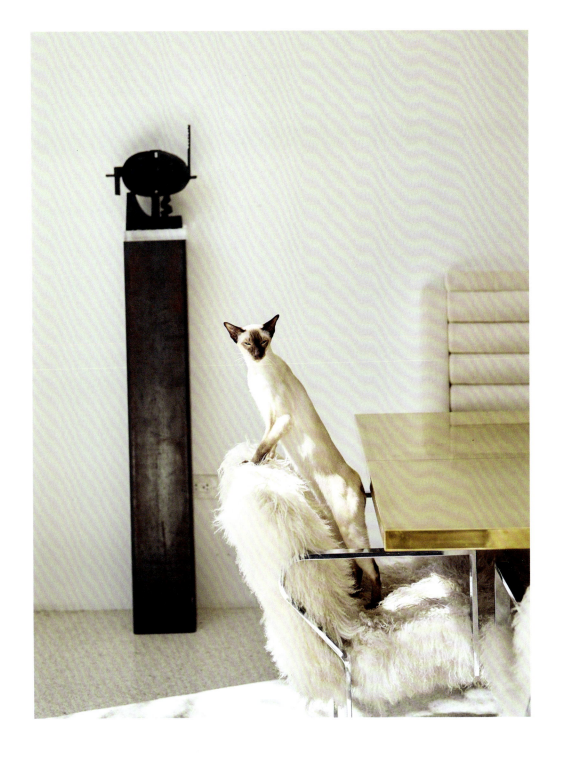

The cats' home is on the top floor of a commercial building in downtown Miami Beach, but once inside, the apartment is an oasis, completely cut off from the city. It has no outward-facing windows and, instead, radiates around a lush open-air atrium. Vibrant colour and polished metal are themes that run across walls, light fixtures, furniture and art, bringing splashes of excitement to the tranquillity of the terrazzo floors and the insistently clear skies above the atrium.

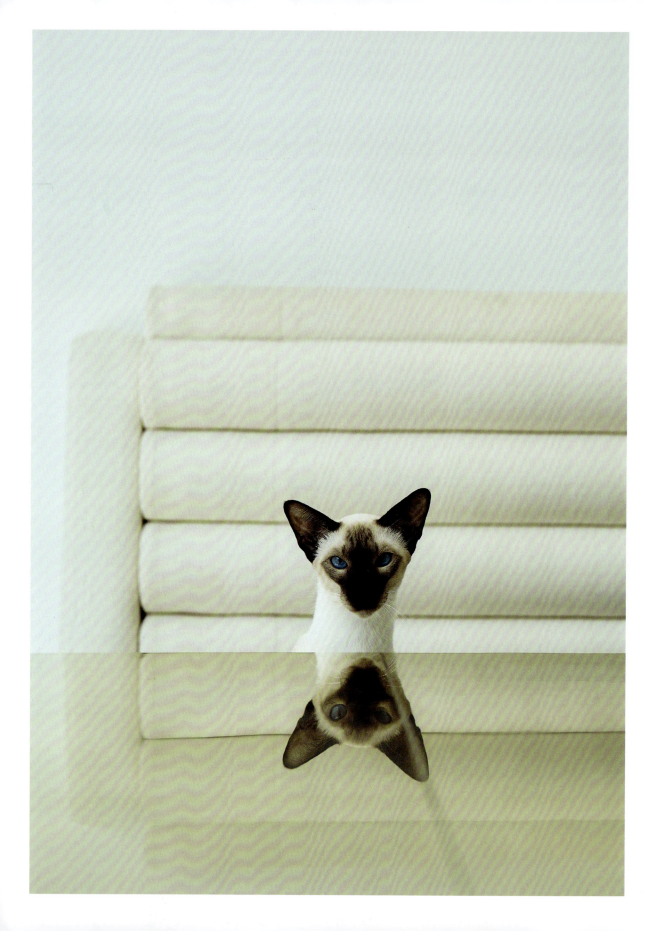

Q&A

DIVA OR DEVOTED FRIEND?
Yes, and yes; the cats have enormous personalities and toggle easily between the two.

INTROVERT OR EXTROVERT?
Alone with their owner, the cats are extroverts, but Kelly – and even Tommy as he tiptoes into adulthood – are shy among strangers.

LAP CAT OR NOT?
Not particularly.

OLD SOUL OR KITTEN AT HEART?
Old souls. Tommy is a kitten, but there is something of a much older cat in the way he sits and contemplates.

EXPLORER OR HOMEBODY?
Explorers. Kelly insists on parameter checks throughout the night.

LAZY OR ACTIVE?
Tommy is both, all energy and all lethargy, while Kelly is consistently lazy.

DOGS – FRIEND OR FOE?
They are getting used to their new dog pal.

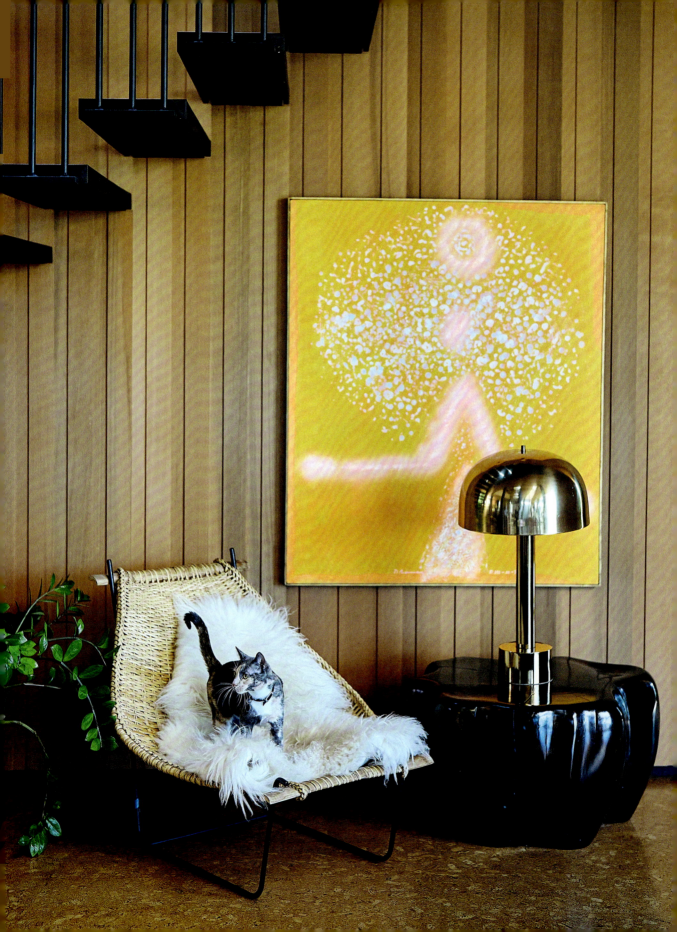

GIGI

ARCHITECT: ASSEMBLEDGE | INTERIOR DESIGNER: JAMIE BUSH
LOCATION: SANTA MONICA, CALIFORNIA

Seeing the confident Gigi with her large family and their two rowdy dogs, it's hard to believe she was once an abandoned kitten, dirty and scared underneath a parked car. True to her origins, the six-year-old shorthair calico spends large portions of the day (and a few sleepless nights) outdoors as a fearless and formidable hunter who brings home her proud catch – regardless of whether it's dead, semi-dead, a headless body or just a head. But Gigi is far from feral; she is just as happy to curl up on a lap for a movie night and has even learned to stand in a row along with the dogs for their nightly cheese treat.

Located on the hills of Santa Monica, Gigi's home is as contemporary as it is warm, and suits her indoor/outdoor habits with an assortment of gardens, verandas and fire pits orbiting the expansive central living space. A massive Stan Bitters stone hearth, natural materials with a predominance of cedar and walls made almost entirely of glass harmonise with the canyon outside, while stunning views of the ocean and nature help hide the fact that the home is in the heart of Los Angeles.

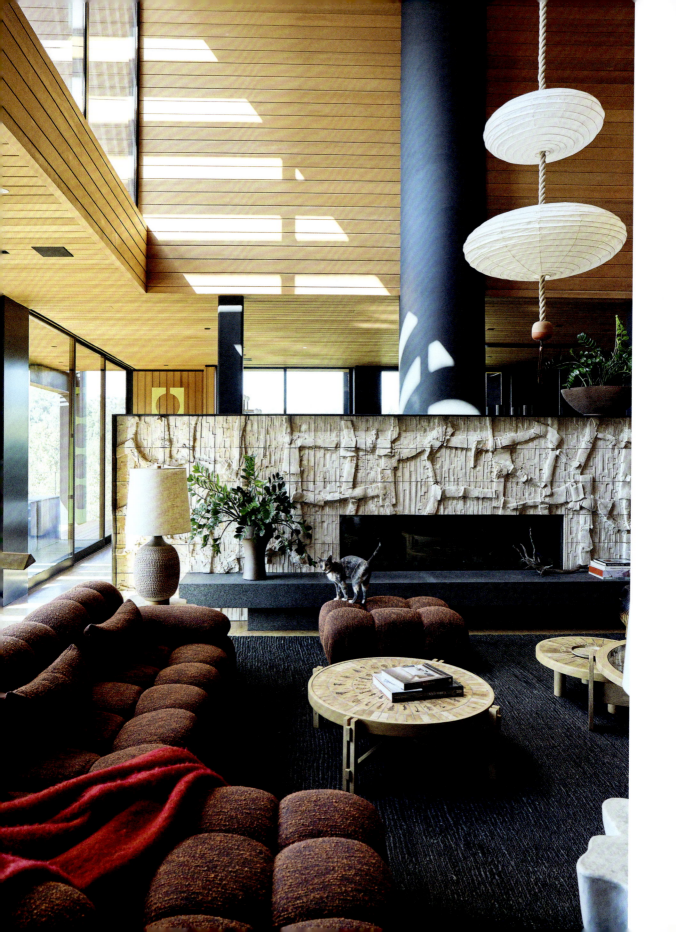

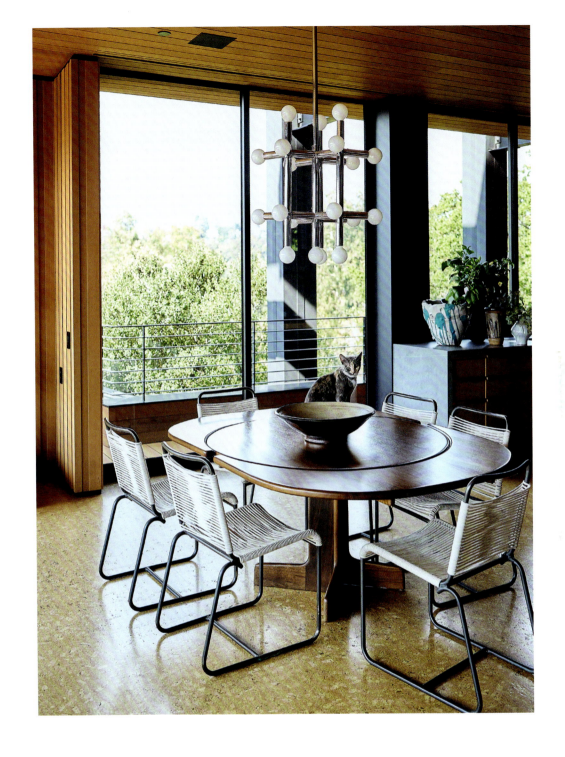

Emerging from the wilderness after a busy day outdoors, Gigi can forget her manners and hunt her food right off her owners' forks.

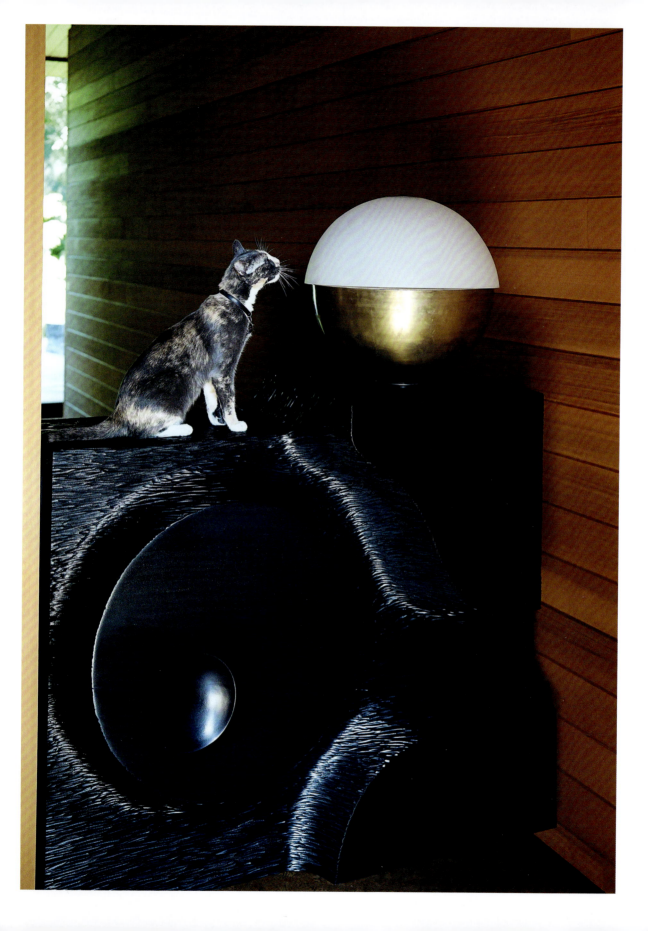

Q&A

DIVA OR DEVOTED FRIEND?
Devoted friend who demands to be fed immediately at the first sign of hunger.

INTROVERT OR EXTROVERT?
Extrovert.

LAP CAT OR NOT?
Loves a lap and loves curling up with the dogs.

OLD SOUL OR KITTEN AT HEART?
Mischievous teenager.

EXPLORER OR HOMEBODY?
Dedicated explorer.

LAZY OR ACTIVE?
Active – but knows how to relax.

DOGS – FRIEND OR FOE?
Best friends.

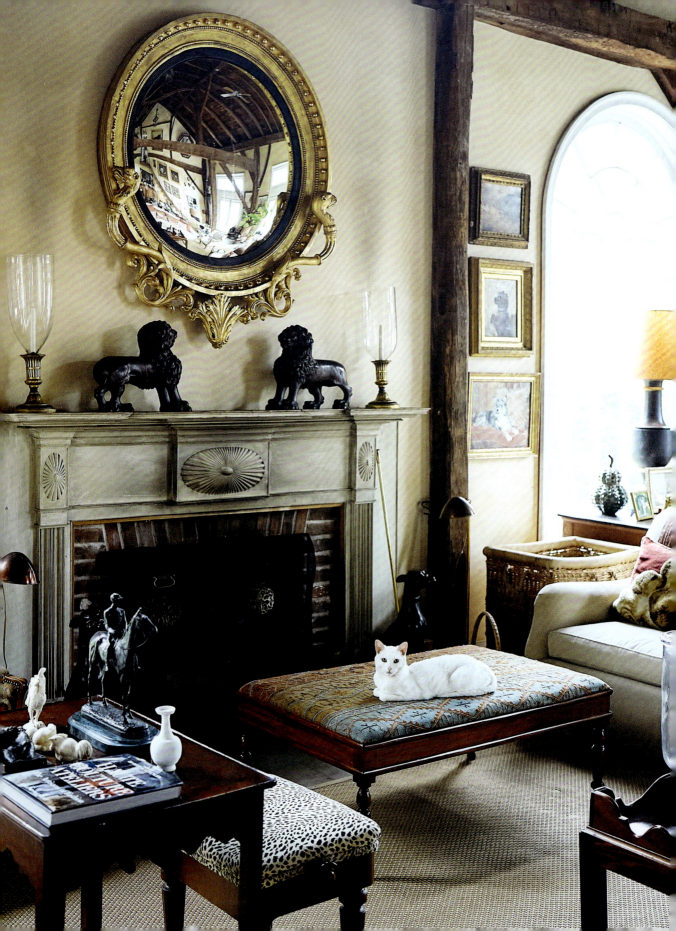

SNOWY

INTERIOR DESIGNER: BUNNY WILLIAMS
LOCATION: CANAAN, LITCHFIELD COUNTY, CONNECTICUT

Snowy was found strolling around the Connecticut countryside and brought in as a barn cat who, in exchange for managing pest control, was given a greenhouse, conservatory and a complete guest house for his living quarters. A heated cat bed, an access door to come and go as he pleases, plus plenty of company from his gardening-enthusiast family offer a cushy life that has not cost the former feral cat his independence.

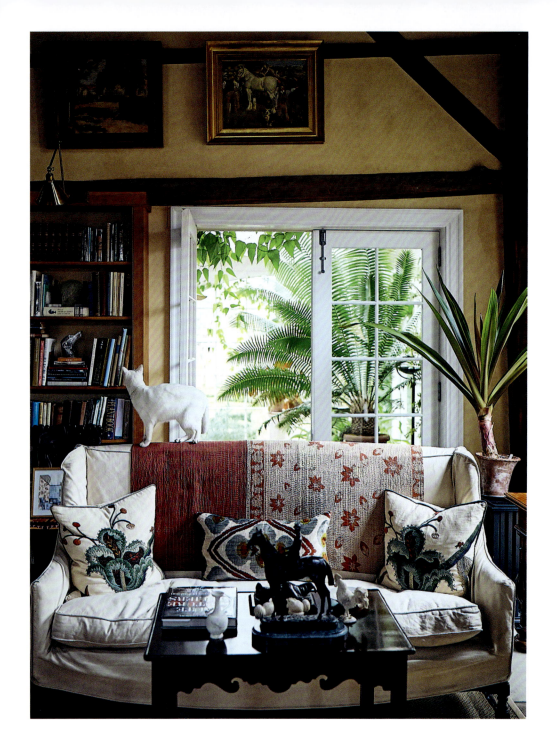

The gardens under Snowy's protection have been almost four decades in the making, meticulously arranged around a 19th-century farmhouse. The greenhouse is an experimental lab filled year-round with ferns, geraniums, begonias and succulents. Nearby, the barn is a take on the British great room, perfect for parties and specifically Christmas, when the nine-metre ceiling fits a dramatically tall tree.

Interior designer: Bunny Williams

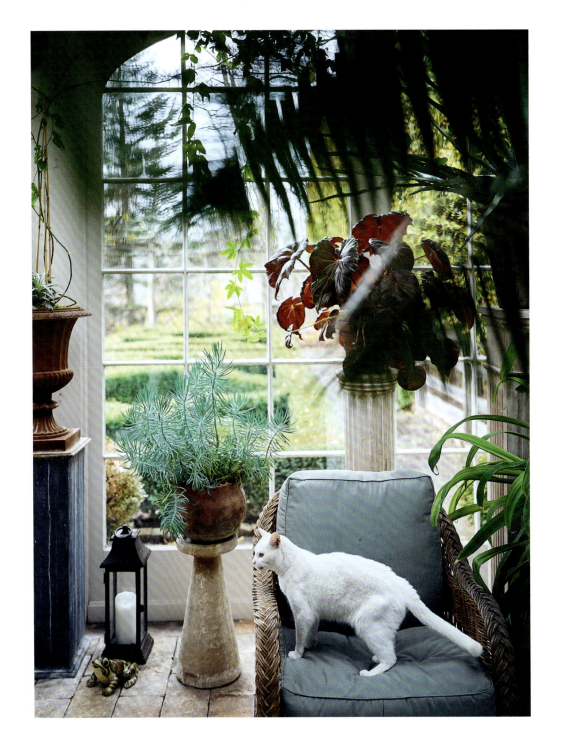

The interiors, designed by Snowy's owner, match the relaxed nature of this rural retreat. Indoor and out, every element of the design is considered – an ever-evolving love affair with a property for Snowy to explore at his leisure.

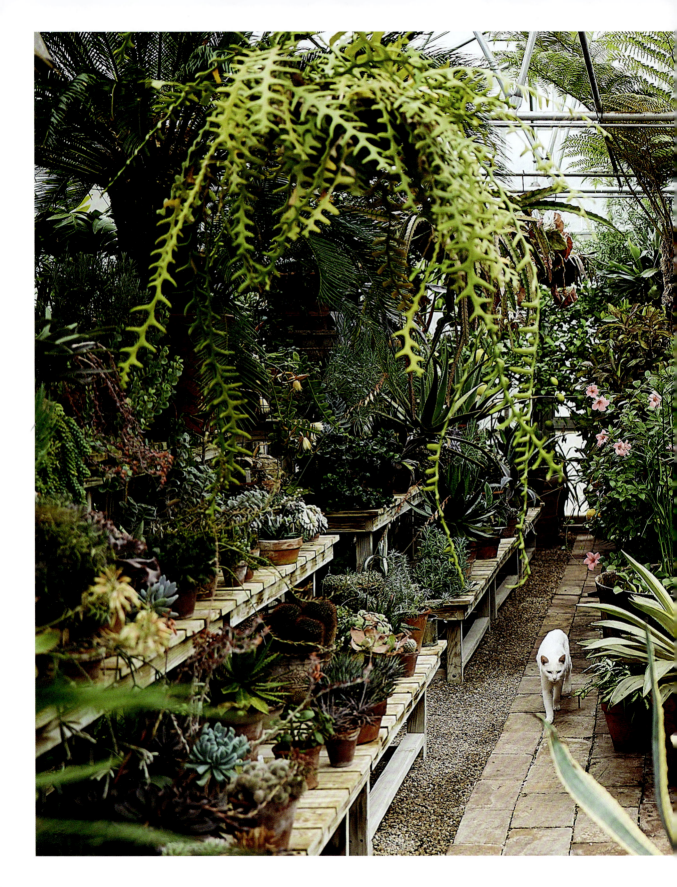

Interior designer: Bunny Williams

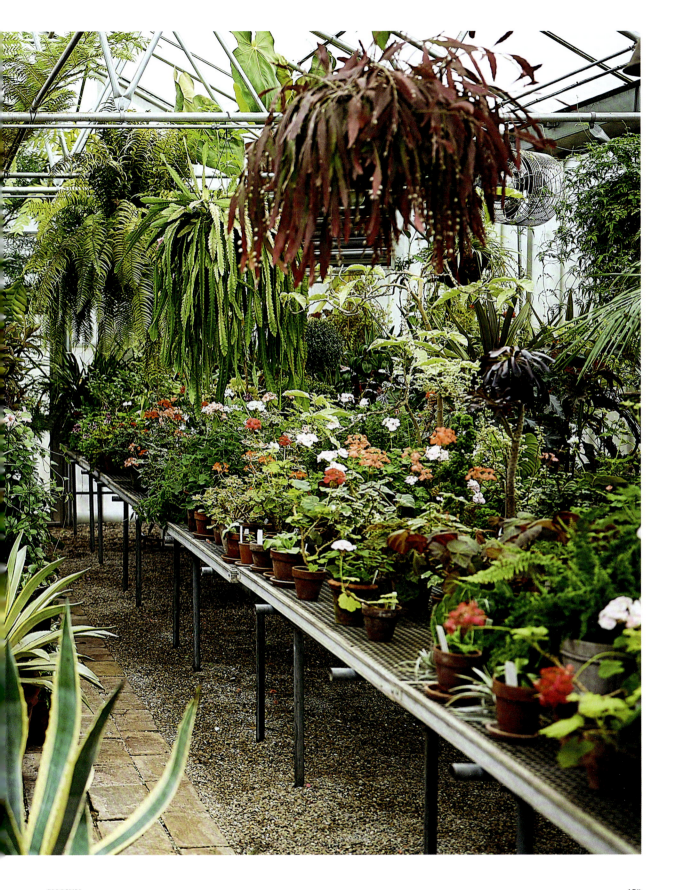

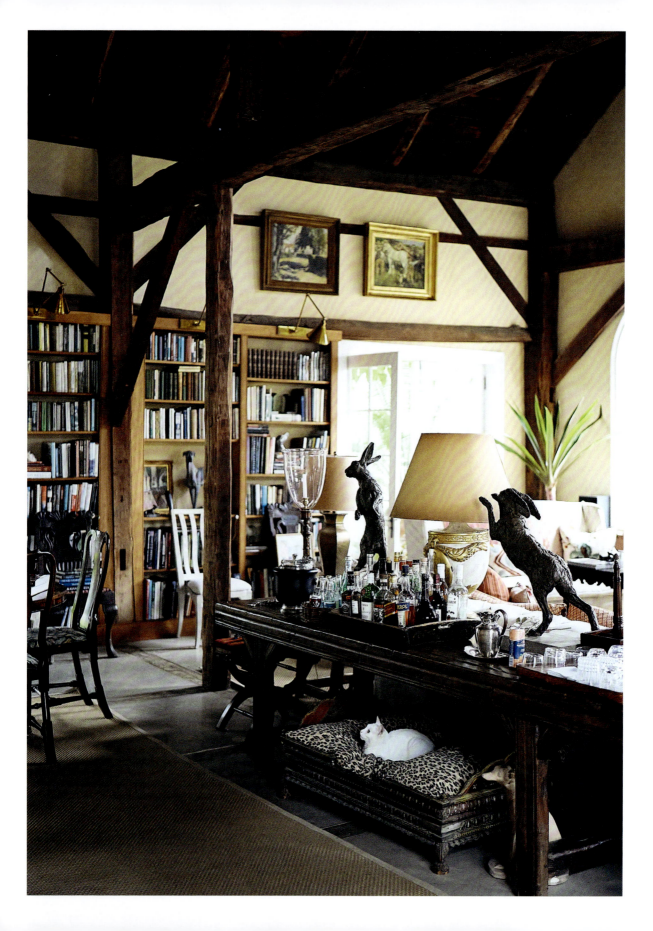

Q&A

DIVA OR DEVOTED FRIEND?
Both.

INTROVERT OR EXTROVERT?
Extrovert, no attention is too much.

LAP CAT OR NOT?
Not, loves affection but on his terms.

OLD SOUL OR KITTEN AT HEART?
A middle-aged adult?

EXPLORER OR HOMEBODY?
Explorer and a great hunter.

LAZY OR ACTIVE?
Very active.

DOGS – FRIEND OR FOE?
Friend, especially to his canine siblings.

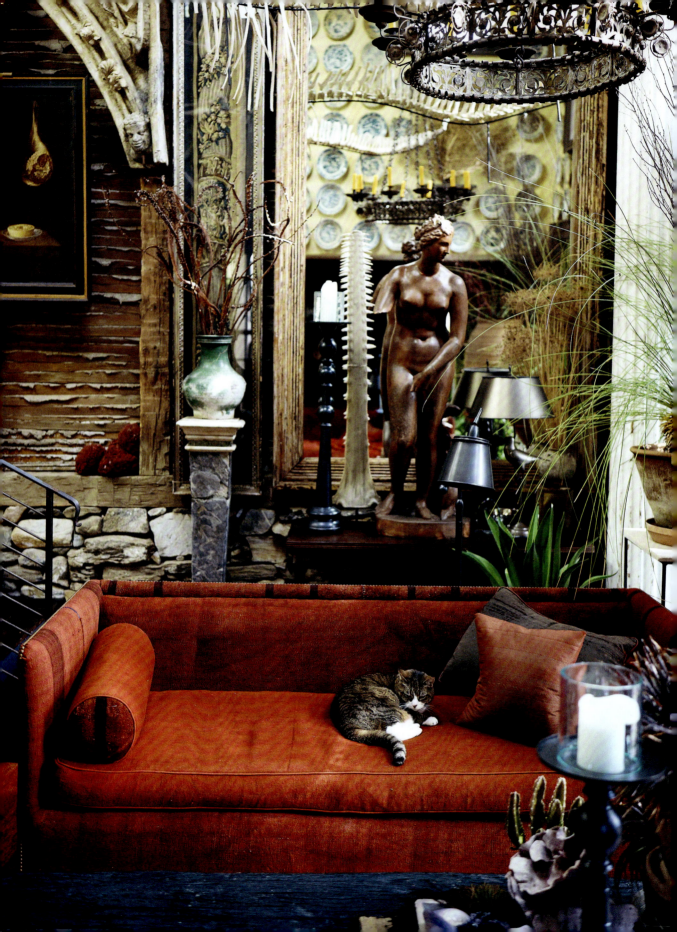

BETTY

INTERIOR DESIGNER: MICHAEL TRAPP
LOCATION: SHARON, LITCHFIELD COUNTY, CONNECTICUT

A decade ago, Betty was dropped at her owner's front door with instructions to put her down. Six years later, the American shorthair tabby, with a touch of Maine Coon showing through in the tufts of her ears and her large size, is still resoundingly grateful. She is a dear companion who, in her old age, wants nothing more than some sunlight and a good scratch, which she demands with raspy meows and accepts with appreciative purrs.

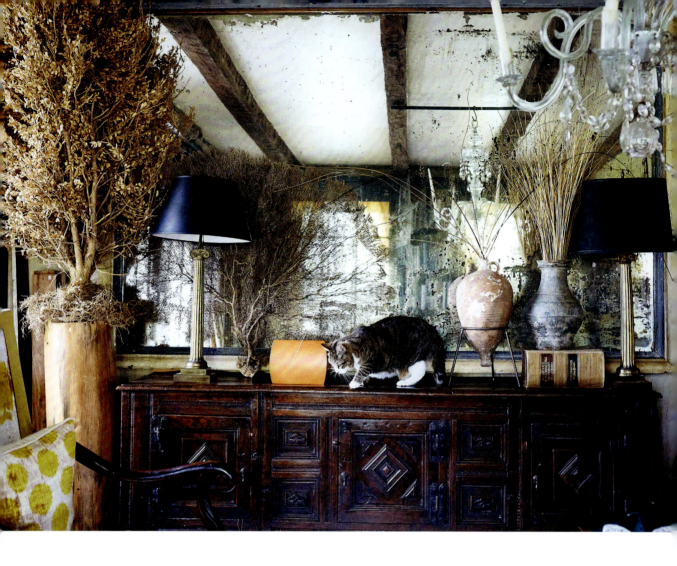

Built in the late 18th century as a roadhouse, Betty's home was deserted by the time her owner moved in. A warehouse-sized barn, which was added to the original house when the property became a farm, is now the main living space. A complete whale skeleton hanging over the dining table, Swatow plates salvaged from a shipwreck, giant French mirrors, old textiles dug up in Anatolia and a 17th-century still life are only a few of the features of this very baroque house.

Interior designer: Michael Trapp

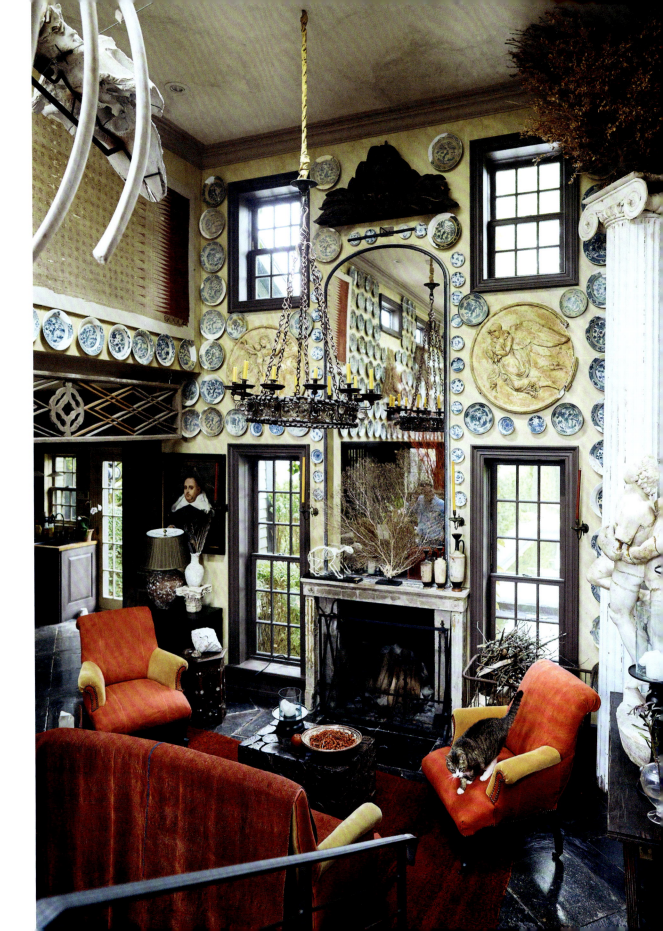

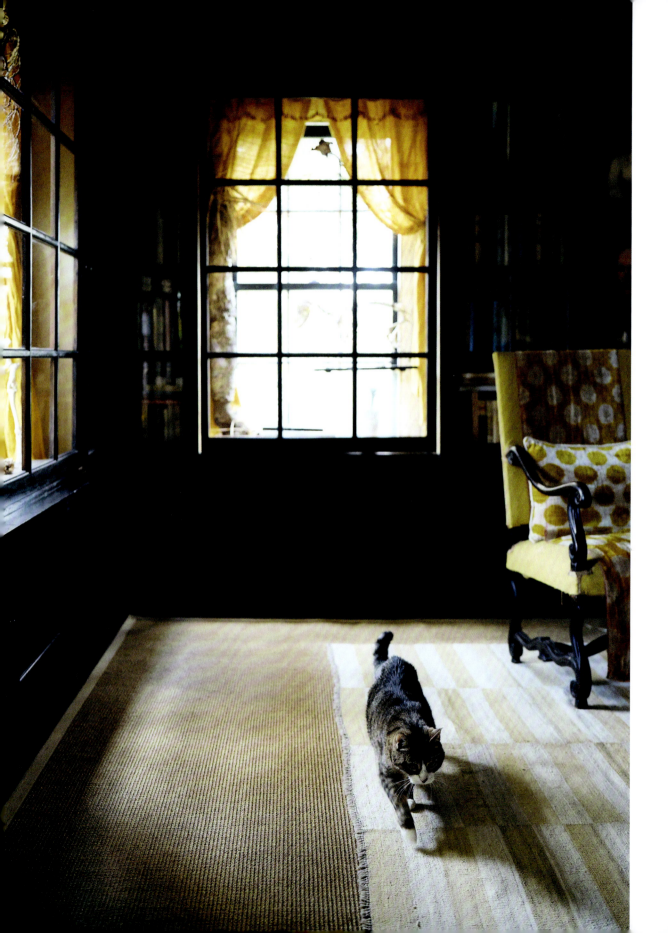

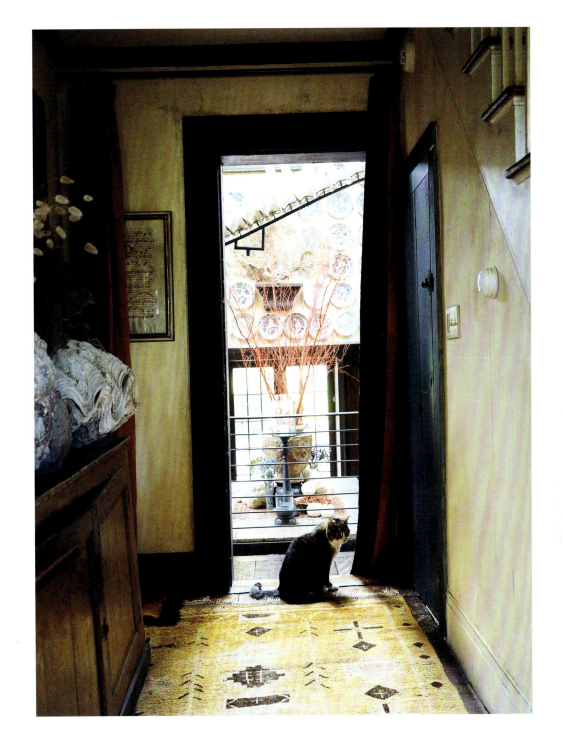

For Betty, this is home – a safe and quiet space where she languidly traces the sun as it moves around the rooms or snuggles on a rug without a thought for its provenance or age.

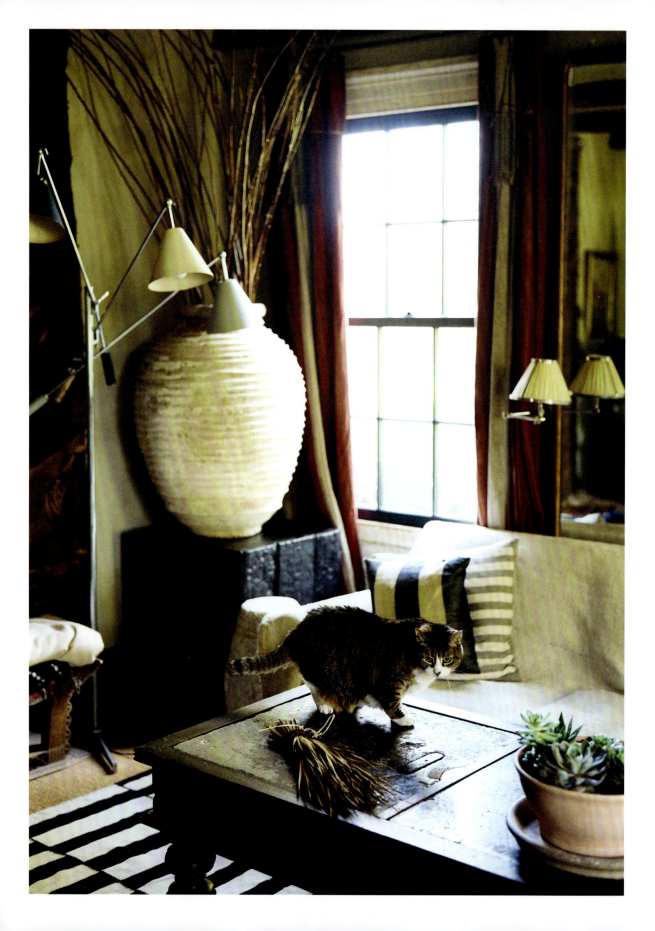

Q&A

DIVA OR DEVOTED FRIEND?
Devoted, and sweet beyond words.

INTROVERT OR EXTROVERT?
Introvert.

LAP CAT OR NOT?
Depends on the time of day.

OLD SOUL OR KITTEN AT HEART?
Old soul.

EXPLORER OR HOMEBODY?
Homebody.

LAZY OR ACTIVE?
Lazy and languorous but sways her hips just like an old movie star.

DOGS – FRIEND OR FOE?
Usually a friend but it depends on the dog.

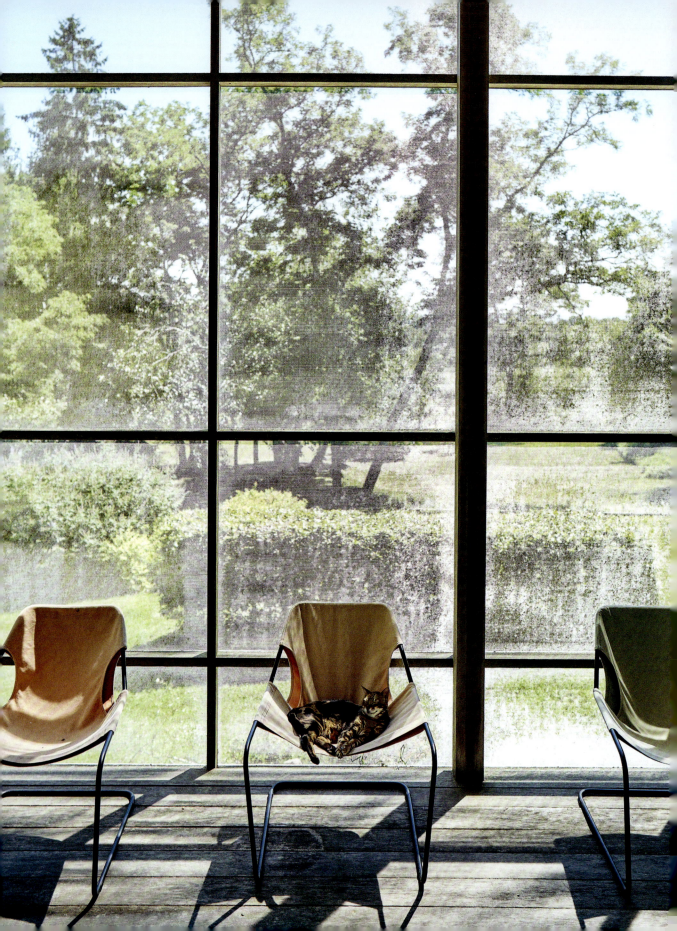

LINUS AND LUCY

ARCHITECT: WILLIAM RYALL
LOCATION: THE HAMPTONS, NEW YORK

Linus and Lucy have a surplus of energy for their quietly modernist home. To their relief – and their owners' – a high open steel beam offers the perfect balancing bar for the Bengal siblings to perform their acrobatic tricks, while a screened-in porch and floor-level windows surrounded by nature are a dependable source of entertainment. Despite these features, the cats will not hesitate to knock all sorts of precious objects to the ground at any lull, for attention or simply the excitement of watching them fall.

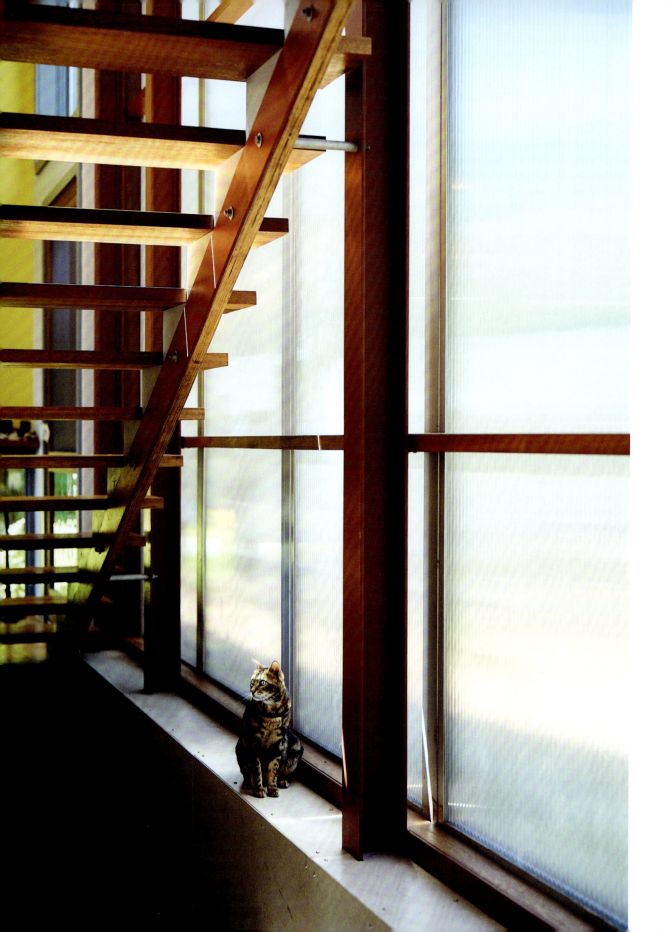

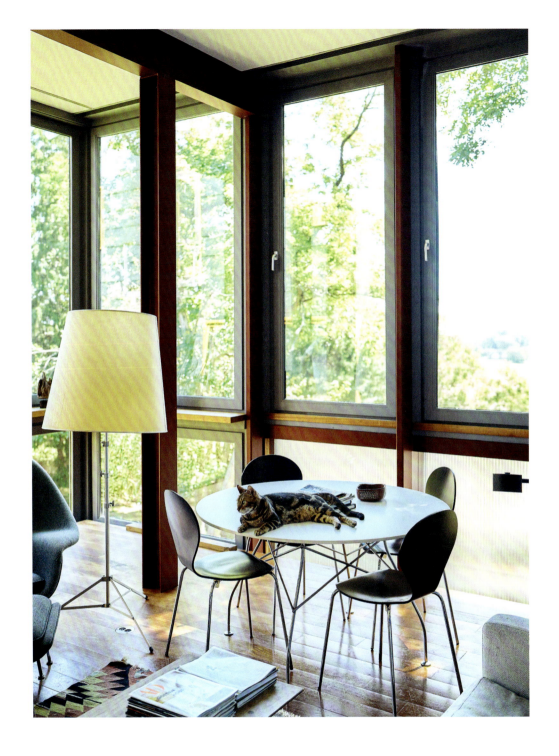

The cats' home takes advantage of its great vistas, with open diagonals from space to space and to the outdoors in every direction. Themes of transparency and translucency are explored through contemporary materials such as glass and zinc panels, but strong colours, native hardwood and two tireless cats add warmth to the almost ethereal architecture that could not be more of its time.

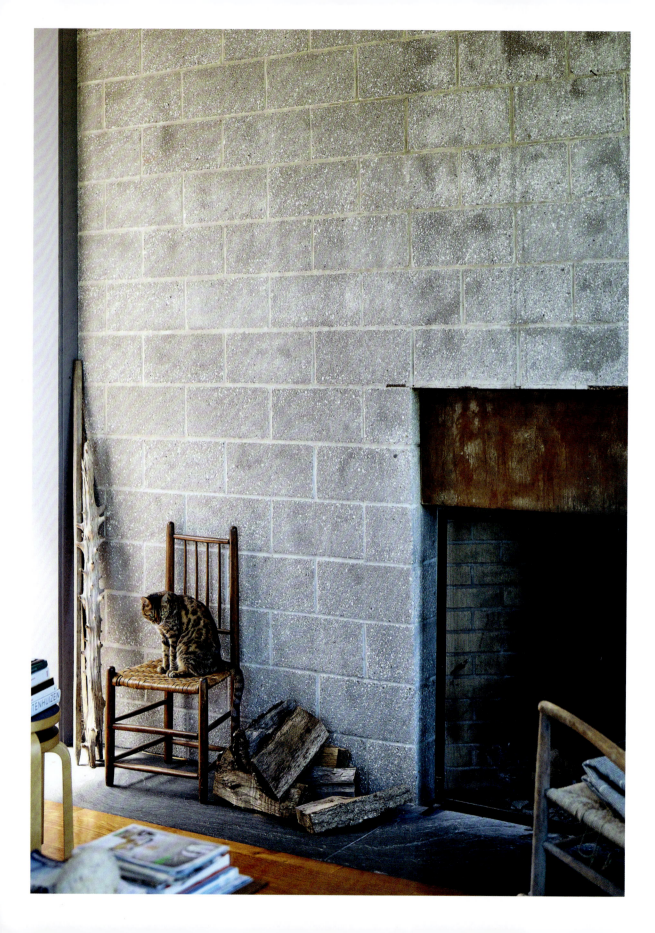

Q&A

DIVA OR DEVOTED FRIEND?
Both have elements of each, but Lucy can be more standoffish.

INTROVERT OR EXTROVERT?
Lucy is an introvert. Linus likes to perform to guests for attention.

LAP CAT OR NOT?
Both are lap cats, with much competition.

OLD SOUL OR KITTEN AT HEART?
Kittens at heart.

EXPLORER OR HOMEBODY?
Tales from around the neighbourhood testify to the cats' adventures.

LAZY OR ACTIVE?
Very, very, *very* active.

DOGS – FRIEND OR FOE?
They think they are friends until they get close.

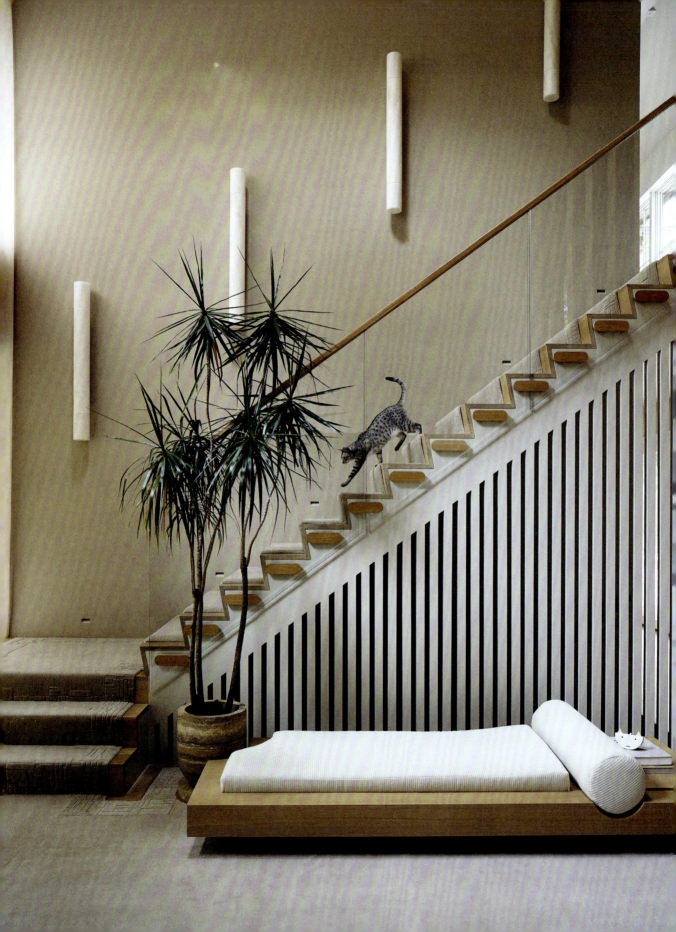

MATSU

INTERIOR DESIGNER: TIMOTHY GODBOLD
LOCATION: SOUTHAMPTON, NEW YORK

Matsu sees nothing wrong with a house that revolves around him. The four-year-old Egyptian Mau has yet to shed his kittenish traits and can be a very needy companion. If he manages some independence, such as scavenging for treats or testing his hunting skills in the yard, it is only to pass the time until he is reunited with his owner and can return to his throne in the living room.

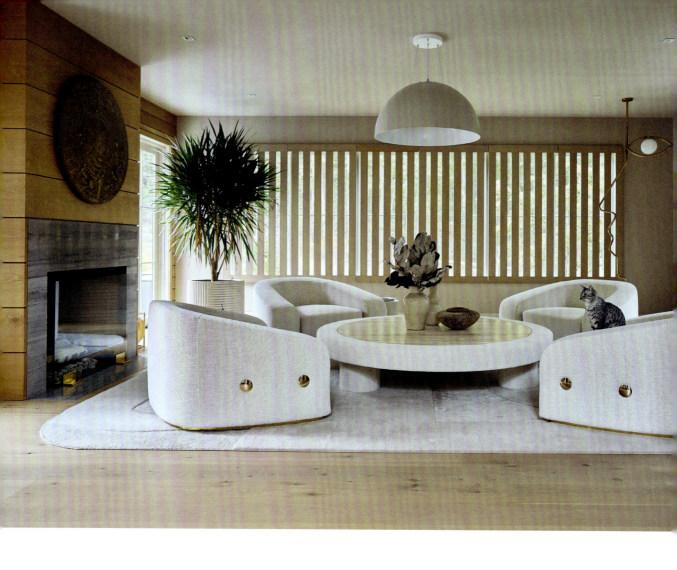

Matsu's home is as dramatic as it is cosy, with texture, shape and colour interplaying around a warm neutral centreline. Sprawling furniture and audacious custom sculptural pieces, as well as a layering of luxurious materials and large contemporary art, are awe-inspiring anchors to the large and very tall spaces.

Interior designer: Timothy Godbold

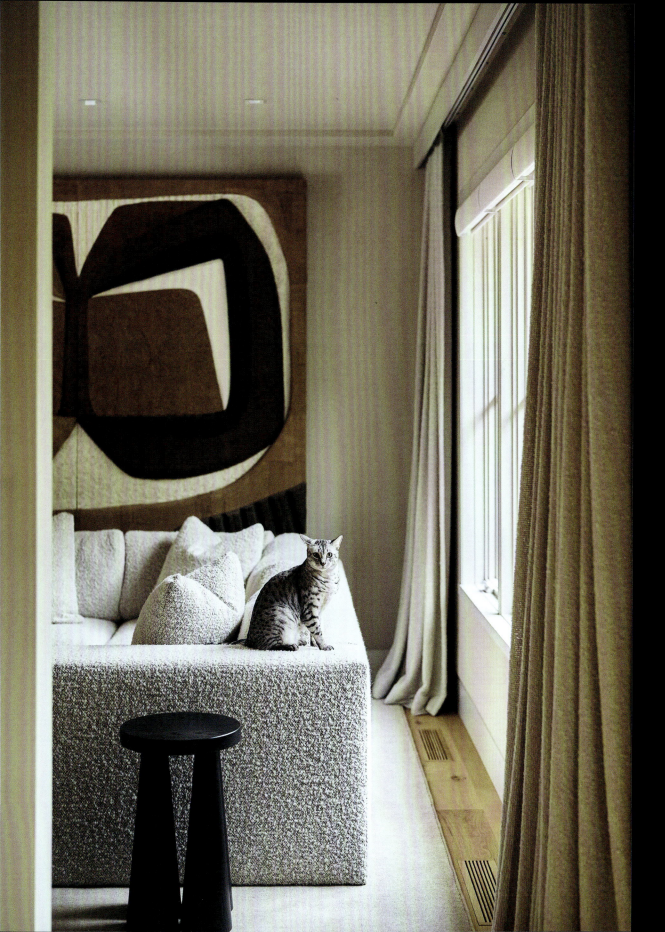

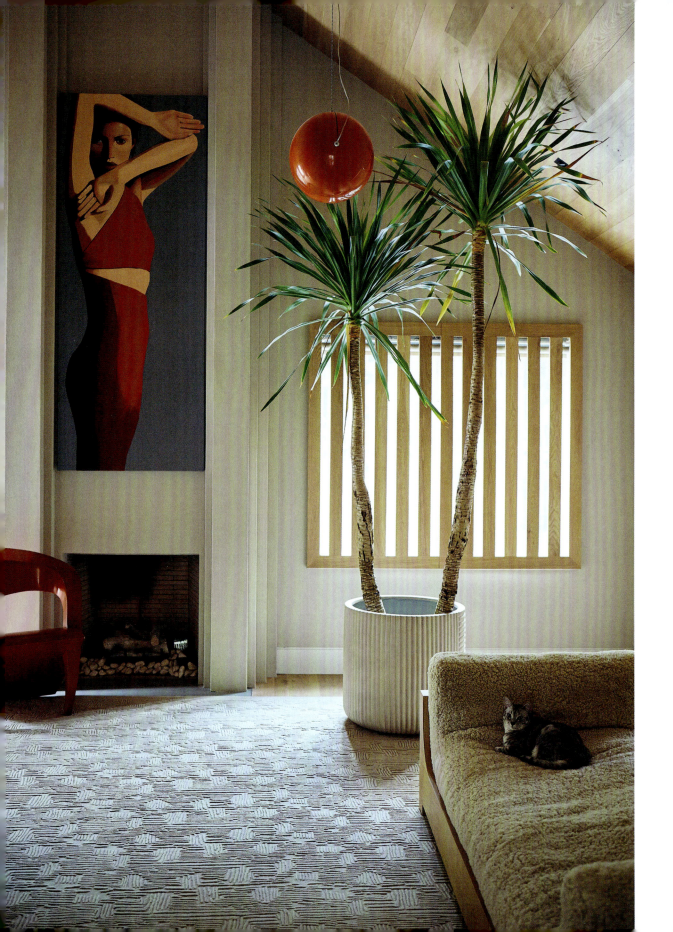

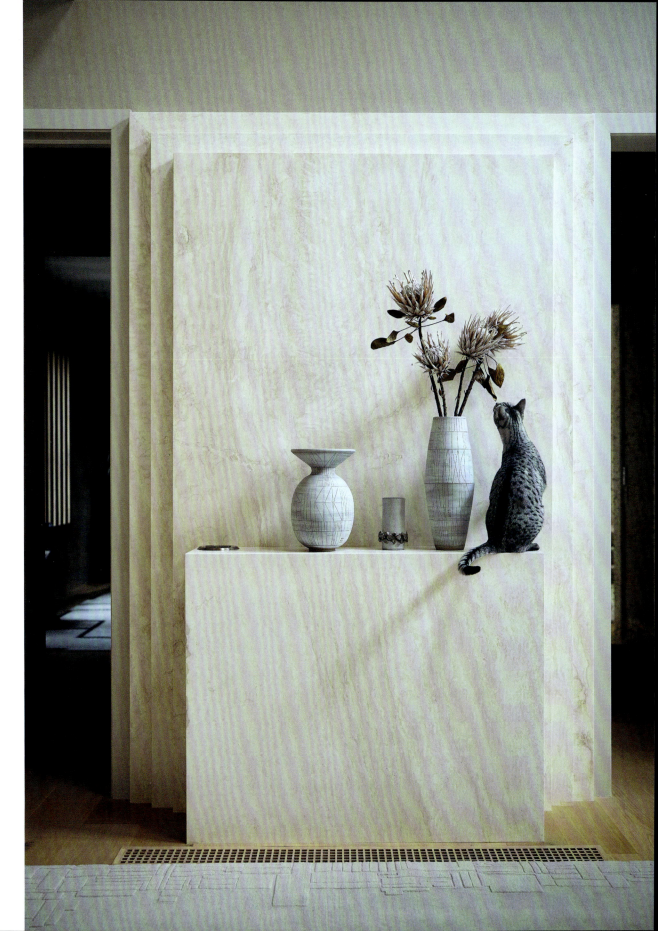

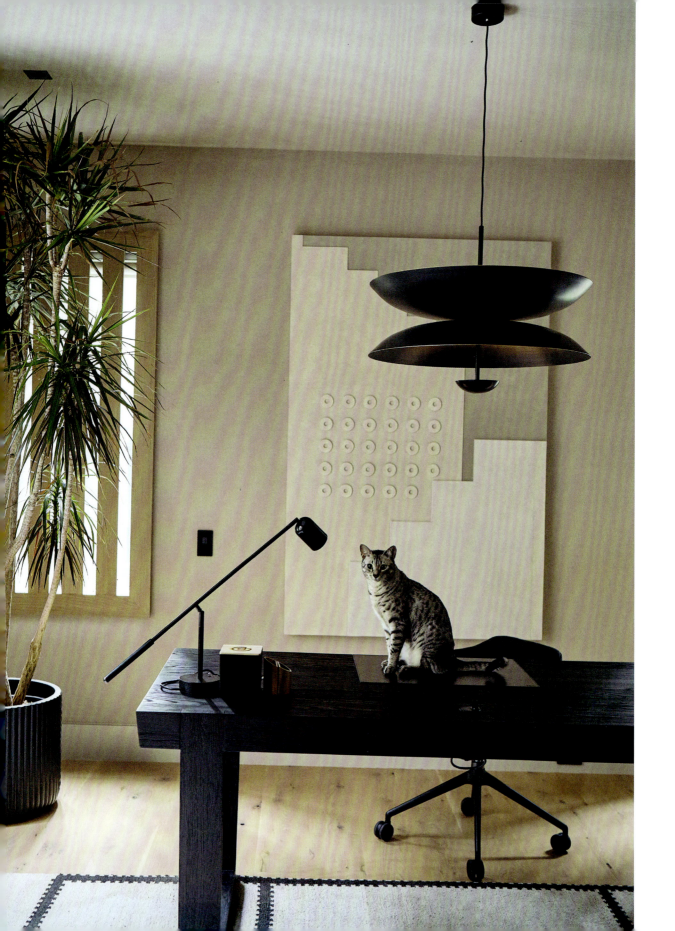

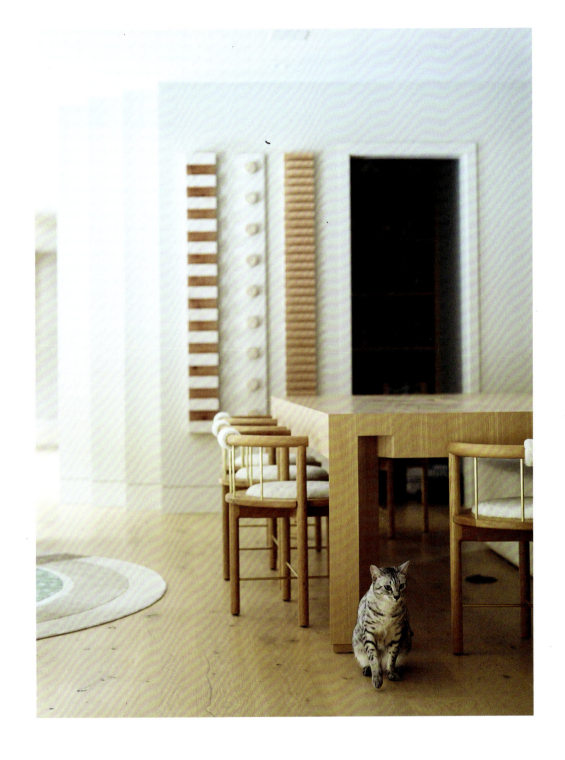

Despite the grandeur, the house has an almost Zen-like atmosphere. Another cat would be content to take it all in from the ultra-comfy furniture. Matsu is more interested in scratching it.

Q&A

DIVA OR DEVOTED FRIEND?
Diva with a capital ... well, every letter.

INTROVERT OR EXTROVERT?
Extrovert.

LAP CAT OR NOT?
Loves to cuddle but finds it hard to sit still.

OLD SOUL OR KITTEN AT HEART?
A little baby.

EXPLORER OR HOMEBODY?
Undecided, a bit of both.

LAZY OR ACTIVE?
Could play, literally, twenty-four hours a day.

DOGS – FRIEND OR FOE?
No strong feelings either way.

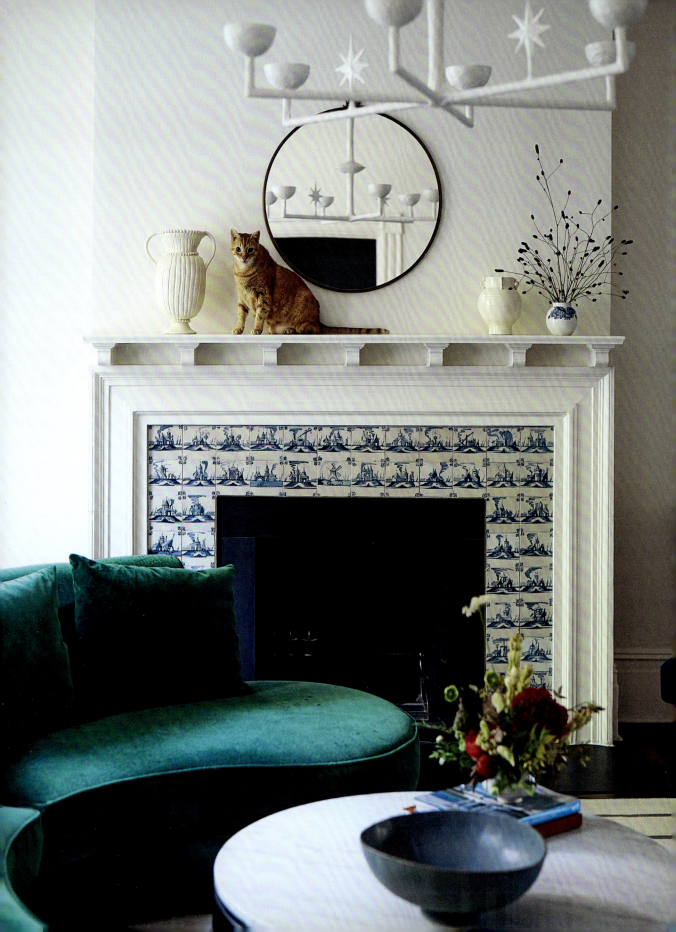

CAPTAIN REGINALD HENRY

INTERIOR DESIGNER: WHITE ARROW
LOCATION: BROOKLYN, NEW YORK

Captain Reginald Henry, aka Reggie, has a way of rolling with the punches. From babies being born to cat siblings lost to old age, the twelve-year-old orange tabby thought he might have seen it all – until a new puppy came in to test his nerves. Luckily, it is nothing a good nap on the main bed or a mouse hunt won't fix. With plenty of food and attention from his humans, Reggie has always found ways to navigate life with docility, devotion and just a hint of a New Yorker's neurosis.

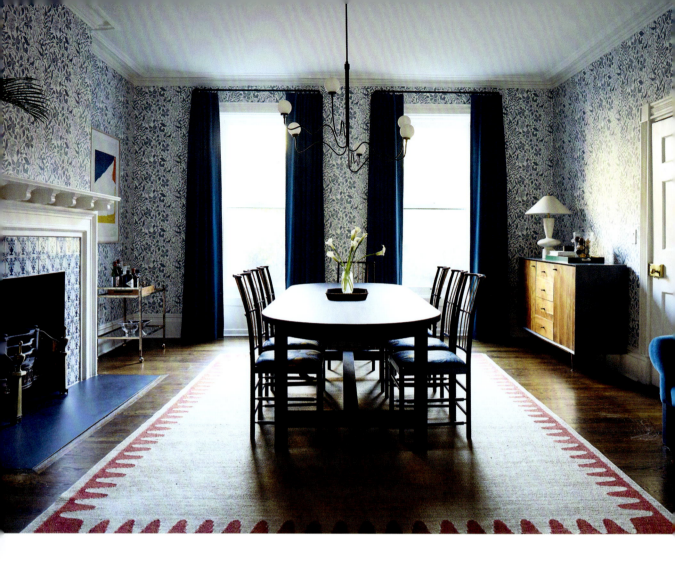

Reggie's home was built soon after the first ferry line between Manhattan and Brooklyn turned this countryside into the city's first suburb. Though nature has since become sparse, handmade Marthe Armitage wallpapering and exuberant Josef Frank textiles reference a bucolic past with a simultaneous nod to cosmopolitan sensibilities and sophistication. From room to room, the house transforms through an array of colours, shapes and materials, including handblown glass, ceramics and sculptural ironwork.

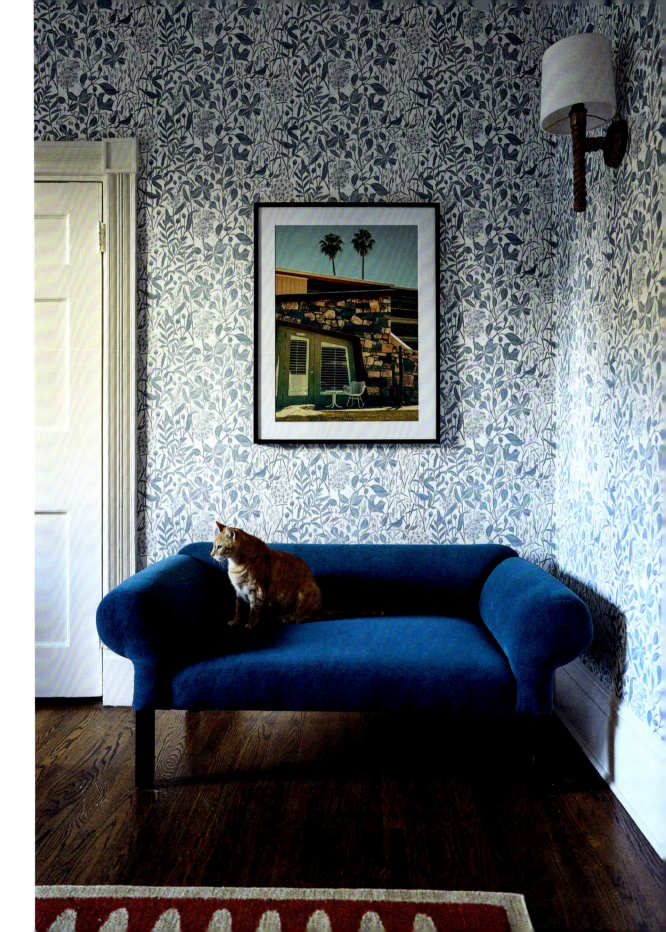

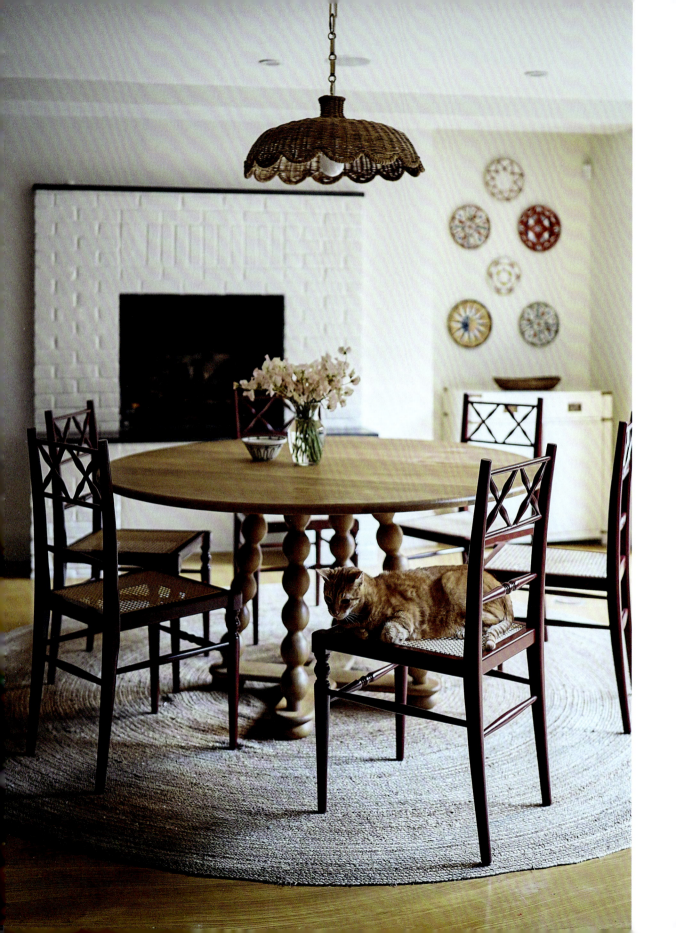

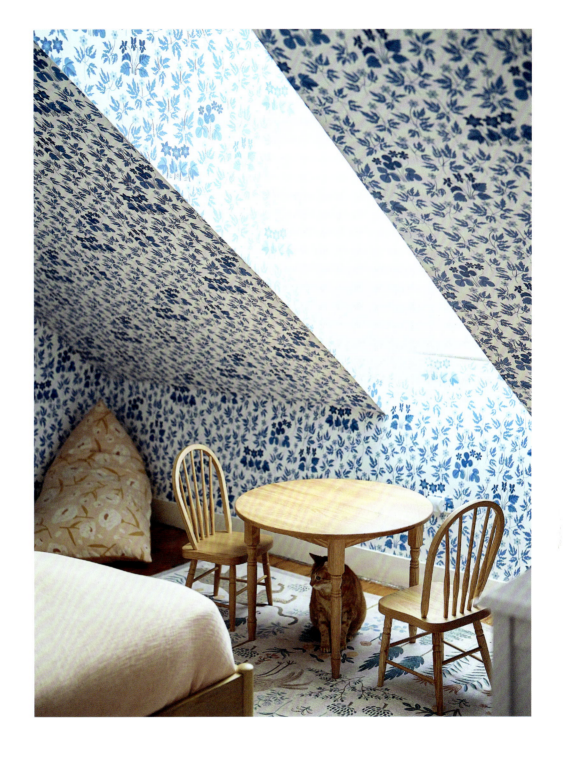

The moods and functions of the different spaces are held together by a pervading playfulness and a tendency for the cosy and practical. The thoughtful design accommodates without compromise, manoeuvring the demands of a growing family with equal measures of style and humour.

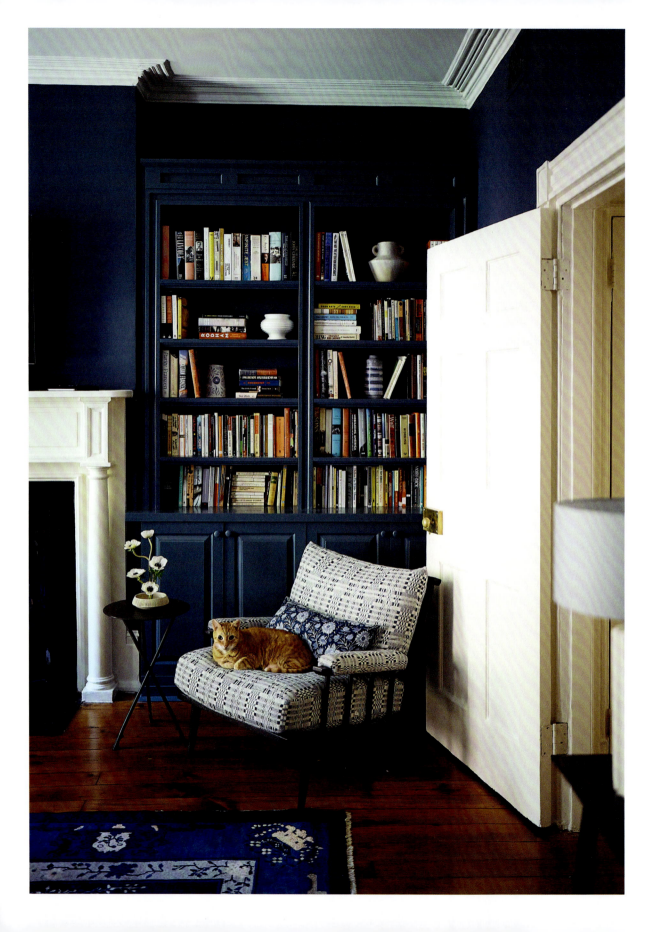

Q&A

DIVA OR DEVOTED FRIEND?
Devoted – and needy – friend.

INTROVERT OR EXTROVERT?
Introvert, until he's hungry.

LAP CAT OR NOT?
Lap cat and not, but more of the former.

OLD SOUL OR KITTEN AT HEART?
Old kitten.

EXPLORER OR HOMEBODY?
Homebody, despite the name, but he thinks of himself as an explorer whenever he dares to stick his nose outside.

LAZY OR ACTIVE?
Inspired by Garfield, he loves naps, food and teasing the dog.

DOGS – FRIEND OR FOE?
Has tallied three nose touches with the new dog.

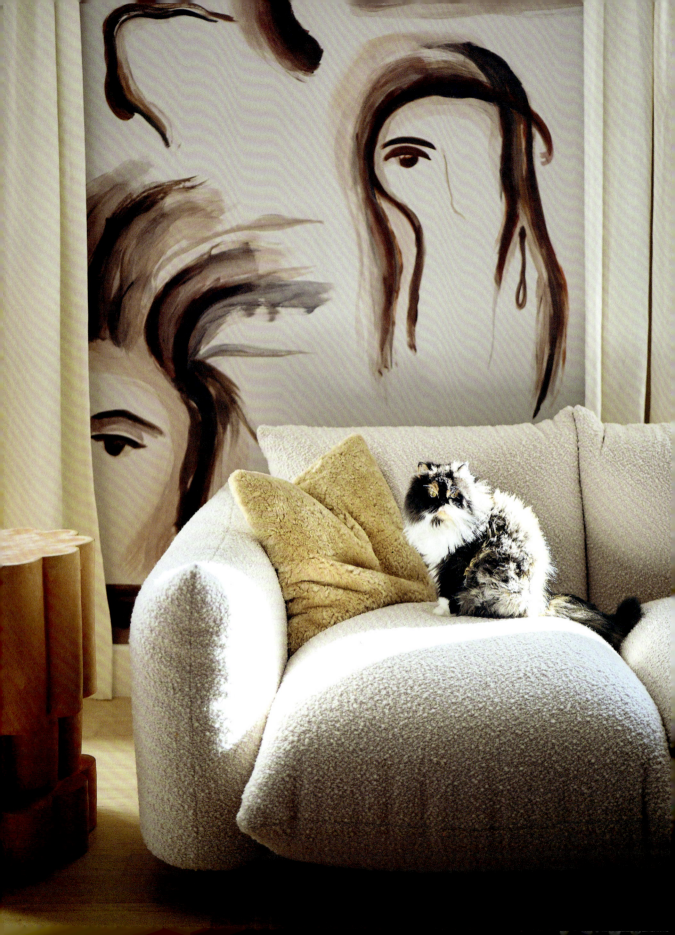

IRIE

INTERIOR DESIGNERS: RACHEL AND NICHOLAS COPE, OF CALICO WALLPAPER
LOCATION: BROOKLYN, NEW YORK

Irie was found roaming around New York City after Hurricane Irene, though it seems the turbulent start left no lasting impression on the eleven-year-old Persian calico. She is a peaceful companion, fond of sleeping, meditating by the window, observing her humans and languidly exploring her home. It is only at mealtime that Irie is quick to jump on the table and keep her family company, hoping for the occasional treat.

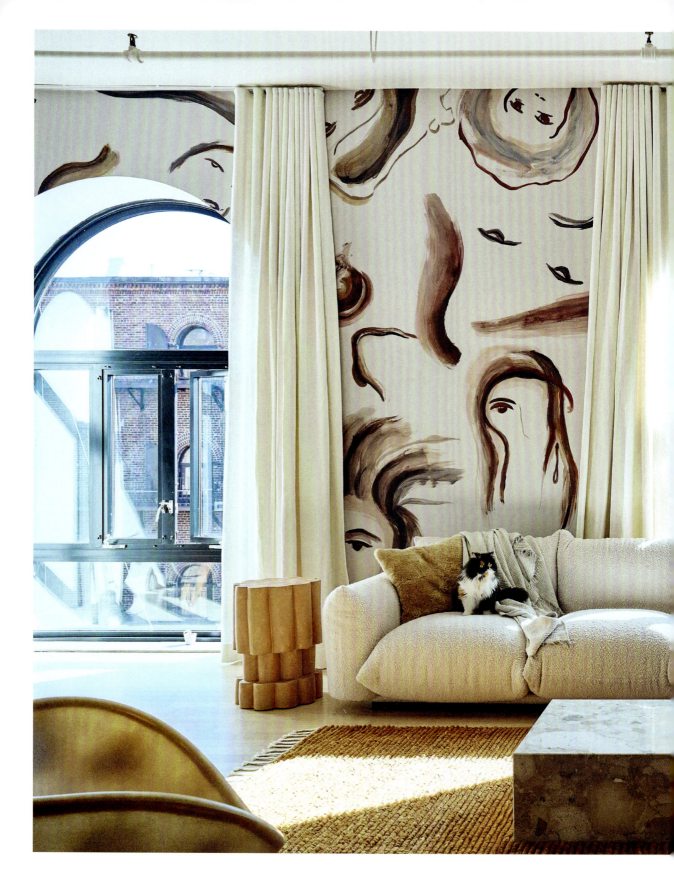

Interior designers: Rachel and Nicholas Cope, of Calico Wallpaper

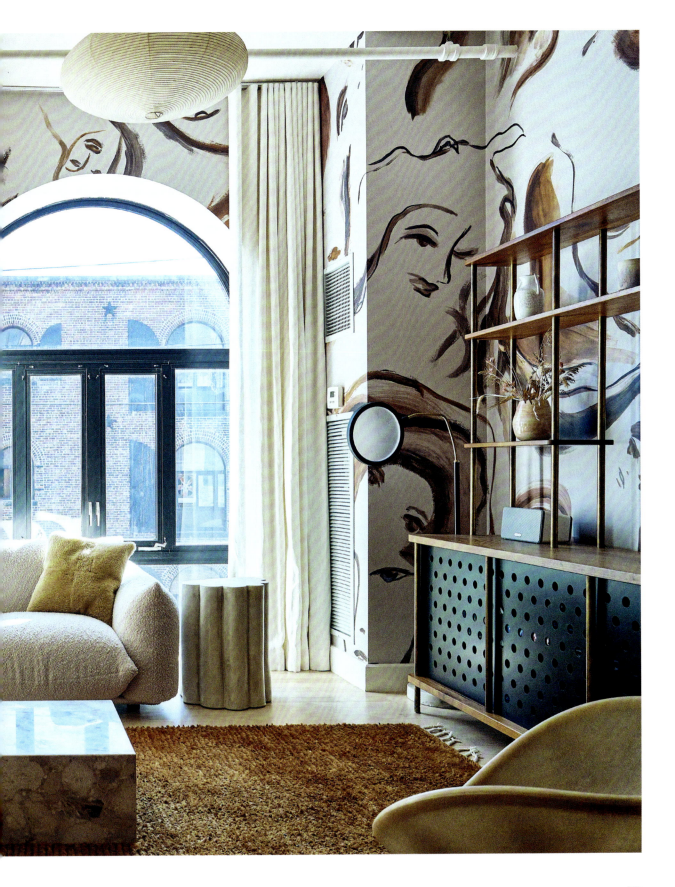

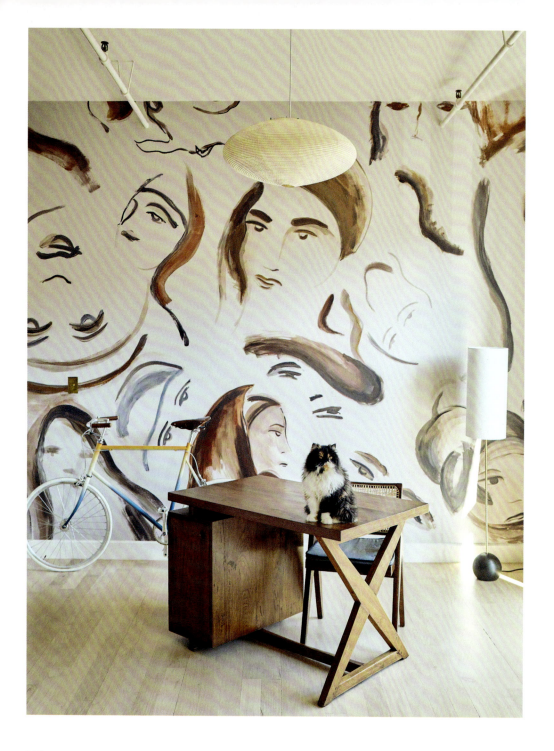

If her name came from a hurricane, Irie's colouring gave name to her owners' wallpaper company, Calico. Their hand-drawn designs take pride of place on the home's tall walls. Right by the water, the loft was once an industrial storage space for coffee beans. Little remains of those days, aside from a couple of original wooden beams, but the industrial structure has left behind an open floorplan that sets no boundaries for an unusual arrangement of design pieces – many by friends such as Piet Hein Eek.

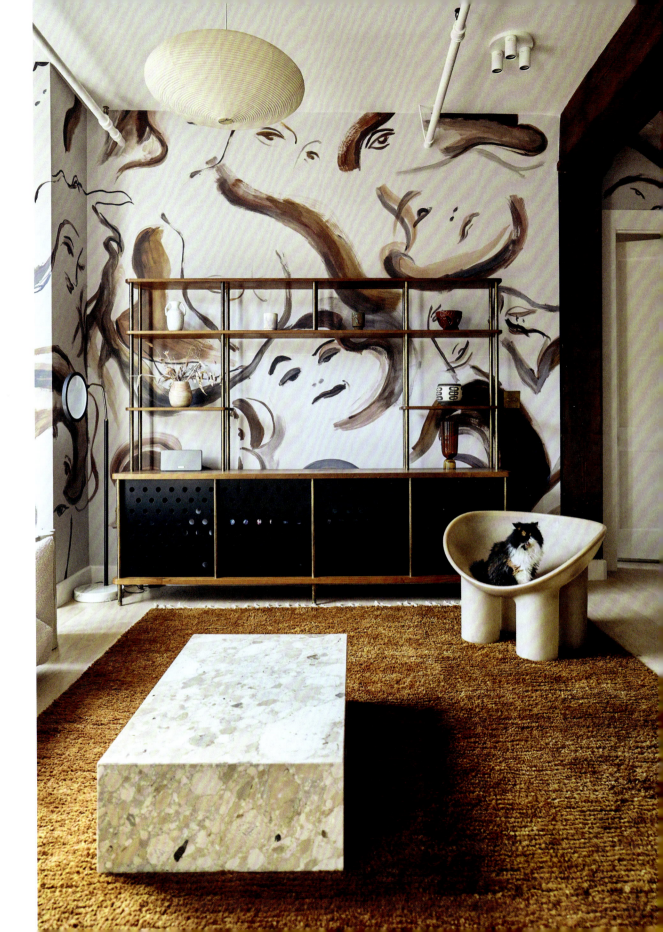

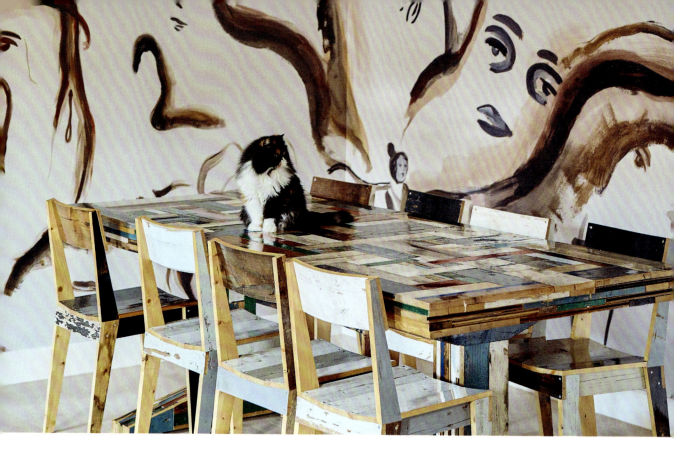

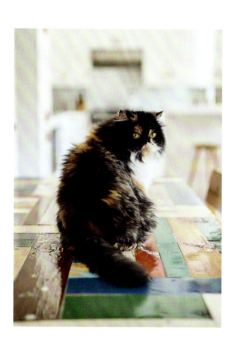

Interior designers: Rachel and Nicholas Cope, of Calico Wallpaper

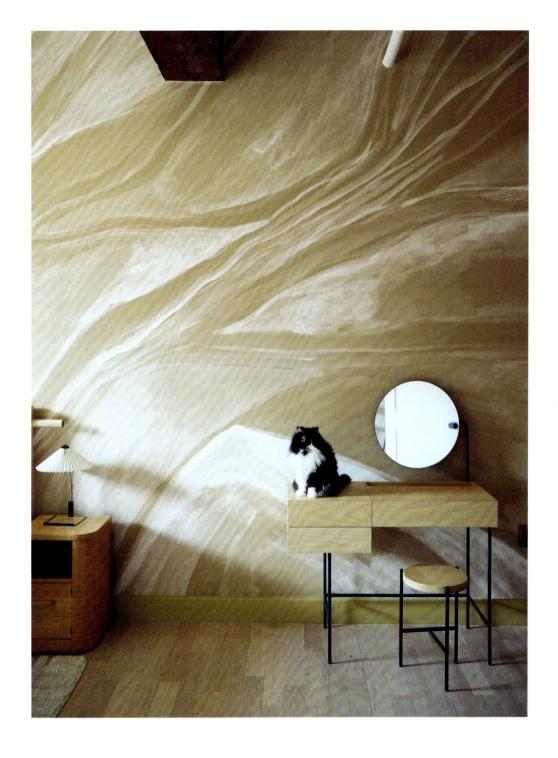

While splashes from more colourful elements add surprise and drama to the space, the home remains as tranquil as its cat – an airy and earthy space where work and family life harmoniously meet, inviting creativity and collaboration.

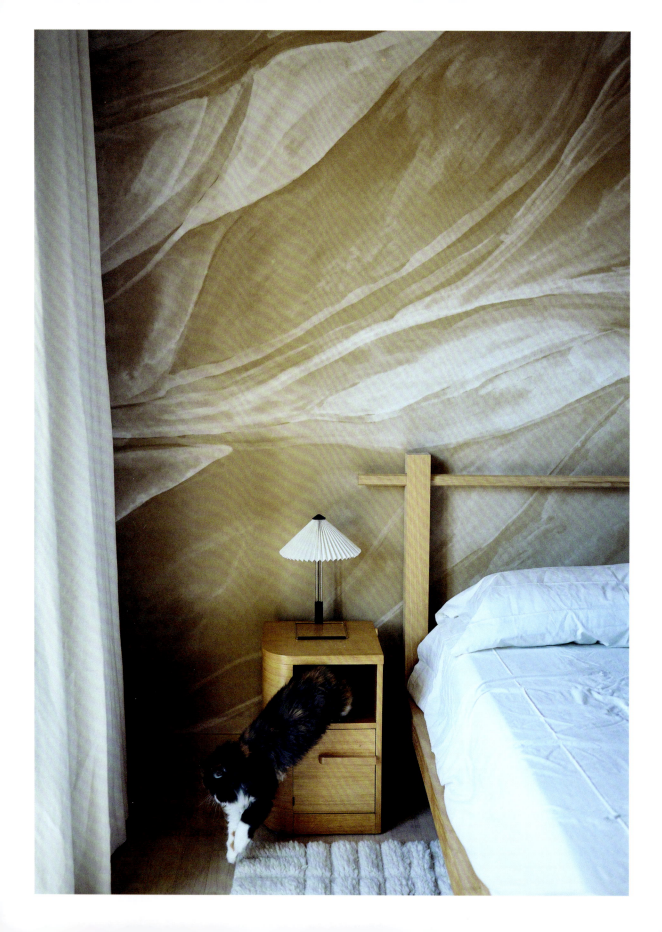

Q&A

DIVA OR DEVOTED FRIEND?
A bit of both.

INTROVERT OR EXTROVERT?
Introvert.

LAP CAT OR NOT?
Not. She sits close by, on her own chair.

OLD SOUL OR KITTEN AT HEART?
Kitten at heart, but a peaceful kitten.

EXPLORER OR HOMEBODY?
Homebody.

LAZY OR ACTIVE?
Very lazy, but her playful side shows every now and then.

DOGS – FRIEND OR FOE?
Foe.

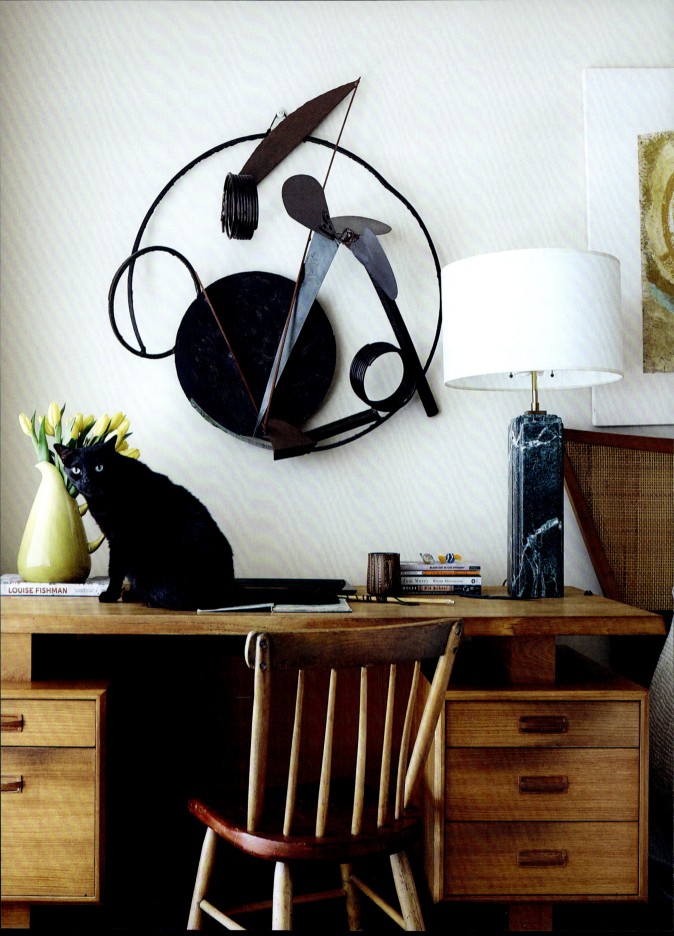

DEL FERBER, HOLLY GO LIGHTLY AND FRED BABY

ARCHITECT: JAMES TIMBERLAKE | INTERIOR DESIGNER: MARGUERITE RODGERS
LOCATION: PHILADELPHIA, PENNSYLVANIA

Once four separate units, this penthouse flat has plenty of room for a triad of cats to disperse. While thirteen-year-old Del Ferber is most often found in a box above the stove, three-year-old Holly Go Lightly has made the main bedroom her own. Fred Baby, also three, has no defined territory and can be spotted zooming between all corners of the apartment, hiding under beds or in any box he happens to find. Each cat has a distinctive favourite vice: Del Ferber loves his well-worn toys and sliced turkey for a treat; Fred Baby prefers fish, especially albacore; and Holly has little time for eating, favouring instead an intense regimen of toy-mouse hunting.

Architect: James Timberlake | Interior designer: Marguerite Rodgers

DEL FERBER, HOLLY GO LIGHTLY AND FRED BABY

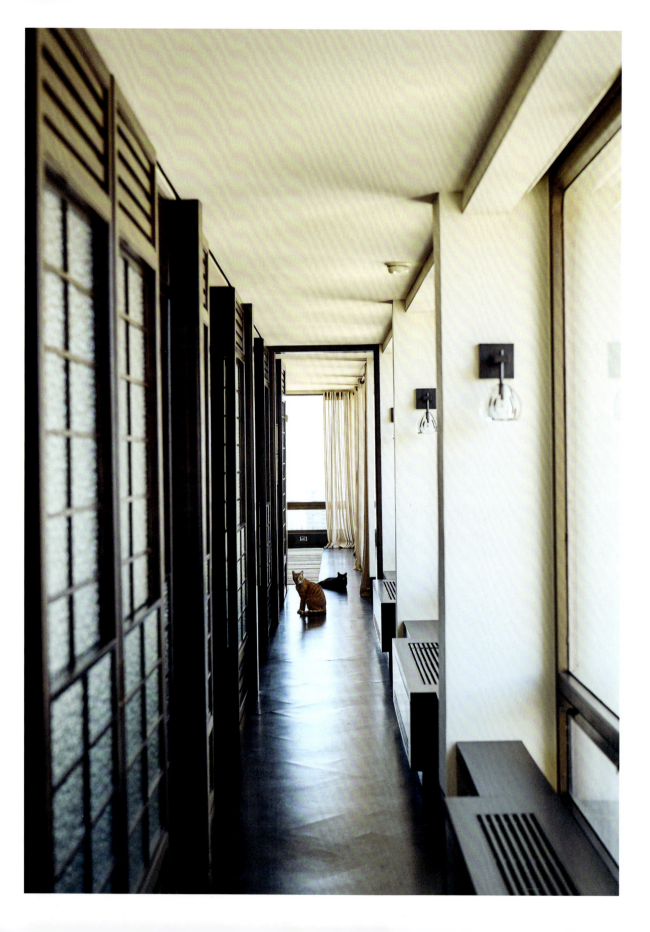

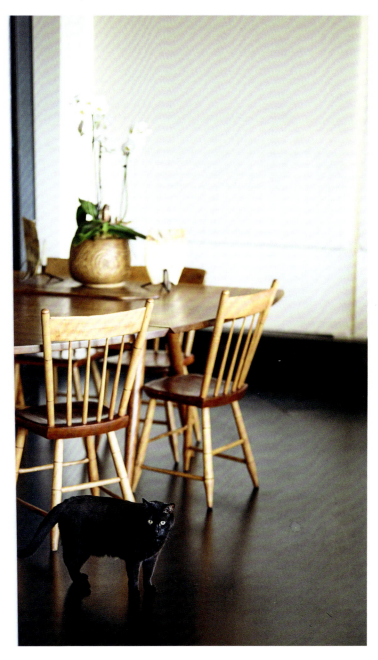

The cats' home soars above downtown Philadelphia, on the thirty-first floor of a newly renovated, iconic I. M. Pei condominium. One long hallway leads into the different rooms through Asian-inspired glass and wood sliding doors. For the felines, this is the ideal racetrack on which to chase their owners, each other and the occasional bird flying outside the hallway's large windows. The abundance of light of Pei's core-and-shell architecture goes hand in hand with a contemporary, Chinese-influenced design that seeks to blend indoor and outdoor. A large and varied art collection complements the 360-degree views, which include landmarks such as Independence Hall and the Liberty Bell.

DEL FERBER, HOLLY GO LIGHTLY AND FRED BABY

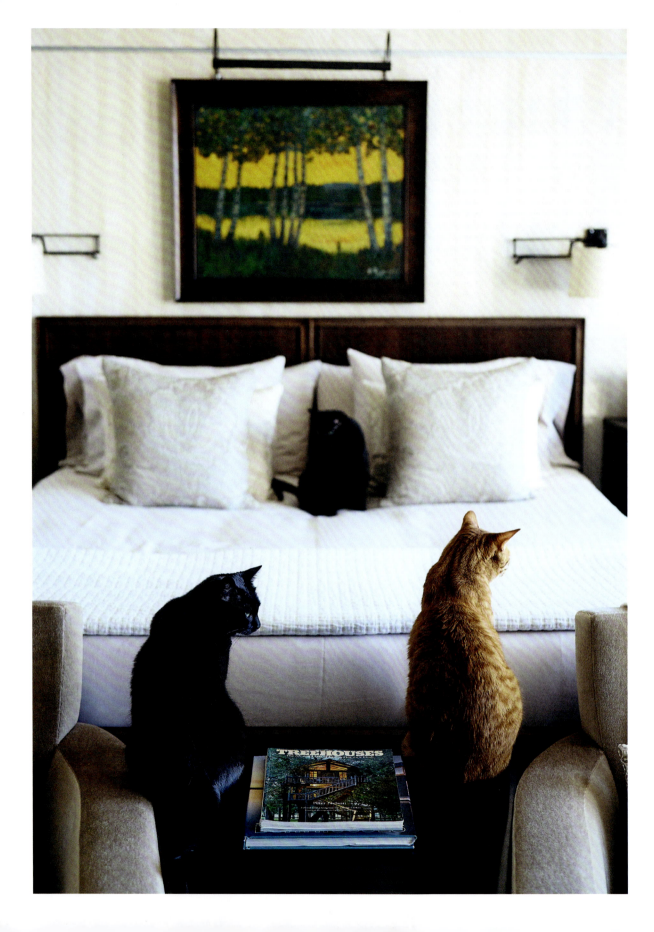

Q&A

DIVA OR DEVOTED FRIEND?
The three are devoted friends, although Fred Baby has picked a favourite human.

INTROVERT OR EXTROVERT?
All extroverts, but Del Ferber has little use for other humans when his owners are around.

LAP CAT OR NOT?
Holly avoids laps but lies on top of her owners at night. Del Ferber and Fred Baby are lappers.

OLD SOUL OR KITTEN AT HEART?
Del Ferber is, understandably, an old soul. The others are kittens at heart.

EXPLORER OR HOMEBODY?
Only Fred Baby is a homebody.

LAZY OR ACTIVE?
Holly Go Lightly alone is active, but Del Ferber used to be in his youth.

DOGS – FRIEND OR FOE?
All foes.

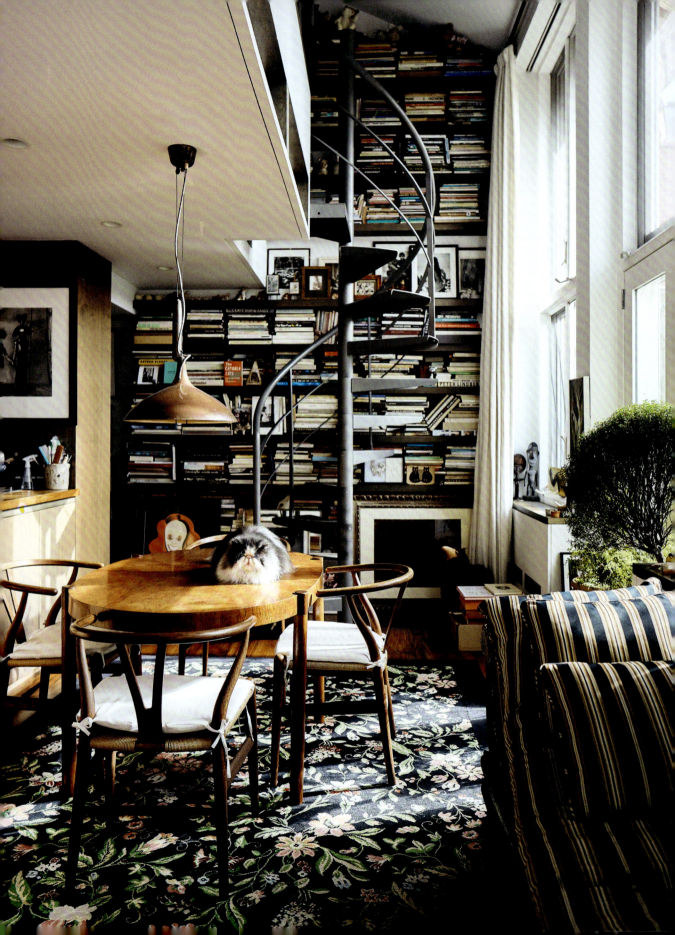

BLANKET, JIMI AND BLONDIE

ARCHITECT: BRAD FLOYD
LOCATION: CHELSEA, NEW YORK

Boasting his own Louis Vuitton line, Blanket is unmatched in the feline world. With a celebrity owner whose illustrations of him have appeared in articles, magazines and books and on fashion accessories, this six-year-old puss is no stranger to the limelight. His siblings, Jimi and Blondie (two pandemic babies), are picking up the modelling trade too, which starts with being very, *very* laid back. The trio have the whims of any star, like their makeshift sauna in a bit of shelf space by the humidifier and a lush green New York balcony with the occasional bird to hunt down.

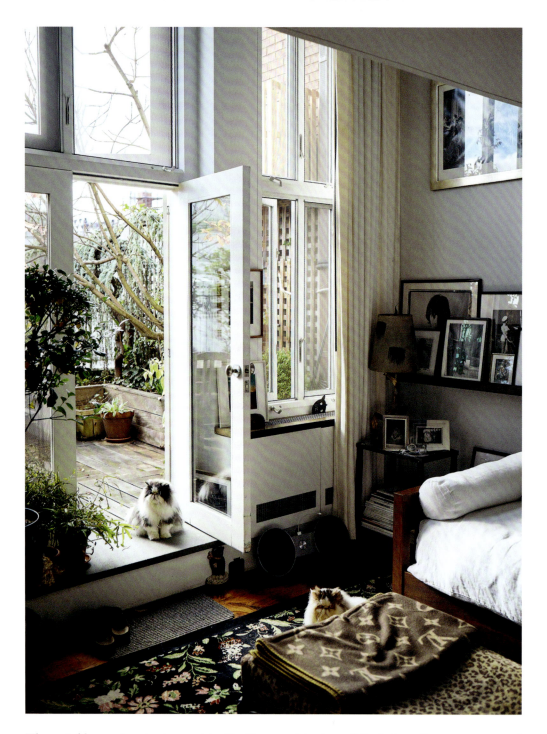

The cats' home is a testament to the lives and tastes of their two famous owners, but all its shelves cannot hold their incredible collection of books, photos and artifacts that fight for space on surfaces, in piles on the floor and in an entire second home. To counter the clutter, the loft's internal divisions were removed, resulting in a space so intimate it almost feels like an extension of the connected second-floor bedroom. The exterior wall was redone with glass panes that let in plenty of light, while the vegetation on and off the balcony keeps the hubbub of the city away.

Architect: Brad Floyd

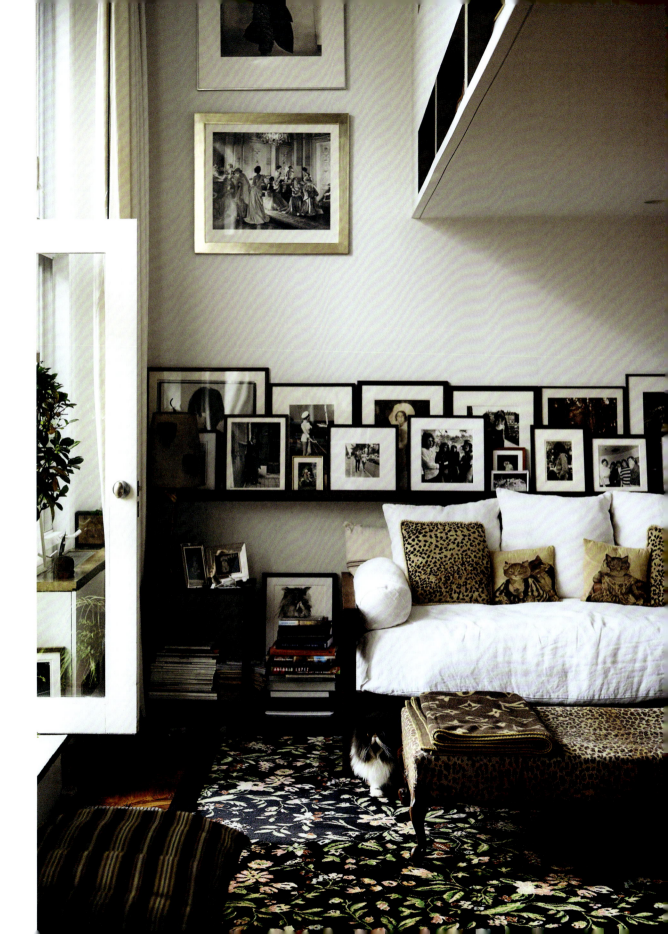

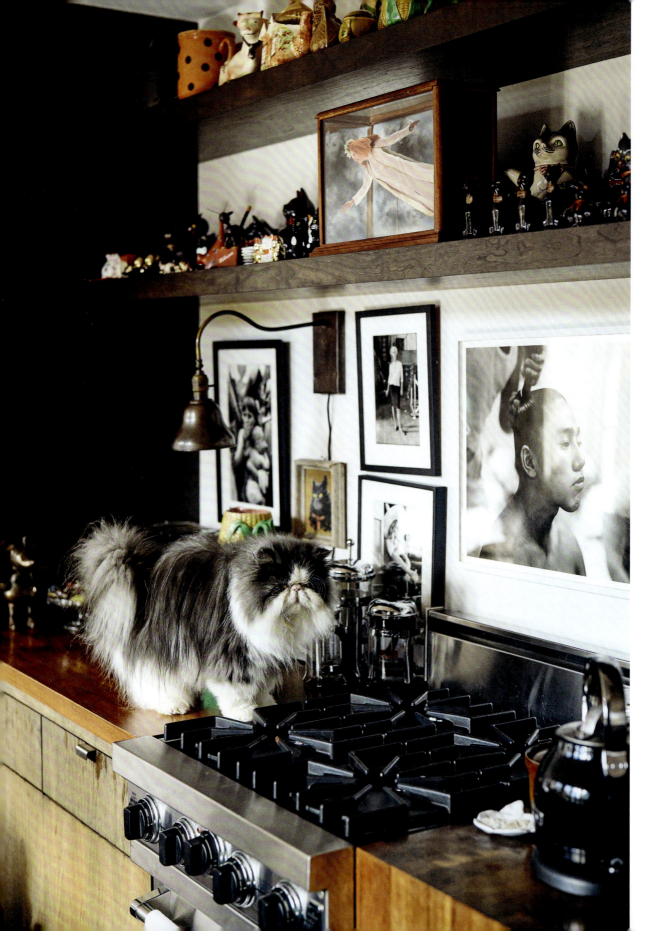

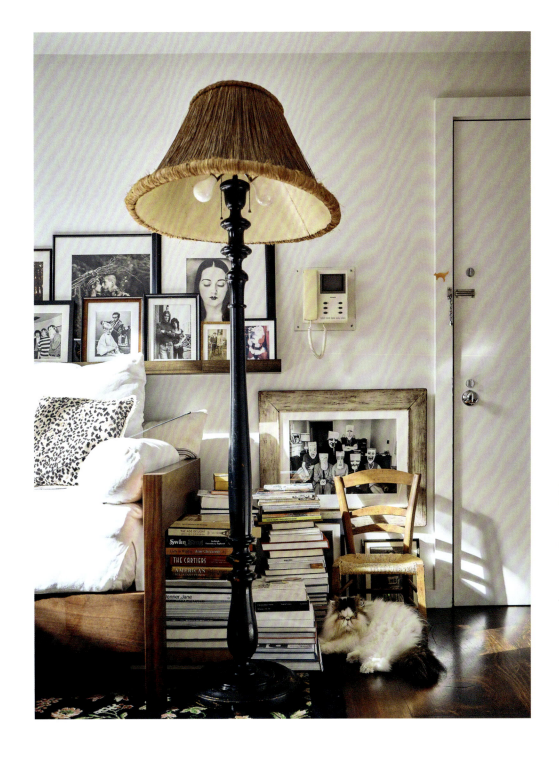

Of course, the cosiness would not be complete without the cats, and they are celebrated in pictures, pillows and figurines in every corner of the home.

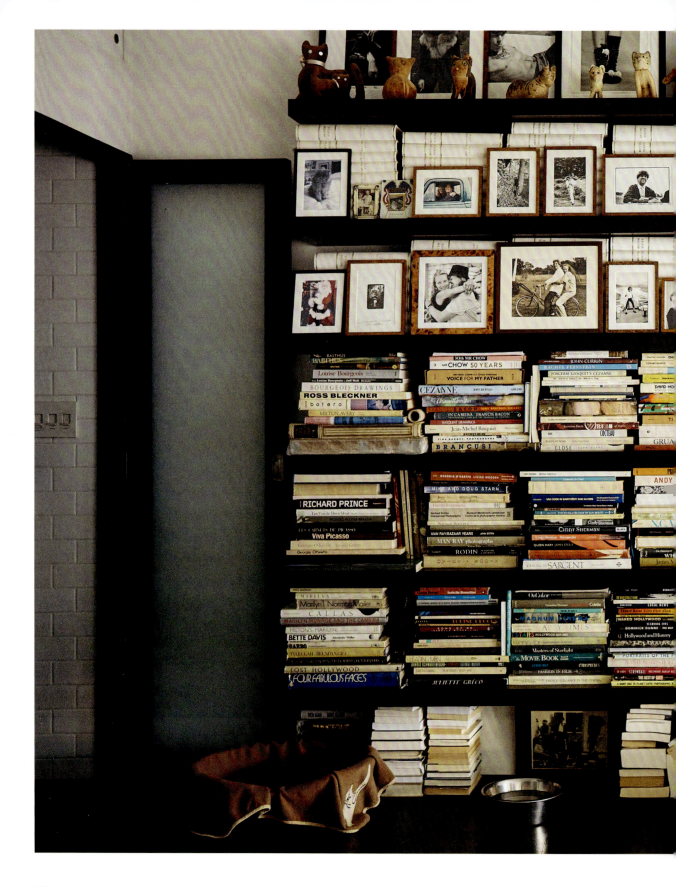

Architect: Brad Floyd

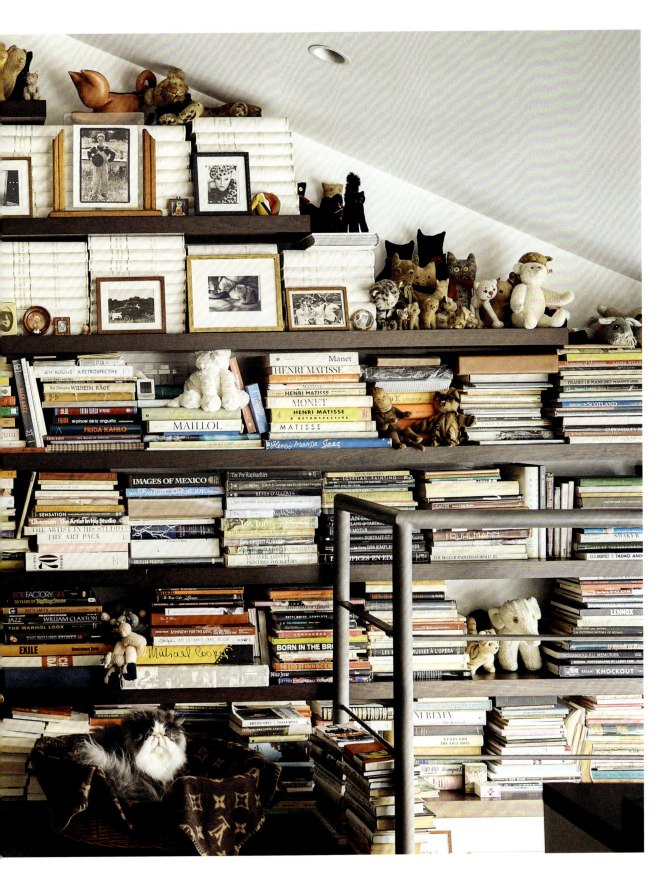

BLANKET, JIMI AND BLONDIE

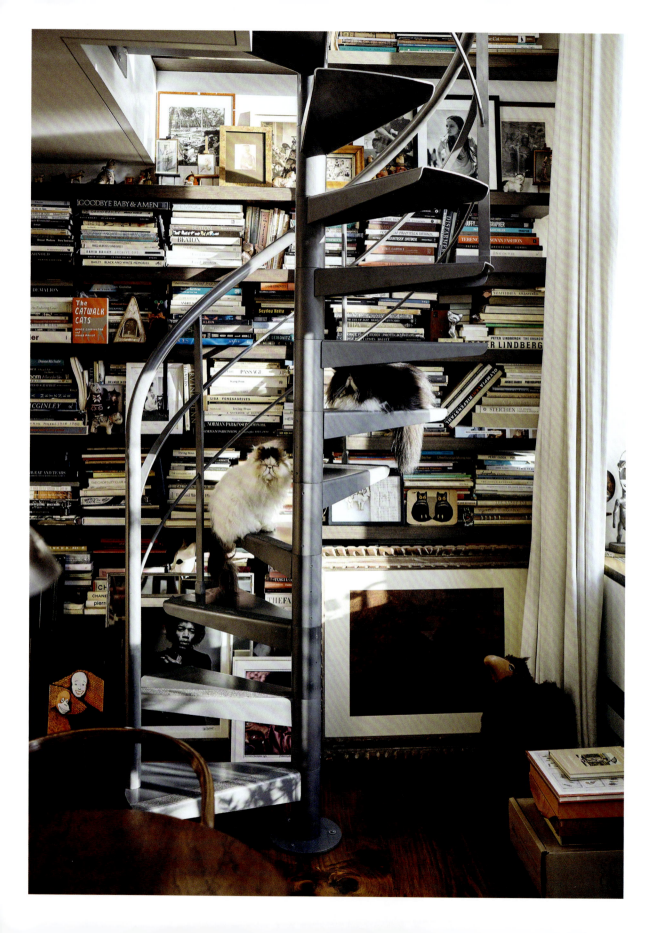

Q&A

DIVA OR DEVOTED FRIEND?
Blanket has mellowed but Blondie is still very much a diva. Jimi is more concerned with having fun.

INTROVERT OR EXTROVERT?
Introverts.

LAP CAT OR NOT?
Not really, but Blanket will jump onto a lap as soon as there is a newspaper on it – his reasons are a mystery.

OLD SOUL OR KITTEN AT HEART?
The boys are old souls, not so Blondie.

EXPLORER OR HOMEBODY?
Explorers. They like running into the outside hallway and waiting by the door of their dog neighbour.

LAZY OR ACTIVE?
Lazy, but Blondie does not walk, she only runs.

DOGS – FRIEND OR FOE?
They tolerate them but have never come nose to nose.

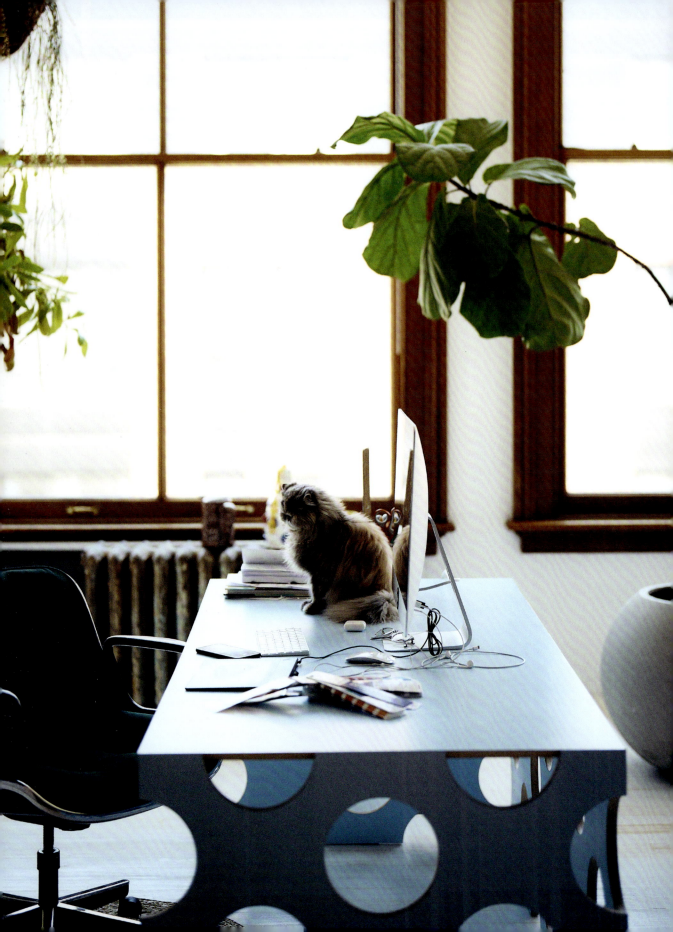

PINOT

ARCHITECT: NEW AFFILIATES
LOCATION: BROOKLYN, NEW YORK

Pinot would be scandalised to be called somebody's pet. She is a misanthropic flatmate whose favourite hangout spot is wherever she will be left alone – including, as needed, the bathroom. The sixteen-year-old Persian mix has toughened over the years, but she knows where her love is needed and greets her owners at the door daily with a deep affection hiding just under her standoffishness.

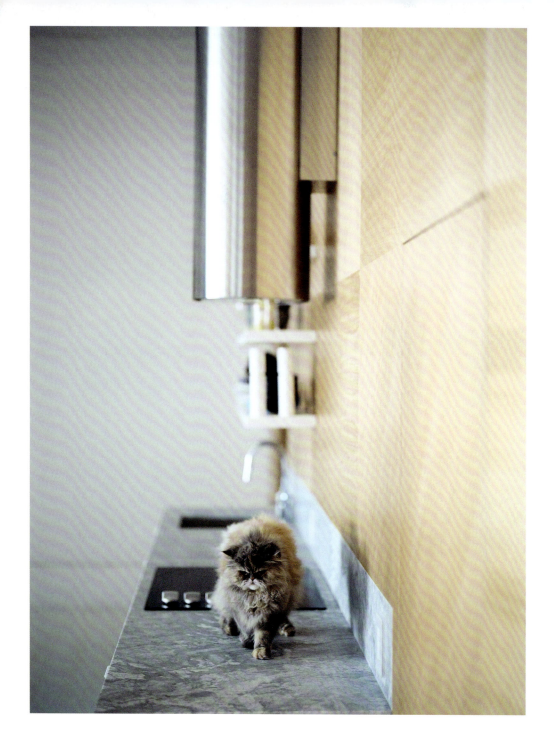

Pinot's home was once the rug section of a 1920s department store and a lighting factory before it was converted into a co-op. Her owners chose to embrace the open floorplan and the space's mercuriality through eclectic and minimalist furniture in constant rearrangement. Leaning more heavily on late 20th-century Italian design these days, the home can change as quickly as its cat's mood. The only constant is the cynical gaze of Darcel Disappoints, a pop-art creation of Pinot's artist owners that watches with judgement in prints around the home.

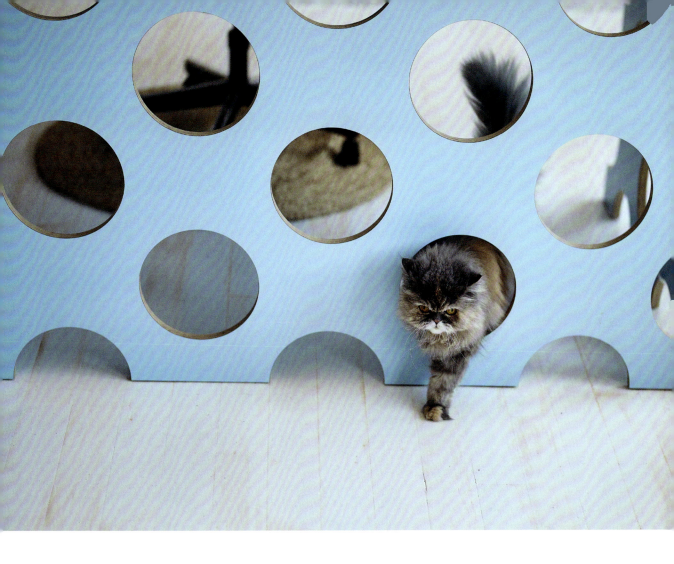

As for the reclusive Pinot, the space's large, unobstructed windows, inherited from its industrial and commercial past, are the perfect vitrine in which to examine – with a feigned disinterest – the lives of the neighbouring pets.

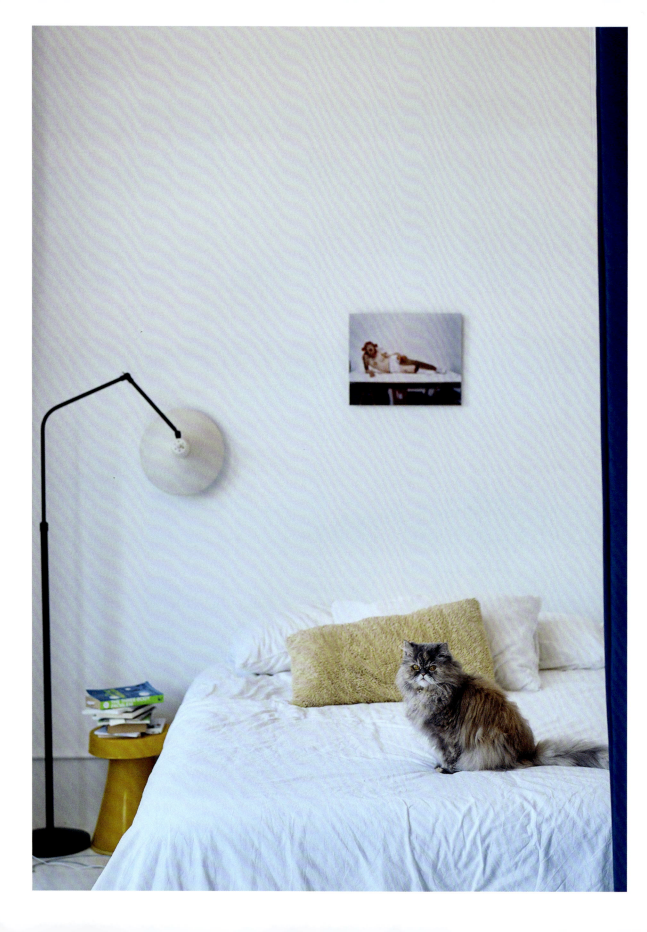

Q&A

DIVA OR DEVOTED FRIEND?
Total diva.

INTROVERT OR EXTROVERT?
Introvert.

LAP CAT OR NOT?
If there were no other place in the world to sit, still not.

OLD SOUL OR KITTEN AT HEART?
Ancient soul.

EXPLORER OR HOMEBODY?
Homebody.

LAZY OR ACTIVE?
As lazy as it gets.

DOGS – FRIEND OR FOE?
Bitter enemy.

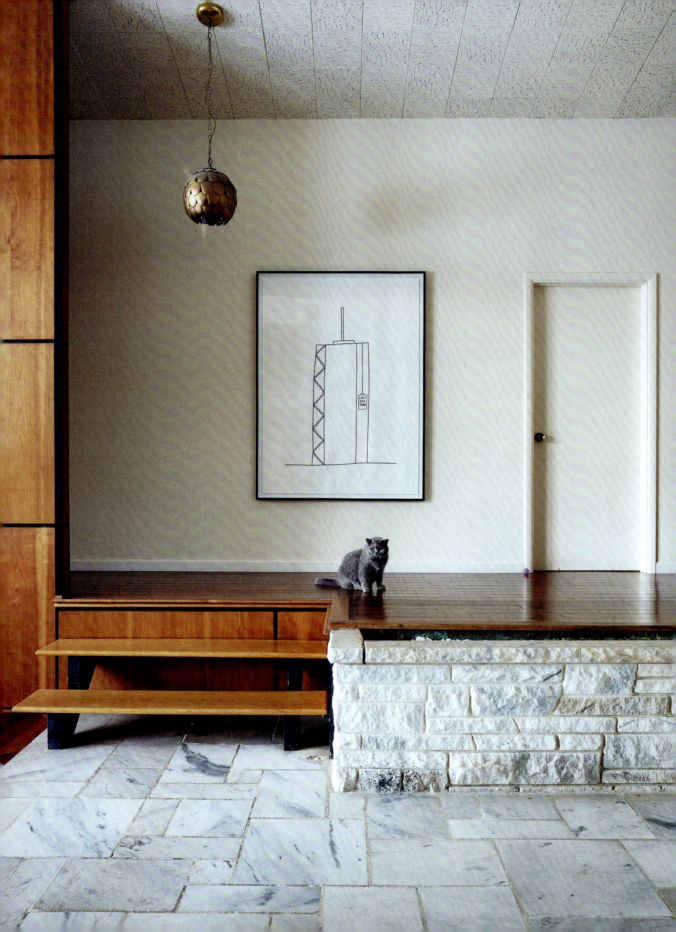

WHALE AND ELEPHANT

LOCATION: KERHONKSON, NEW YORK

Whale and Elephant are two old souls with a routine as precise as a Swiss clock's engine. The thirteen- and fifteen-year-old British shorthairs rouse their owner at 6.30 am on the dot, only to take over the bed and spend another day in strict retirement mode. After lazily watching the birds in the state park outside or lying on the speaker system now fully converted into a cat bed, the pair are happy to use any leftover energy to move over to the couch by the fireplace for a perfect wintery tableau vivant. Then back to bed, where the cats can shed up to their bodyweight in hair, necessitating an almost daily switching of sheets.

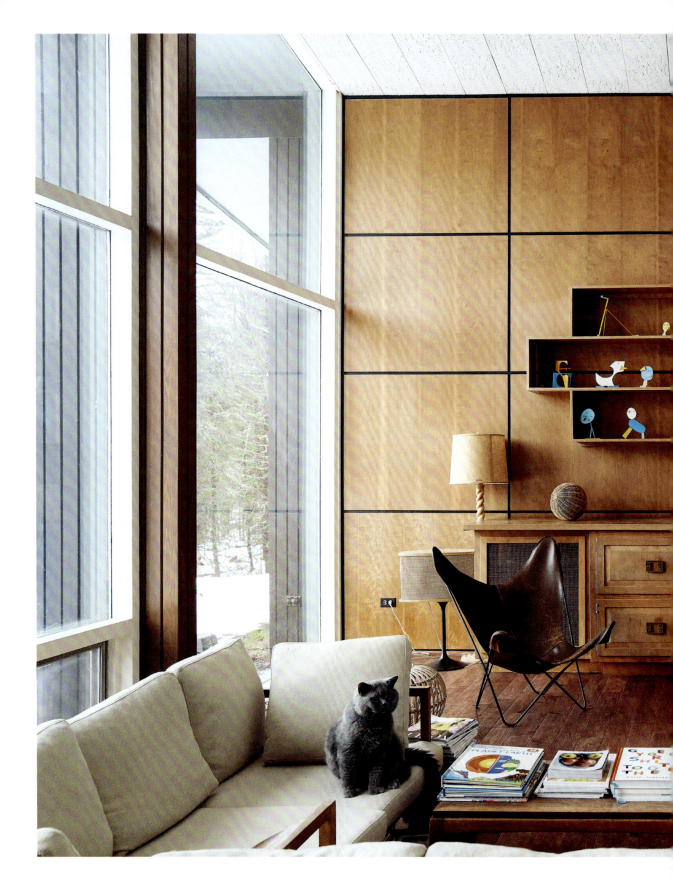

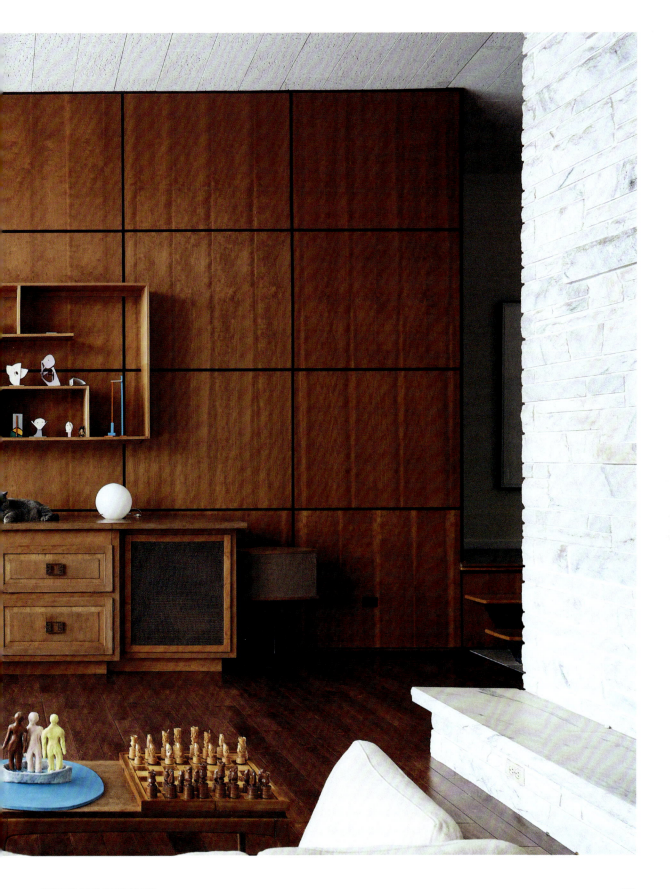

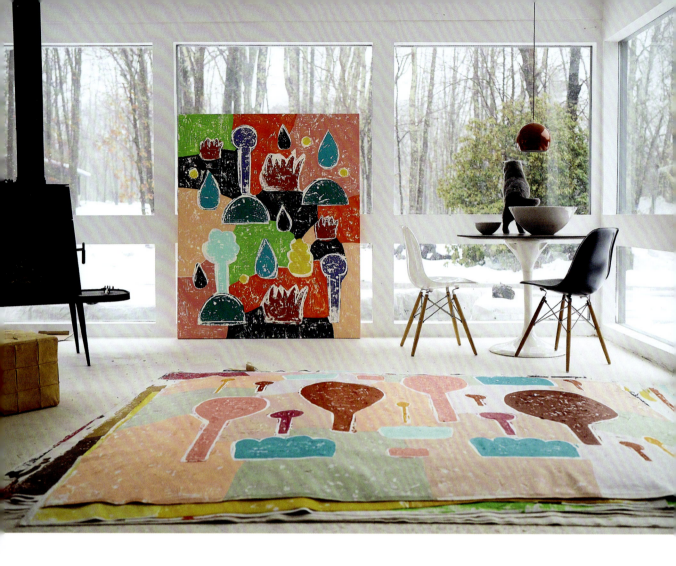

The cats live in a 1959 upstate New York home that feels like a time capsule of mid-century architecture and design, with most of its features still intact. Large windows offer extraordinary nature views that change from season to season, topped off by the Catskill Escarpment in the horizon. Marble, glass and wood mix a penchant for natural materials with brilliant colour that helps animate the very generous rooms. Colour is also central to the work of the cats' artist owner, which is displayed throughout the house.

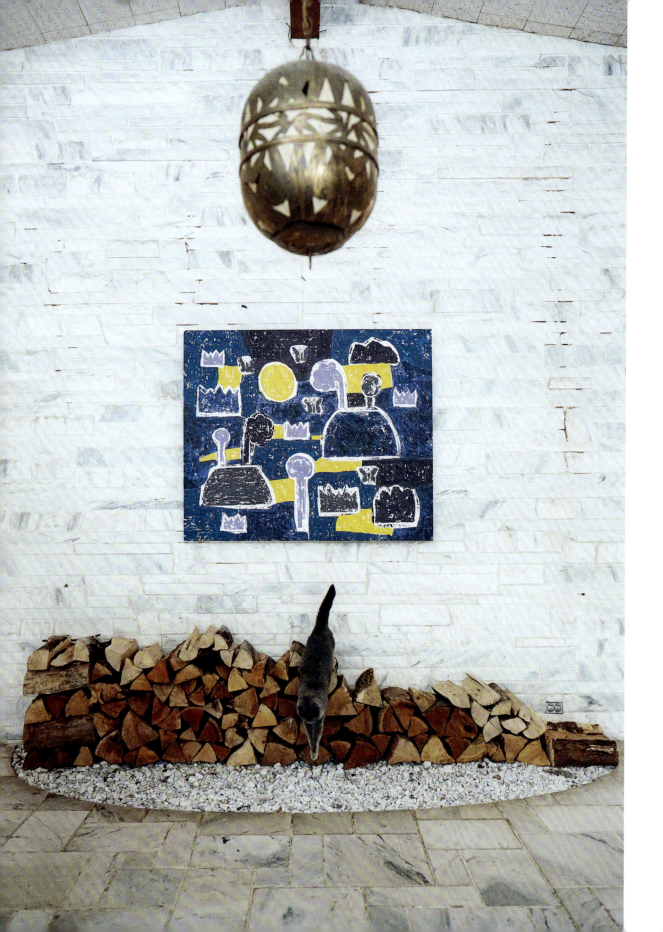

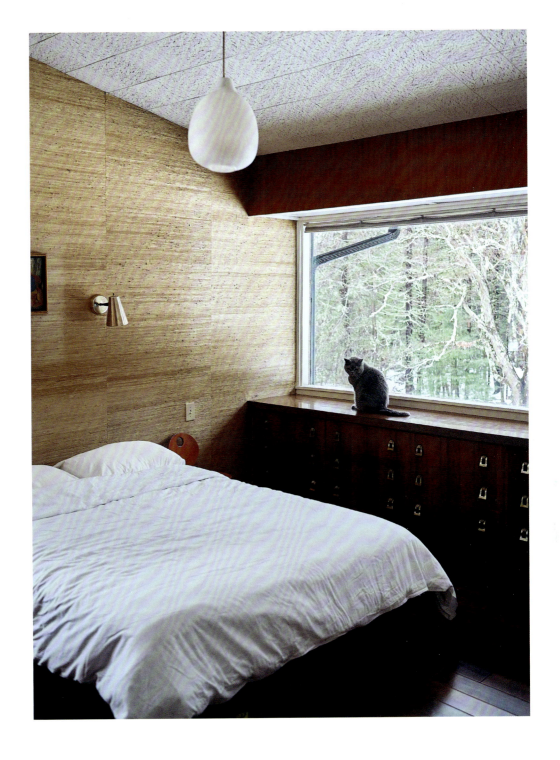

There is something about Whale and Elephant's breed that fits perfectly with their home's unassuming style. They are at times like a moving piece of furniture – that is, of course, if they can be bothered to move at all.

Q&A

DIVA OR DEVOTED FRIEND?
Divas.

INTROVERT OR EXTROVERT?
One extrovert, one introvert.

LAP CAT OR NOT?
Not, but they snuggle close by.

OLD SOUL OR KITTEN AT HEART?
Old souls from the cradle.

EXPLORER OR HOMEBODY?
Homebodies.

LAZY OR ACTIVE?
Any lazier, they would be statues.

DOGS – FRIEND OR FOE?
Foe.

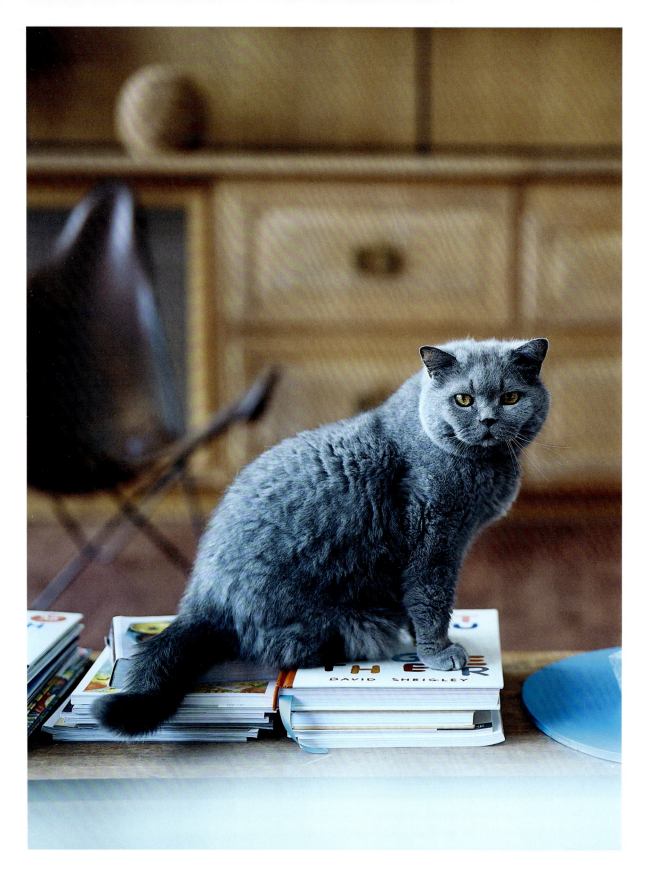

ACKNOWLEDGEMENTS

When it comes to creating any layered project, I always think of the people who have helped to make it happen. Without the support and hard work of so many, this book would not exist.

That's why I want to extend a very big thank you to all those who have played a role in making this project possible. From the writers to the editors, the designers to the printers, and everyone in between – your hard work, creativity and dedication have made this project a reality. For that, I am truly grateful.

I'm especially grateful to those who have allowed me to photograph their homes and their beloved cats, as these images form the heart and soul of the book. So, to all the homeowners and feline friends who have shared their space and their lives with me, thank you for your generosity and trust.

Barrett Hanharan at Lindsey Adelman Studio, Michael Nicolaci, Jason Laan, Queenie Chan, AeLi Park, Jenny Nguyen, Benedikt Josef, Blair Brindley and Cailin Shannon-Wunder played an outsized role in helping the book be what it is! Extra shout outs to Molly Bates, Nicole Fuller, Jane Garmey, Julio Salcedo, Timothy Godbold, Bianca Jafari, Paulina de Laveaux, Evi O + Studio and Rafael Waack.

First published in Australia in 2023
by Thames & Hudson Australia Pty Ltd
11 Central Boulevard, Portside Business Park
Port Melbourne, Naarm 3207
ABN: 72 004 751 964

First published in the United States of America in 2024
by Thames & Hudson Inc.
500 Fifth Avenue
New York, New York 10110

House Cat © Thames & Hudson Australia 2023
Text © Paul Barbera with Rafael Waack
Images © Paul Barbera

26 25 24 23 5 4 3 2 1

The moral right of the author has been asserted.

All rights reserved. No part of this publication may be reproduced or transmitted in any form or by any means, electronic or mechanical, including photocopy, recording or any other information storage or retrieval system, without prior permission in writing from the publisher.

Any copy of this book issued by the publisher is sold subject to the condition that it shall not by way of trade or otherwise be lent, resold, hired out or otherwise circulated without the publisher's prior consent in any form or binding or cover other than that in which it is published and without a similar condition including these words being imposed on a subsequent purchaser.

Thames & Hudson Australia wishes to acknowledge that Aboriginal and Torres Strait Islander people are the first storytellers of this nation and the traditional custodians of the land on which we live and work. We acknowledge their continuing culture and pay respect to Elders past, present and future.

ISBN 978-1-760-76300-8
ISBN 978-1-760-76403-6 (US Edition)

 A catalogue record for this book is available from the National Library of Australia

Library of Congress Control Number 2023935652

Every effort has been made to trace accurate ownership of copyrighted text and visual materials used in this book. Errors or omissions will be corrected in subsequent editions, provided notification is sent to the publisher.

Front cover: Gary and Gunnar
Interior designer: Kelly Behun
Back cover: Matsu
Interior designer: Timothy Godbold
Photography: Paul Barbera

Design: Evi-O.Studio | Evi O.
Illustration: Evi-O.Studio | Katherine Zhang
Typesetting: Evi-O.Studio | Siena Zadro
Editing: Bianca Jafari and Rachel Carter
Printed and bound in China by C&C Offset Printing Co., Ltd

FSC® is dedicated to the promotion of responsible forest management worldwide. This book is made of material from FSC®-certified forests and other controlled sources.

Be the first to know about our new releases, exclusive content and author events by visiting
thamesandhudson.com.au
thamesandhudsonusa.com
thamesandhudson.com

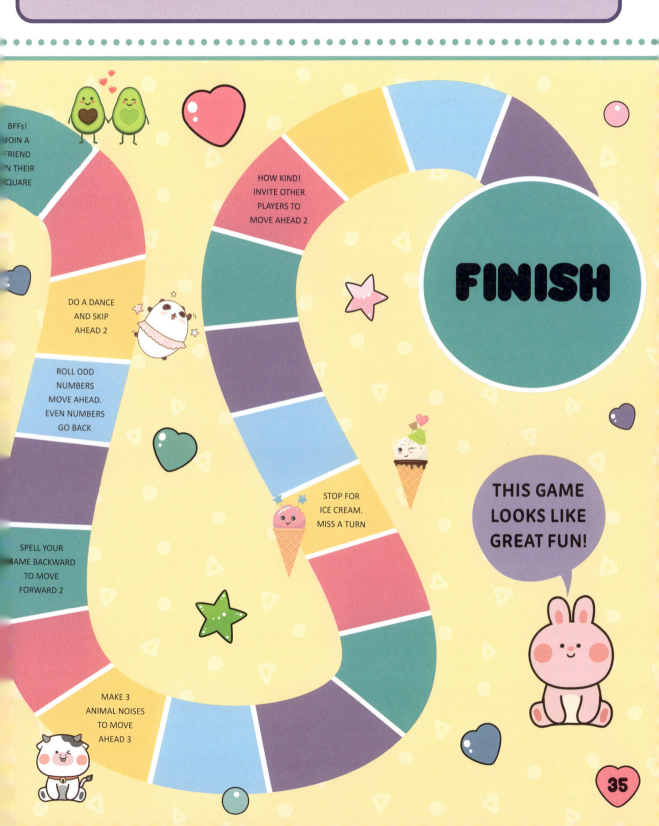

SKETCHING SNACKS

Follow the steps to draw these delicious doodles.
Trace them in pencil first, then use pen when you have the final shape.
Finally, color them in!

ICE CREAM

1 First draw a triangle with a circle on top.

2 Add a cute face and criss-cross to the waffle cone.

NOW IT'S YOUR TURN!

STRAWBERRY

1 Start with a heart shape and cover the top with your leaves.

2 Then add a stalk, a face, and little dots for pips.

NOW IT'S YOUR TURN!

CUPCAKE

1 First draw a rectangle with an egg shape on top.

2 Add a cute heart topper, face, and sprinkles.

NOW IT'S YOUR TURN!

WATERMELON

1 First draw a triangle with rounded edges.

2 Then add extra lines to the bottom edge for the rind, a face, and some seeds.

NOW IT'S YOUR TURN!

I LOVED THE TIME WE ...

MY MOST FUN DAY WAS WHEN I ...

PERFECT MOMENTS

There's nothing sweeter than looking back at your happiest days.
Draw your best memories in these photo frames.
Maybe a family holiday or eating ice cream with friends?

I'LL NEVER FORGET ...

BEST OF ALL WAS ...

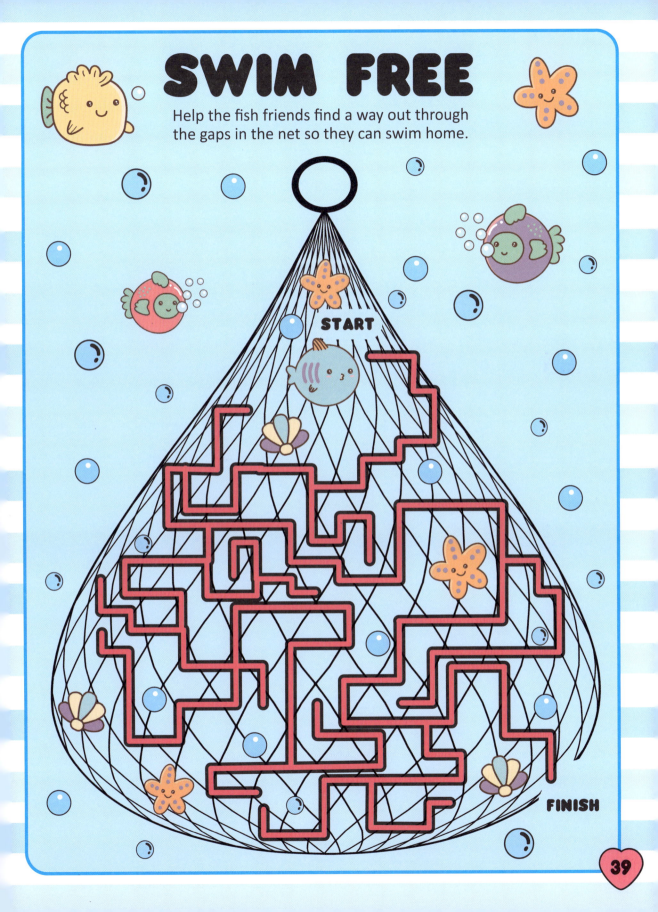

MONSTER MIX

Make up an adorable monster! Choose a body shape, arms, legs, and eyes for your creature. Will you add horns, wings, a tail, fur, or fangs? It's up to you!

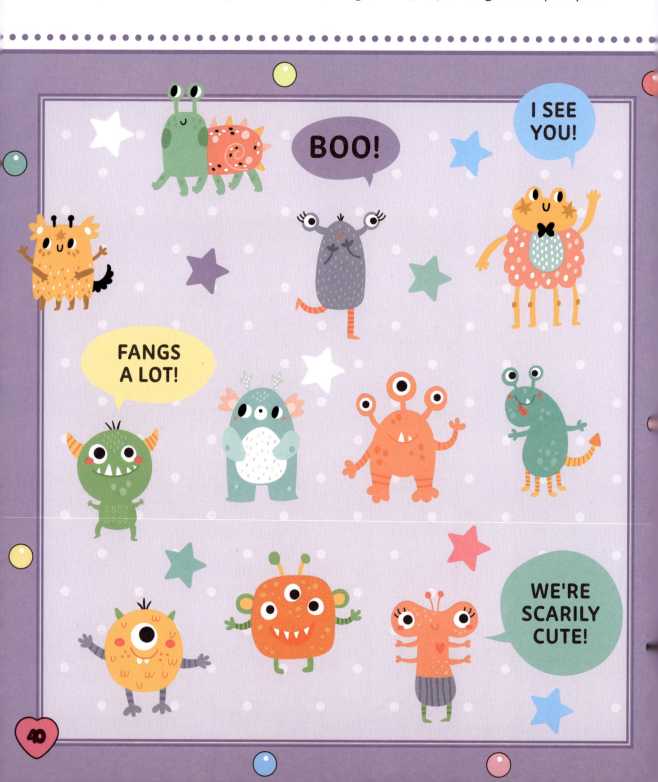

PURR-FECT PLANTER

Crafts

Recycle a plastic bottle by turning it into a pretty pussycat planter.

YOU WILL NEED:

- ★ Old drinks bottle
- ★ Scissors
- ★ Felt tips/markers
- ★ Paint (testers or leftover wall paint are perfect)
- ★ Kitchen roll

INSTRUCTIONS

1. Use the marker to draw your kawaii planter shape.

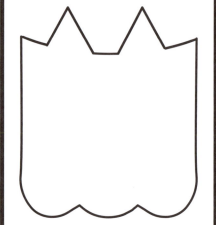

2. Ask an adult to help you cut out the planter, then wipe the marker pen off with damp kitchen towel.

42

3. Paint the planter—it will need two or three coats. If you don't have paint, you could always cover the planter with colored paper.

4. Once your final coat of paint is dry, use a felt tip or marker to draw the super cute features of your planter like eyes, nose, and ears.

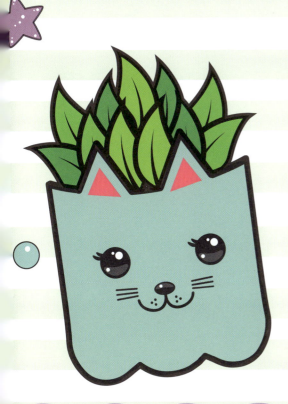

ASK AN ADULT IF YOU NEED HELP USING SCISSORS.

.................................... IS HAVING A PARTY

AT ..

ON ..

RSVP ..

WE WOULD LOVE YOU TO JOIN US!

COLOR ME IN!

How many different types of food can you find? Give them all a splash of tasty color!

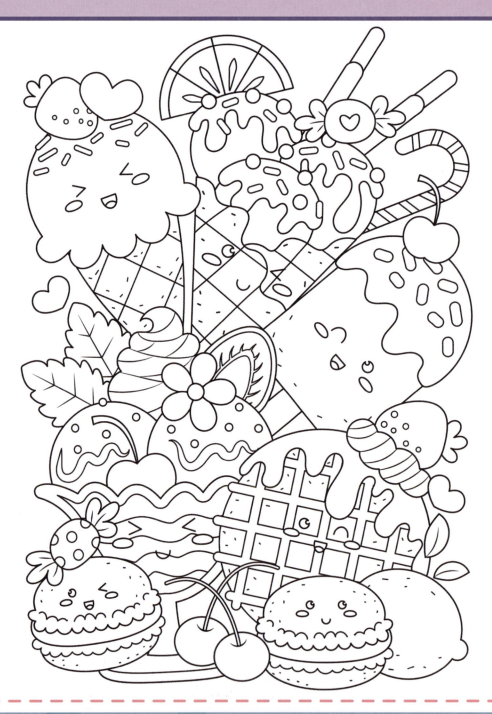

CUPCAKE CRAZY

What flavor is this giant cupcake?
Color it in to make it good enough to eat!

Crafts

MAKE A DONUT KEYRING

Follow these simple steps to make your own super sweet key ring!

YOU WILL NEED:

- Felt x 2 colors
- Thread
- Needle
- Pencil
- Scissors
- Beads or sequins
- Cotton wool
- Keyring chain or ribbon

1 Cut out two donut shapes from felt, like this. They both need to be the same size.

 Sweet!

2 For the icing, use the other felt colour. Cut out a circle (the same size as the donut shapes). Then draw a squiggly line around the edge.

3 Carefully snip along the edges of the squiggly line – now it looks like icing.

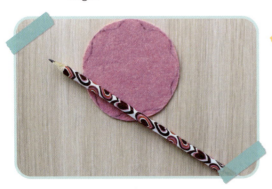

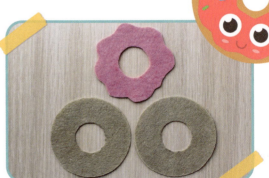

 Sew or stick to add colorful beads or sequins. These will be the sprinkles!

 Sew the icing onto one of the felt donut circles.

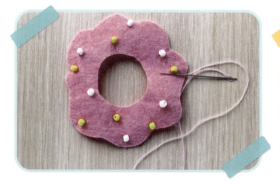

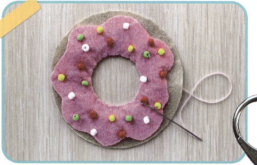

 Then stitch together the two pieces of felt donut, leaving a gap. Stuff this gap with cotton wool and sew it closed.

 Finally, sew it onto a keyring chain. If you don't have one, you could use a loop of ribbon instead!

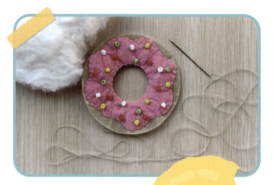

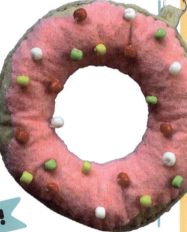

A-do-rable!

ALWAYS ASK AN ADULT TO HELP WITH CUTTING AND SEWING!

TRY THIS!

Braid together two or three pieces of wool or ribbon and thread your donut onto the end. If you make the braid long enough, you could use it as a bookmark.

51

TIPPY TOES

PRACTICE USING YOUR CHOPSTICKS!

START

Find a way across a grid, without waking the sleeping dumplings. Only step on spaces where the dumplings have their eyes open.

YUMMY STEAMED OR FRIED!

FINISH

CUPCAKE CUTENESS

WHAT FLAVOR IS EACH COLOR?

Color in all of the cakes in the bakery window to make a display in dazzling rainbow shades. Then, practice drawing some breakfast treats.

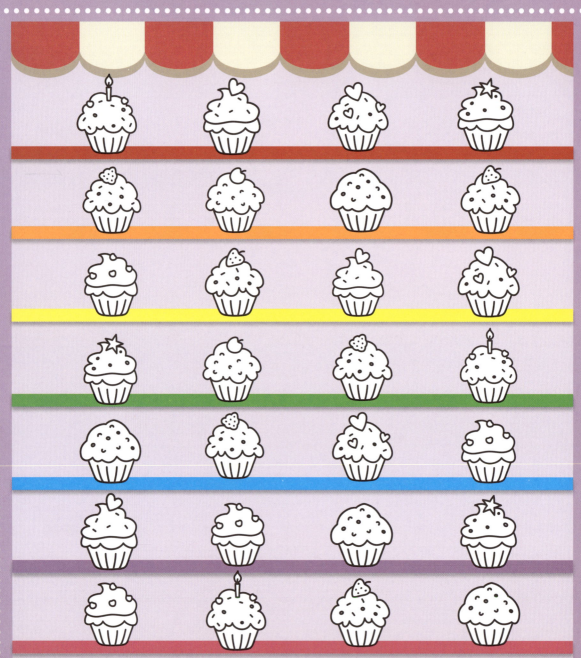

54

CRESCENT

1 First draw a rounded off square with semicircles on each side.

2 Then add the extra shapes each side and a super cute face!

NOW IT'S YOUR TURN!

TOAST

1 Draw a square with two semicircles on the top corners.

2 Add a second outline on the top and left edges for the crust. Add eyes, nose and mouth.

NOW IT'S YOUR TURN!

MUFFIN

1 Draw a rectangle with a cloud on top.

2 Add sprinkles and a super cute smile.

NOW IT'S YOUR TURN!

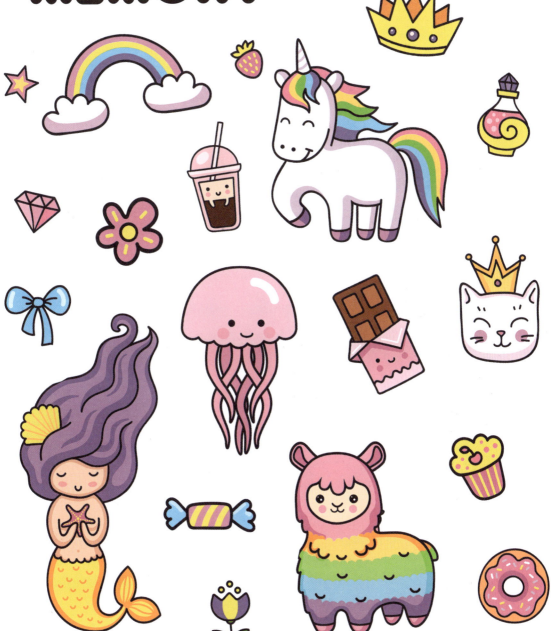

WHAT'S MISSING?

Can you work out which three objects have disappeared from the last page without looking back?

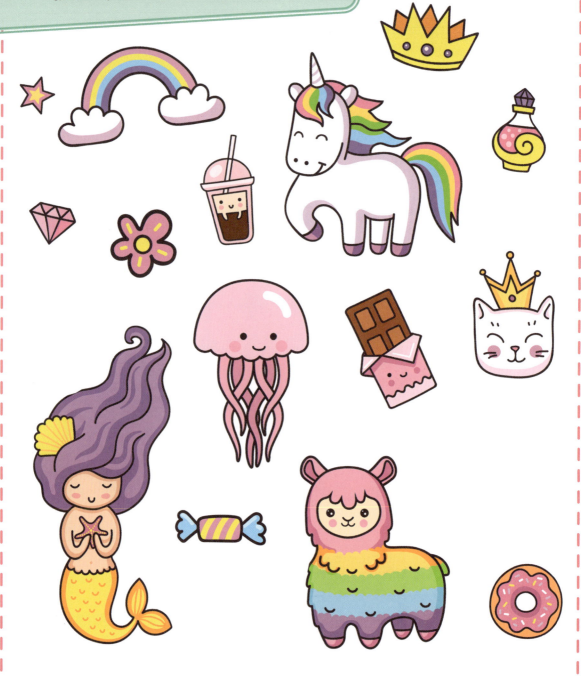

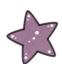 **Crafts**

POP-UP GREETINGS

Surprise! Here's how to make a pretty pop-up card to delight a friend.

YOU WILL NEED:

- Colored card
- Scissors
- Glue
- Pencil
- Coloring pens

1 Fold one sheet of card in half.

2 Ask an adult to cut two snips in the fold as shown. Snip more than one pair if you like.

3 Open the card and push out the snipped sections.

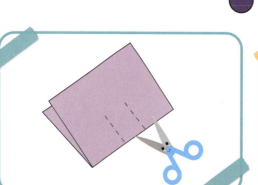

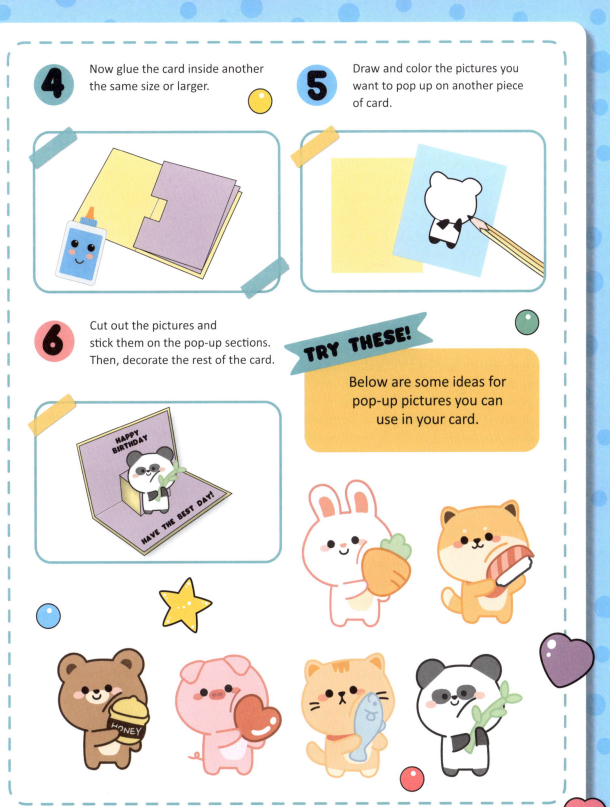

OODLES OF NOODLES

There's been an explosion in the noodle factory and everyone has lost their belongings. Follow the noodle trails to find each cute critter's snack, then draw it in the box next to them.

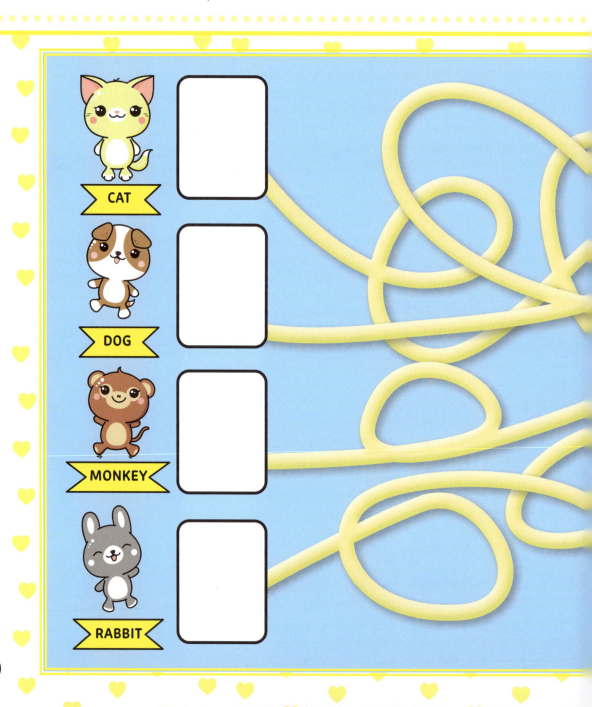

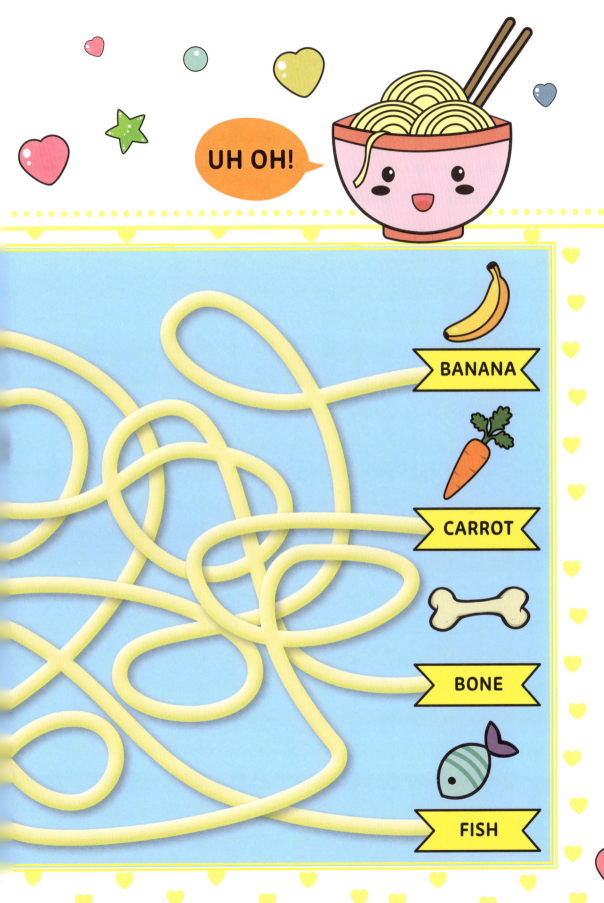

PENCIL POPPER

Crafts

Brighten up your pencil collection with a cute cloud pencil topper!

YOU WILL NEED:

- White card
- Scissors
- Coloring pens
- String
- Sticky tape
- Glue

STEP 1

Fold a sheet of white card in half and draw a cloud shape on it plus several hearts in rainbow colors.

STEP 2

Ask an adult to carefully cut them out so you have two matching clouds and lots of matching hearts.

STEP 3

Draw cute eyes and a smile on one of the clouds.

STEP 4

Cut short lengths of string and glue matching hearts together along the length.

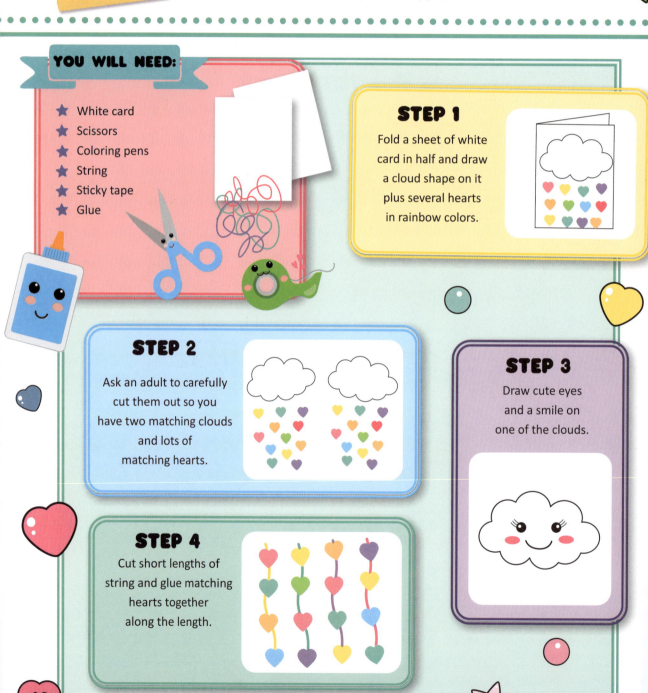

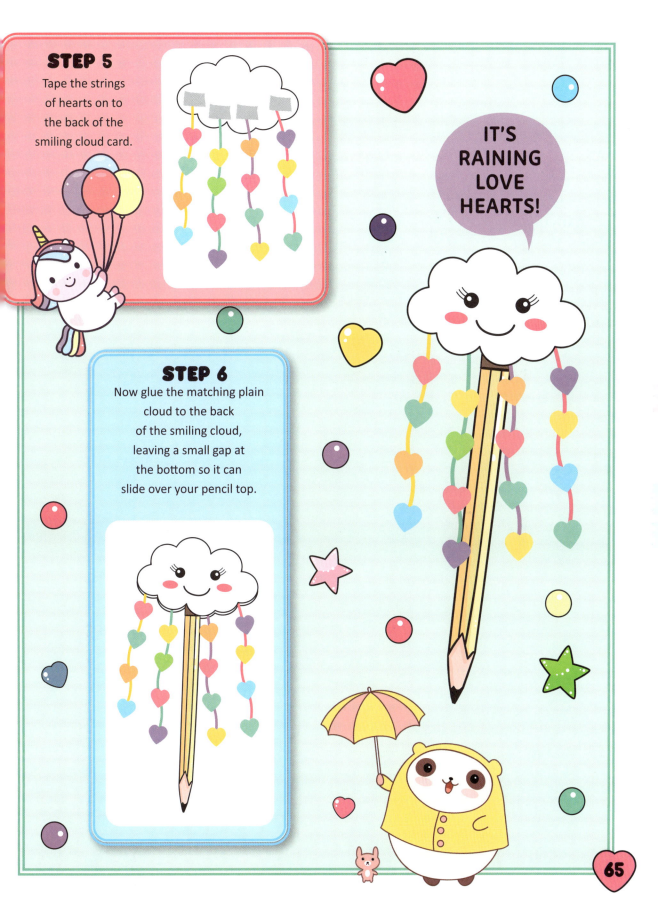

TWICE AS NICE

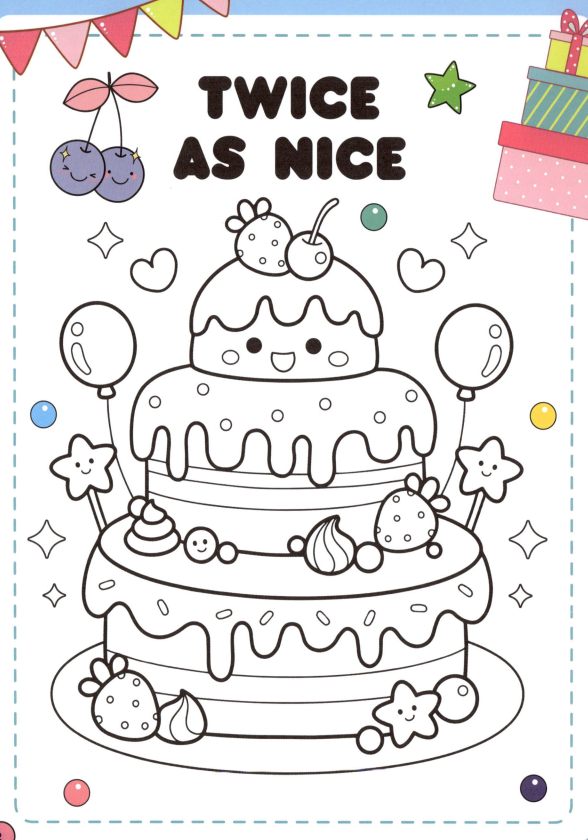

A set of twins are having a birthday, and they both have a cake. The one on the opposite page is a reflection of the one on this page but with 10 tiny differences. Can you find them all? Then, color both cakes in your tastiest shades.

WHO'S HIDING?

Shade in the shapes with dots.
What cute and cuddly animal do you see?

MAKES A CHANGE FROM BAMBOO!

KITTY CUDDLES

Time for a cat nap! Color in this collection of kitties with lots of different fur patterns. Which one is the cutest?

PERKY PANCAKE

Your friends and family will flip when you make them pancakes. Follow the recipe then choose which tasty toppings to add.

INGREDIENTS:

- ★ 10½ oz self-rising flour
- ★ 1 tsp baking powder
- ★ 1 tbsp superfine sugar
- ★ 2 eggs
- ★ 1 tbsp maple syrup
- ★ 1¼ cups milk
- ★ Toppings!

STEP 1

Put the flour, baking powder, and sugar in a large bowl with a pinch of salt. Add the eggs and whisk them together into a batter, adding the syrup and milk as you go.

STEP 2

Ask an adult to heat a little oil and butter in a frying pan. When it's hot, add a few spoonfuls of the pancake batter.

STEP 3

When the batter has started to bubble, flip the pancake to cook the other side.

STEP 4

When both sides are done, put the pancake on a plate to serve right away or cook more to make a delicious pancake pile.

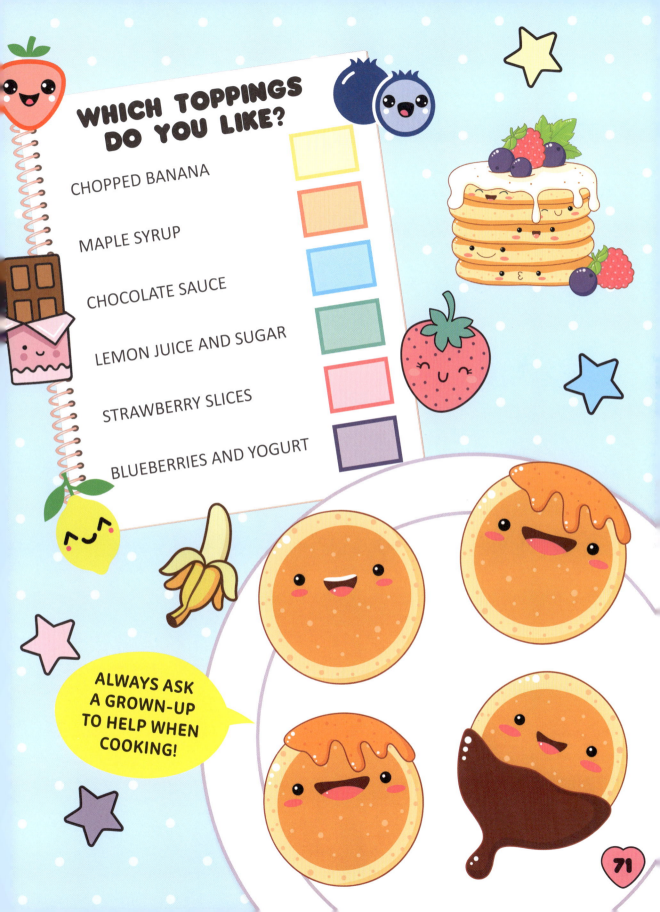

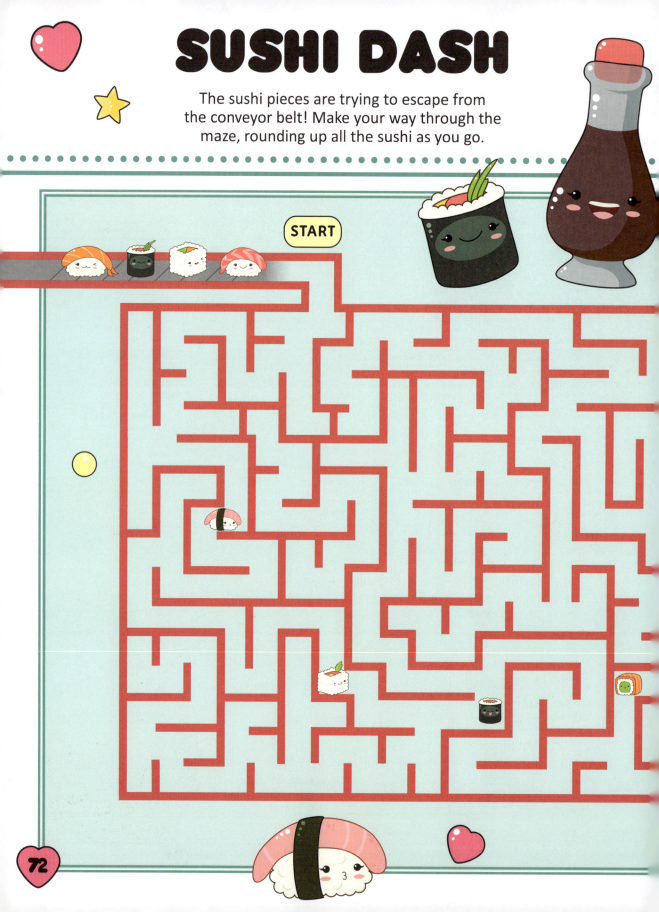

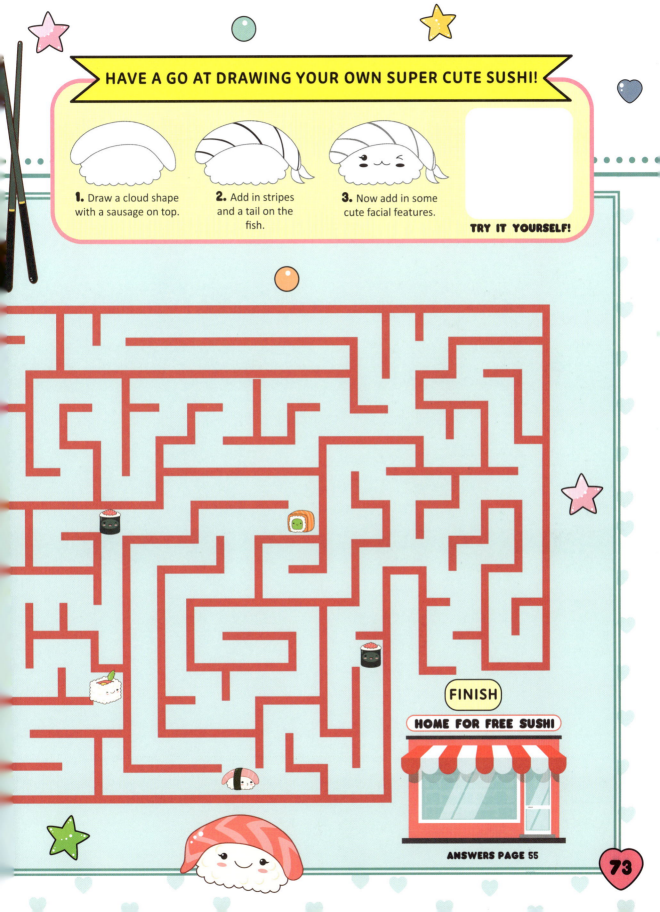

FEAST FOR THE EYES

KIDS MENU
YUM FOR YOUR TUM!

MINI MENU

MAIN DISHES

Burger
Pizza
Spaghetti
Noodle soup
Burrito
Hot dog

SIDE DISHES

Fries
Salad
Nachos
Popcorn

Decorate this cool kids' menu with funny food pictures. What would you choose?

DRINKS
- Bubble tea
- Soda
- Juice
- Milkshake

DESSERTS
- Ice cream
- Chocolate brownie
- Cheesecake
- Fruit

SLURP!

Give your brain a break and color in this crazy collection of monsters, animals, and more using your brightest shades.

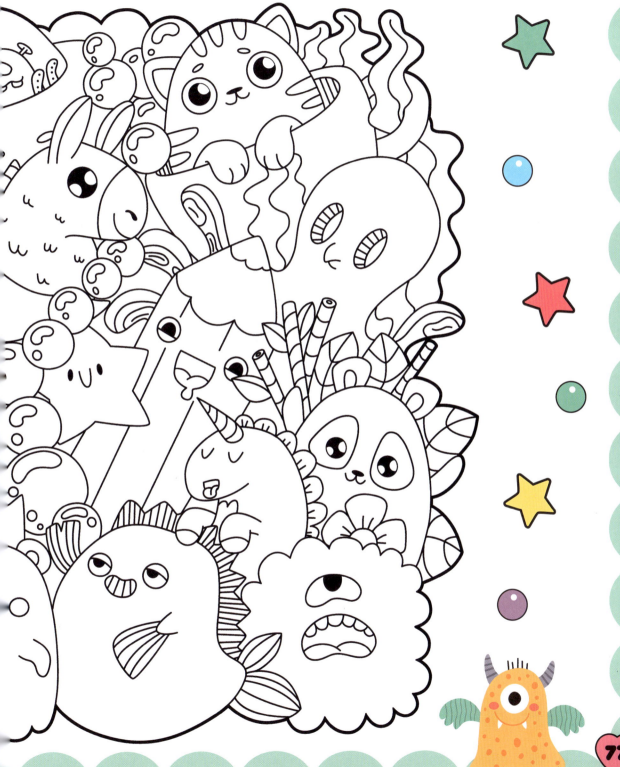

FRIENDLY FEAST

Choose an emoji expression to draw on each of these tasty treats.
If you could choose three to eat, what would you pick?

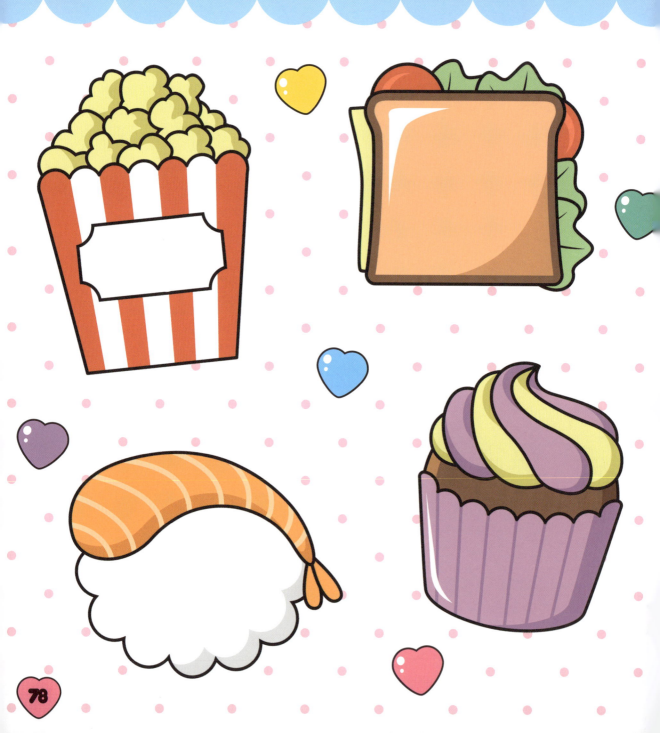

ANSWERS

P10 FROG A, BEAR B, LION D
GIRAFFE C, FOX A

P16

P21

P24

P28

P39

P52

P57 THE CUPCAKE, THE BOW, THE PURPLE FLOWER AND THE STRAWBERRY DISAPPEARED.

P62

P66

P68

P72